NINETEENTH·CENTURY
ROMANTIC
BRONZES

French, English and American Bronzes 1830–1915

JEREMY COOPER

DAVID & CHARLES

NEWTON ABBOT · LONDON

To my parents

0 7153 6346 8

Typesetting and printing by Jolly & Barber Ltd, Rugby, Warwickshire
Bound by Webb, Son & Company Limited, Southgate, London N14

Designed by John Leath

NINETEENTH-CENTURY
ROMANTIC BRONZES

Contents

Preface

This study of Romantic sculpture can supply no more than the basic information about the four topics discussed, but considerable efforts have been made to clarify the stylistic developments of the period and to include every significant sculptor in his appropriate place. The wide range of the text has naturally involved certain simplifications and some important figures have been dealt with peremptorily, although hopefully this need not be misleading if the spirit of the book speaks clearly.

Nineteenth-century sculpture has yet to receive sufficient academic attention, but one recent work for each topic proved invaluable, namely Dr Ruth Mirolli's catalogue of the Exhibition *Nineteenth Century French Sculpture* at the Speed Art Museum, Louisville, Kentucky, in December 1971, Lavinia Handley-Read's catalogue of *British Sculpture 1850 to 1914* at the Fine Art Society, London, in 1968, Wayne Craven's *Sculpture in America*, New York, 1968, and Jane Horswell's *Les Animaliers*, Woodbridge, 1971. In addition many experts and collectors have given help and advice, for which I am grateful, and longer consideration of other's expertise would no doubt have prevented errors. However, the detailed individual studies deserved of each of these subjects will surely be undertaken before long.

Specific gratitude must be expressed to my secretary Sue Dewar, who gives continuous support both with her admirable efficiency and with her happy enthusiasm. Also of course I am indebted to Sotheby's Belgravia as an institution, first for bringing me to the subject of nineteenth-century sculpture and secondly for offering the rare satisfaction of enthralling work and company.

Many private collectors and public museums have generously allowed the reproduction of their bronzes and I am grateful for their assistance. The plates are acknowledged individually on p. 157. No one has done more to help in this area than Jeanette Kynch who took practically all those photographs ascribed to Sotheby's Belgravia, and many others besides; the quality of her work is consistently high.

Note: Page numbers in square brackets in the text refer to colour plates. Those numbers in parentheses relate to black-and-white plates.

Introduction

In view of the growing interest in the political, social and artistic history of the nineteenth century, it is strange to find that so little attention has been paid to Romantic Bronzes, a subject which combines all three of these aspects. Perhaps art historians have been daunted by visions of endless galleries of sentimental marble statuary and cities groaning under the massive burden of jingoistic public monuments; certainly the habitual dismissal of the specifically Victorian past must have influenced the restriction of interest to a regular nibble ar either end, the Neo-Classicism of the 1820s and Rodin's revolutionary contribution of the 1870s to the modern movement.

It was therefore with respectful consideration for the traditional distrust of the subject that our particular approach was chosen. Firstly, the concentration entirely on sculpture in bronze immediately removed, without any distortion of the facts of sculptural development, the necessity of focusing even momentarily on those depressing galleries of unimaginative marbles. No distortion occurred because all the nineteenth-century sculptors who made a direct contribution to our subject, Romantic Bronzes, either worked primarily for bronze or sculpted in marble with an eye to reproduction in bronze. Obviously the dividing line is not absolute, especially in the early years, but it is quite justifiable to isolate Romantic Bronzes from general sculptural history, not only for the better appreciation of this delightful, tactile medium, but also because the employment of bronze was in itself a distinguishing feature of the Romantic sculptors.

Secondly, the decision to tackle the general history of French, English and American bronzes from 1830 to 1915 was influenced by the desire to give a panoramic view of the fascinating interaction that occurred in this period between sculptors of different generations and between the art of the three countries. Indeed the nineteenth century was a period of such prolific production and accelerated invention that enjoyment of the details seemed impossible without prior understanding of the broad strokes of stylistic development.

The critic's task is to untangle the thread of artistic creativity linking the artists of the past, and although the line of development may often seem to turn upon itself inexplicably and even to disappear altogether, its path through sculpture in bronze of the nineteenth century was intricate and exciting.

The Romantic ideal was first strongly expressed by the painters of the

1820s in both England and France, but partly because of the expense of materials and the restrictions of the system of patronage the sculptors took far longer to break away from the narrowness of classical discipline. Gradually in France through the 1830s and 1840s greater freedom of expression was established and sculpture began to assume the characteristics of a Romantic art, characteristics which included an admiration of nature, a concern for the human predicament, and a growing involvement with movement of surface and form in bronze. From France the new ideals spread first to England and then to America where they were given individual interpretations, until totally different criteria began to emerge again in France towards the end of the century. Rodin was, of course, the bold initiator of this modern movement towards abstract expression which, although reliant on the discoveries of Romanticism, provided a clear end to this discussion of Romantic Bronzes.

A glance through the illustrations will reveal the immense scope of this largely unexplored field, and this study can do no more than shade in the general outline to a complex period of sculptural endeavour. The term 'Romantic' has long defied scholastic definition but it is used in this context to describe all the varied strains of sculptural style that emerged from the long-reaching Neo-Classical shadow until naturalistic use of the human figure was engulfed by the Abstract and Expressionist landslides set in motion by Rodin. In all four chapters each sculptor is therefore discussed in relative detail according to his position in this stylistically defined development of the Romantic Bronze.

The subject is an exciting one and a particular favourite of the author's, and the underlying aim has been not merely to supply information but to provide the reader with the basic visual and historical understanding to permit his own personal enjoyment of some glorious bronzes.

1 French Sculpture from David d'Angers to Rodin

As the stylistic development of French sculpture in the nineteenth century was intricately entwined with the turbulent political history of the period, it is important from the first to reach an understanding of the relationship between the sculptor's activity and the patronage of the state, on which he was largely dependent.

In the present days of highly individual, experimental art it is difficult to visualise the situation in which all but a small percentage of the French sculptors mentioned in this book studied at one time or another at the École des Beaux-Arts in Paris. There, in the 1830s, year after year the students competed for the top academic honour, the Prix de Rome, a distinction which ensured the further immersion of the most talented in the limited classical disciplines of their professors, who themselves had passed generations earlier through exactly the same process of instruction. And the tyranny continued over all sculptors whether Beaux-Arts graduates or not, as the only means of attracting the public's eye was by exhibition at the yearly Salons, the entries for which were judged autocratically by members of the 'Institut', and naturally enough any sculpture that failed to conform to the narrow standards of the establishment was rejected.

This depressing situation could have been, and indeed eventually was, relieved by the operation of private patronage, but the process was slow because until after World War I the sculptor regularly saw his highest function in the personal expression of the national ideal in a public monument. For example, in the mid-nineteenth century Charles Baudelaire, the active apologist of Romanticism, described the public monument as the *rôle divin* of the sculptor, an opinion still reiterated less extravagantly but equally strongly by Auguste Rodin at the end of the century. In these circumstances it is easy to see why the political climate and the mood of public patronage had such a powerful influence on the natural stylistic tendencies of the individual French sculptors.

The phases in the development of the Romantic style in sculpture therefore corresponded broadly with the three decisive divisions in political

history – the reign of Louis-Philippe from 1830 to 1848, the Second Empire from 1851 to 1870, and the Third Republic from 1871 to 1915.

The July Monarchy of 1830 began in an atmosphere of elation for the sculptors, as Louis-Philippe initiated a full-scale rehabilitation of Napoleonic monuments, so that all the unfinished work of the previous two decades was recommissioned from leading sculptors of the day. Thus the revived Bourbon regime must be credited with perhaps the most important Parisian monument of all ages, the Arc de Triomphe in the Place de l'Étoile, and also with the completion of numerous other public works that glorified the achievements of France and its people. But unfortunately the euphoria was short-lived in both historical and artistic terms, as Louis-Philippe showed himself to be a dull, reactionary monarch, lacking the emotional attractions required to convince the people of his right to seize the crown by force. By the 1840s a complete dissociation of identity had occurred between the well-being of the people and the safety of the crown, an emotional state which was aggravated by economic crisis and resulted in the popular revolution of 1848 against the monarchy.

Both these factors were reflected in artistic circles, where all the progressive sculptors objected to the stranglehold of reactionary classicism on the Schools and Salons; despite the rash of commissions at the beginning of the reign, both artists and critics believed that sculptural taste had even deteriorated. Sensing the dangers of Romanticism, the Institut closed its ranks and all but the most innocuous sculpture was refused at the Salons. Indeed, the most revolutionary figurative sculptor of the time, Auguste Préault, was totally banned from the Salons from 1834 till 1848. Other heads fell as Rude, Fratin, Daumier and Barye had sculpture regularly refused, and even the classicist Etex felt obliged on principle to write in anger against the unjustified rejections of Barye and Delacroix in 1837. At the same time Baudelaire and the critics welcomed with open arms the decision of Antonin Moine to set up his own independent school of drawing in 1834. Affected also by the economic crisis in the 1840s which brought public commissions to a standstill, the sculptors of imagination almost all became ardent republicans, and the revolutionary spirit of the Romantic artists is indicated by the fact that after the failure of their republican enterprises the sculptors David d'Angers and François Rude, already in their sixties, were forced into exile on the election of Louis-Napoleon as President in 1851.

Inevitably the drama of historical events could not be matched visually by the sculpture of the Romantic revolution. In painting, changes occurred earlier and more dramatically, but then the nature of the painter's art allowed for speedy adaptation of technique to accommodate newly felt desires to express the personal excitement and emotive associations of a situation, as opposed to the old-fashioned taste for heroic didacticism. Techniques in the relatively laborious medium of sculpture perforce developed more slowly, although some sculptors were no less Romantic in their philosophy.

The efficacy of the Beaux-Arts system defined that change, if it came at all, would come from within, and the first member of the establishment to

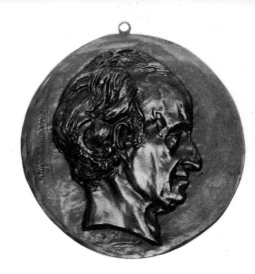

1 A selection of portrait medallions by David d'Angers of contemporaries such as Filippo Buonaroti and of characters of the past such as Robespierre.

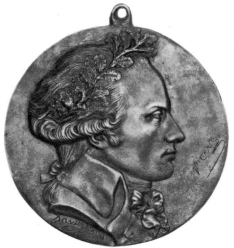

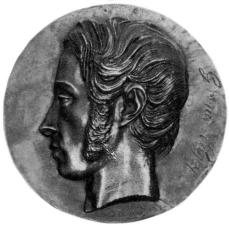

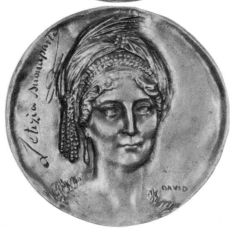

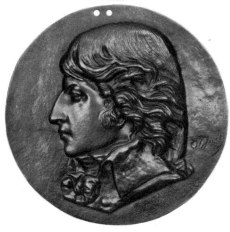

show signs of inherent sympathies with the tenets of Romanticism was P. J. David, called David d'Angers (1788–1856), whose 'Carnets' (notebooks) revealed a critical romantic spirit of considerable power. Naturally, a pupil of Canova, a protégé of the painter Jacques-Louis David and an admirer of Flaxman was unlikely to dispose of classicism in one cut of the chisel, but nevertheless in 1828, the year in which the Carnets began, David d'Angers took up in earnest a form of sculptural expression which completely contradicted the teaching of his masters. These small portrait roundels of famous men and women of his time (1) which David executed for his own private pleasure were of crucial importance because they gave unprecedented attention to contemporary man in his natural habit. Before David d'Angers, and indeed for a long time after, man was honoured in idealised sculpture with obtuse philosophical reference to the classical hero, whereas these bronze portraits, and also of course the Carnets, for the first time in sculpture acknowledged the absolute relevance of the natural appearance and inner emotions of the living man.

But despite the lasting appeal of these medallions it would be wrong to think of David d'Angers as a consistent 'Romantic' for both he and the classicist Pradier were companion professors at the École des Beaux-Arts before 1830 and thus in the mind of a total Romantic like Préault, David was indistinguishable from 'les reptiles de l'Institut'. And there can be no denying that David's principal means of expression was in the Neo-Classical idiom with busts like 'Chenier' (2), in which the individual character of the sitter was dissolved by the acidity of the style. Indeed, David's superb confidence in the established classical mode secured him in November 1830 one of the chief commissions of the new regime, the Panthéon frieze 'Aux Grands Hommes La Patrie Reconnaissante' (3), which embodied the strongest artistic and philosophical principles of his period in the combined classical-historicist memorial to the nation's heroes.

All the same, David's traditional style contrasted dramatically with his written and spoken art theories in which there was much talk of the need, in his own words, to *rendre l'âme* in art and to 'create in the spirit of joy', a point of view tendered with complete clarity in the five hundred or so different bronze portrait medallions [p. 107] but only very occasionally in any other work.

David d'Angers was invariably rude about contemporary sculptors, and Jean-Jacques Pradier (1790–1852) could not expect to escape criticism, for his work involved a dexterous but utterly lifeless sentimentalisation of classical ideals. Nevertheless Pradier's work was immensely successful and his limpid marbles were reproduced inexhaustibly in various media to delight the essentially bourgeois taste that soon emerged under Louis-Philippe. By 1840 the Neo-Classical style had lost its keenness and these bronzes (4) induced Baudelaire to conclude in 1846 that 'the pitiful state of sculpture' was entirely due to Pradier's leadership, although in all fairness this sculptor's success was merely a symptom of decay and not its cause. Indeed this inherent weakness in French sculpture seemed to hang on indefinitely when a young pupil of Pradier's, Claude Eugène Guillaume (1822–1905), was able to command attention for his classical inanities

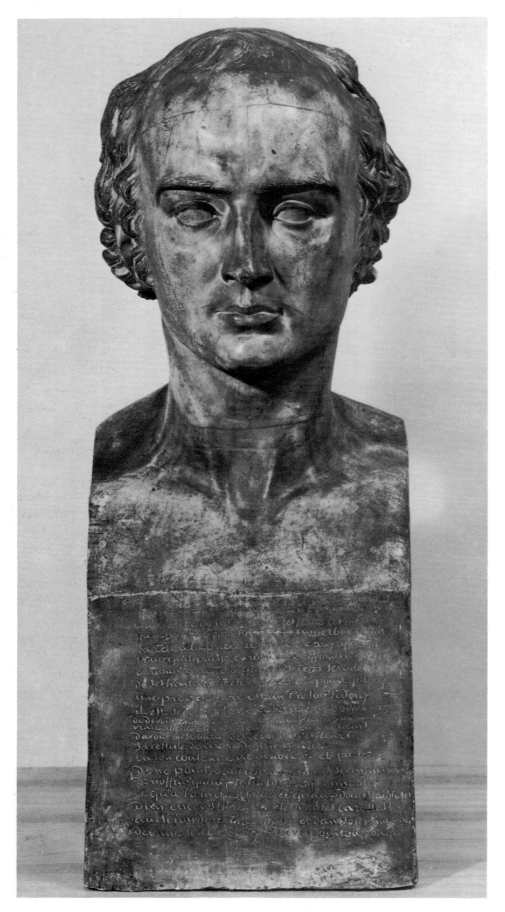

2 A terracotta bust of 'Chenier', a commission from David d'Angers in which the classical style contrasted with the romanticism of the medallions.

3 David d'Angers' first important commission was for the frieze of the Panthéon in 1830.

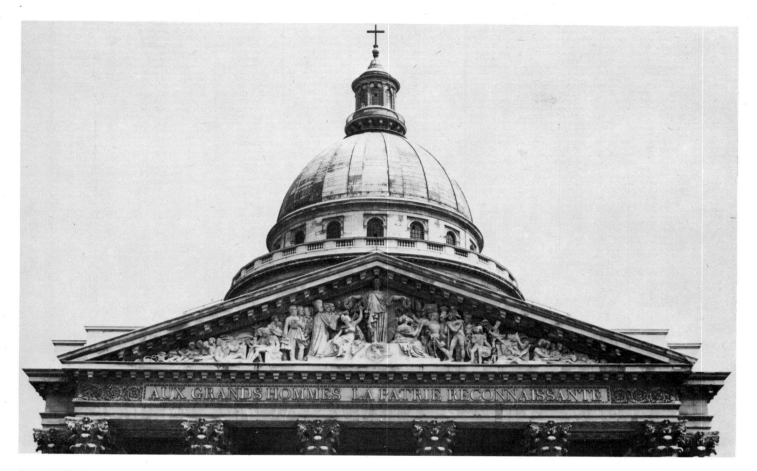

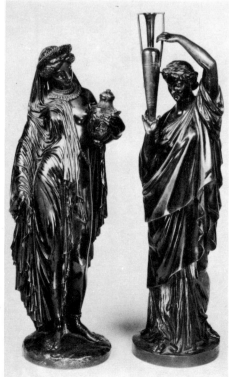

4 These two bronze classical figures are typical of the commercial work of the influential sculptor Jean-Jacques Pradier (1790–1852).

almost to the last years of the century; and some other of Pradier's pupils even surpassed the master in affluence, for Antoine Etex (1808–88) became an extremely wealthy man after his early recognition with the Arc de Triomphe commissions in the 1830s. It is ironical that Etex's rare and indecisive excursion into realism, his 'Géricault Monument' (5), merely served to emphasise the paucity of sculptural design when compared with the early Romantic painting, Géricault's 'The Raft of the Medusa' of 1819, reproduced in bronze relief at the base of the painter's monument.

Baudelaire's Salon criticisms do not give an entirely accurate view of contemporary sculpture, for although a tireless advocate of Romantic principles, Baudelaire's actual visual understanding was suspect. His loud adulation of Auguste Clesinger (1814–83) was therefore a reaction as much to the sculptor's life-style as to his work, for in Baudelaire's estimation Clesinger was a perfect example of the cultured man, as the sculptor divided his attention between charming and witty excursions into the highest Parisian society and the luxurious life in Italy of the 'Renaissance' artist. By all accounts Baudelaire was not mistaken in describing Clesinger as a *diable d'homme*, but this forceful social spirit seldom found expression in sculpture as even his studies of the Romantic's idol, Madame Sabatier, were shackled by revivalist principles, and his only imposing work was the 'Combat de Toreaux' of 1863 which, despite a lack of realism, contained distinguished formal pleasures in the bold interlocking of masses.

Baudelaire did not begin his Salon criticisms until 1845, the year of the death of François-Joseph Bosio (1768–1845), but the two would never

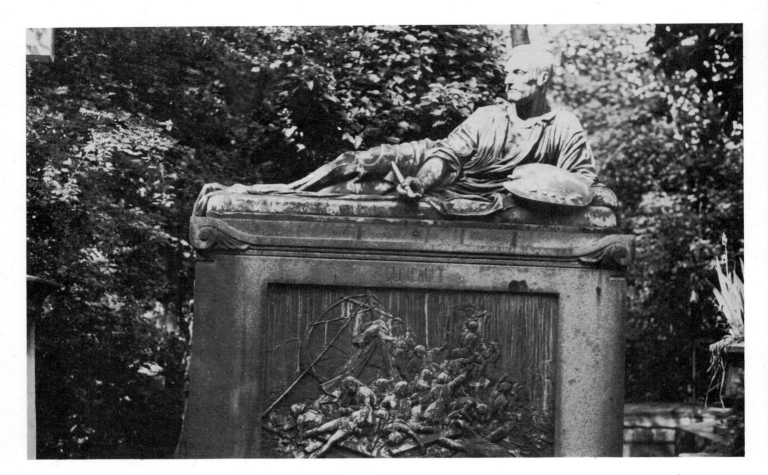

have been allies, for Bosio, an incurable stutterer, bowed feebly before one regime after another in contrast to the fiery independence of the Baudelairian Romantic. But in fact Bosio had a far wider sympathy with sculptural Romanticism than Baudelaire's hero Clesinger, despite his forty years' seniority; indeed as early as 1824 Bosio produced a small silvered bronze statuette of 'Henry IV' (6) which revealed a sensitive figurative understanding of literary romanticism, and at the same time he was at work on his magnificent portrait bust of 'Charles X', now in Versailles, which brought out in unprecedented realism the cruel inner nature of this proud monarch, a quality which overshadowed the revivalist form of the bust.

Bosio's bravest work 'The Young Indian Girl', which he exhibited at the age of seventy-seven in 1845, went further than the sculpture of most of his contemporaries, but it had a crucial precedent, the 'Neapolitan Fisherboy' (7) of François Rude (1784–1855). The significance of this work can be judged from the comment of Edmund Gosse in 1894: 'Modern sculpture dates from 1833, when François Rude exhibited his "Young Neapolitan Fisherboy" in the Salon. This was the first attempt made anywhere to present, under an exact and individual form, the human body as it exists before our eyes.' Gosse tended to over-dramatisation in his desire for literary stylishness, but Rude's 'Fisherboy' was indeed a remarkable breakthrough in its choice of both an anti-heroic, natural subject and a realistic pose. Even its basic conception was Romantic, for Rude had never been to Italy as the political situation had prevented him from taking up his

6 A silvered bronze statuette of Henry IV by Bosio, an early example of historical romanticism in sculpture in 1824.

Francis Derwent-Wood's stay in Paris in the late 1890s contributed these Rodinesque qualities to his 'Motherhood'. (*Sotheby's Belgravia*)

7 The 'Young Neapolitan Fisherboy' of 1833 by François Rude was one of the first Salon sculptures to exhibit an artist's involvement with naturalism.

award in 1812, and indeed the smooth, untextured surface was all that remained of the pure classical traditions. Rude, beginning with his peasant background, always projected an untraditional character, and from 1814 until 1827 was forced to suffer exile in Brussels for his Bonapartist sympathies, and even after his return continued to conduct a campaign against formalism in the Schools. As the reign of Louis-Philippe progressed, Rude found it more and more difficult to exhibit publicly, and in 1846 all sixteen of his pupils were also refused entry to the Salons for no reason other than their connections with Rude.

In a sense Rude's artistic personality was limited by his period, for his creativity was confined to the classical idiom (21) to the exclusion (apart from his last work, the 'Marshal Ney Monument') of imaginative forms in

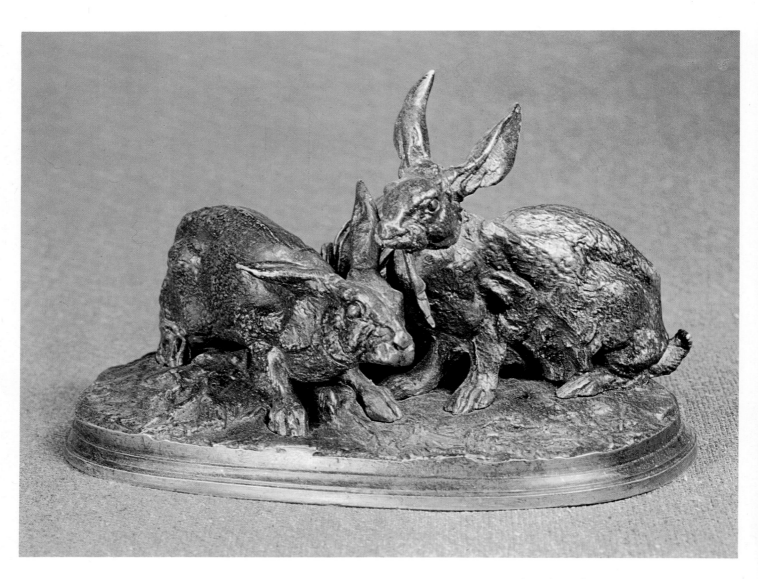

The realism of P. J. Mène's sculpture led, during his lifetime, to great popularity in both England and France. (*Sotheby's Belgravia*)

modern dress. So the pose of 'Mercury' (8) in 1828 inevitably lacked the freedom of a similar subject, 'Perseus Arming' (67), by Gilbert in 1884, although it did achieve the maximum naturalism of pose within its period limitations. However, in his 'Departure of the Volunteers of 1792' (9), raised on the Arc de Triomphe in 1836, Rude created one of those rare pieces of sculpture that transcend a period or a style and establish themselves as perfect representations of their chosen theme. The subject was of course close to Rude's heart, but the way in which he captured the spirit of nationalism was nevertheless especially moving, and the overriding figure, 'The Genius of Liberty', contradicted all the established classical principles in its unequivocal exaltation of a living ideal.

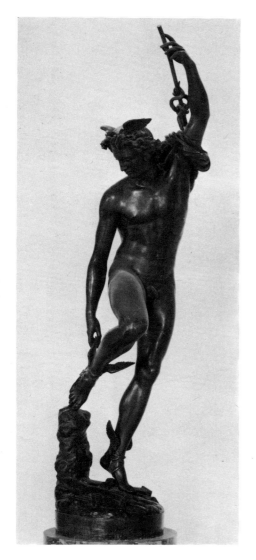

8 François Rude's 'Mercury' of 1828 was more traditional in its devotion to classical proportions and subject.

Françoise Rude seized upon the opportunity of honouring Napoleon personally when he solicited the commission for a private monument from Captain Noisot, the Commander of the Grenadier Guard at Elba. The earliest version, 'The Imperial Eagle Watching over the Dead Napoleon' (10), achieved true pathos and this flowing realism in bronze would have fitted easily into the progressive sculpture of thirty years later. Perhaps of even greater significance is the fact that Rude intended this to be a private expression of homage and himself described it as 'the echo of an emotion'; this work and that sentiment establish Rude as the first fully fledged Romantic sculptor, his only rival being Antoine Louis Barye (1796–1875) whose animal bronzes described in chapter 4 struck similar revolutionary chords.

But François Rude was not entirely alone, for his friend Francisque-Joseph Duret (1804–65), although by no means as adventurous in his style, did make a positive contribution to the development of French sculpture, for his 'Dancing Neapolitan Boy' (11) of 1833 and the companion 'Lute Player' (12) anticipated the joyous treatment by Carpeaux in the 1860s of identical subjects (22). Duret, a quiet, dedicated artist, remained at the forefront of the growing Romantic movement, but he was never capable of the revolutionary steps made by Antoine-Augustin Préault (1809–79). Préault was one of the few influential sculptors of the period to progress without direct instruction from the École des Beaux-Arts, although he did benefit from a short phase of pupilage to David d'Angers until these two opinionated characters inevitably quarrelled. Préault always retained a firm admiration for David, being particularly impressed, of course, by the medallions, a form of expression which he took to himself in very similar vein. It is surprising that Baudelaire failed to exalt Préault, for the young sculptor quickly established himself as a member of Paris' Romantic clique, being a particularly close friend of the poet Gérard de Nerval, and indeed by the 1850s his Romantic brilliance had become almost legendary. Inevitably Préault speedily antagonised the Salon judges who allowed 'La Tuerie' (13) into the Salon of 1834 only as a discouraging influence on potential rebels, and his work was not accepted again until after the revolution of 1848. Actually the judges' plans backfired, for 'La Tuerie' secured many admirers amongst the progressives; although not fully controlled by the artist, its symbolist power was quite breath-taking for 1834, and nothing was seen for many decades to compare with these realistic faces and grasping hands gathered in a surreal composition. Préault welcomed

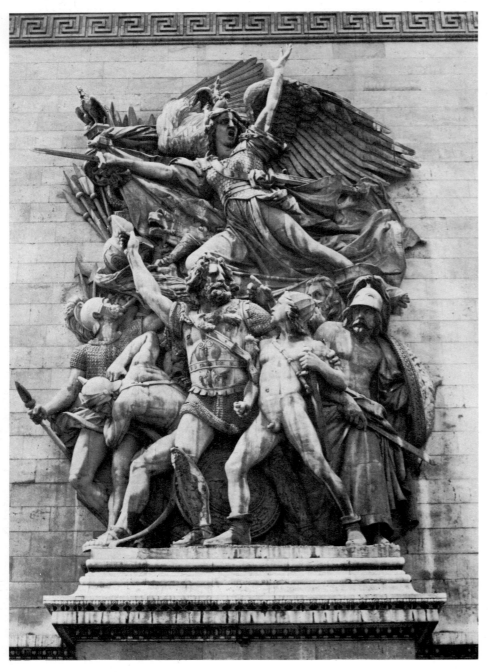

9 The 'Departure of the Volunteers' was pro-
duced by François Rude in 1836 for the Arc de
Triomphe and went further than any contem-
porary sculpture in expression of the national
ideal.

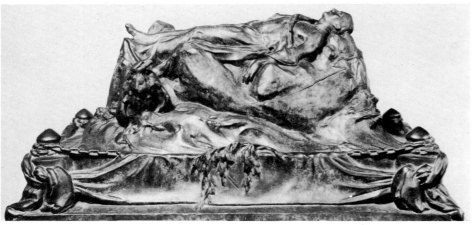

10 Like many Romantic sculptors in France,
Rude was a Bonapartist and his personal devo-
tion was expressed in 'The Imperial Eagle
Watching over the Dead Napoleon', a study
for his commission from Noisot in 1841.

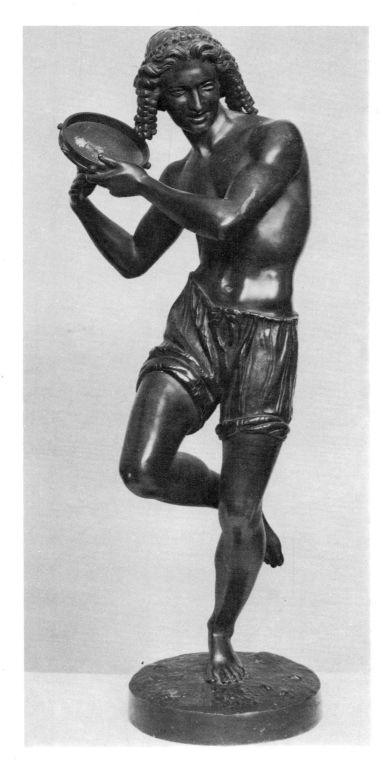
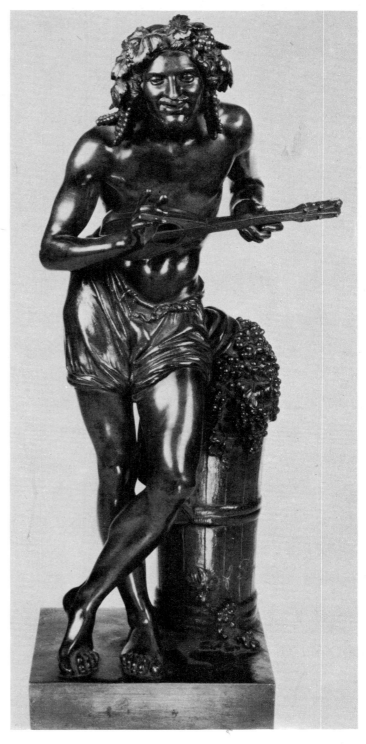

11 (above) 'The Dancing Neapolitan Boy', a study of a favourite theme of the French Romantics, exhibited in 1833 by Francisque-Joseph Duret.

12 (above right) 'The Lute Player', by Duret, the companion piece to 11, contrasting with a later treatment of a similar subject, 28, by Duret's follower Dubois.

his return to the Salon in 1848 with a plaster version of 'Ophelia' (14), a favourite subject in romantic literature and painting to which Préault succeeded in bringing a personal poetry in bronze; more delicate and complete than 'La Tuerie', his 'Ophelia' justly claimed to be the definitive Romantic bronze of the first half of the century.

Honoré Daumier (1808–79) was one of Préault's closest friends as they shared similar political and artistic ideals, Daumier being both an untiring opponent of the July Monarchy and equally revolutionary in artistic ex-

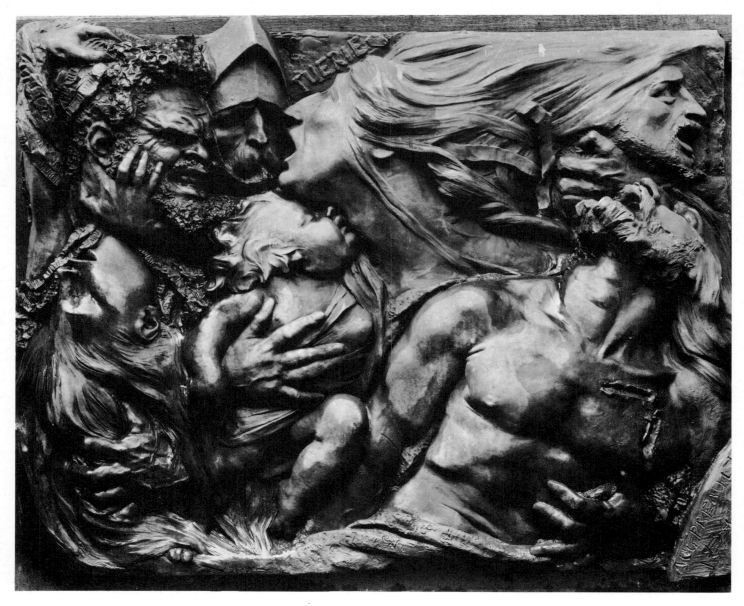

pression. Daumier was best known as a painter and political caricaturist, using the *Charivari* and *La Caricature* to lampoon the government, and it is often assumed that he also 'invented' the modern sculptural caricature. In fact Daumier gained inspiration for his impressionistic clay figures from the exhibitions at the founders Susse Frères of Jean-Pierre Dantan's inventions in this field from 1832 onwards. Dantan (1800–69) was a more active sculptor than Daumier, and, despite his nomadic life, established a wide reputation with portrait busts. His caricatures can be seen as a broadening attempt to introduce the element of humour into sculpture, where Daumier's *charges* were centred on a forceful intellectual message. It is fitting that the last illustration of pre-Second Empire Sculpture should be Daumier's 'Ratapoil' (15) on which he was already working in 1850, for it pilloried the new Bonapartist regime even before it arrived. 'Ratapoil' was unprecedented in two ways. First, its sole purpose was the embodiment of personal feeling, the communication of a living belief, and not the repetition of a heroic ideal. Secondly, Daumier's impressionistic technique in

13 'La Tuerie' by Préault exhibited at the Salon of 1834 possessed amazing modernity in its perspectiveless intensity.

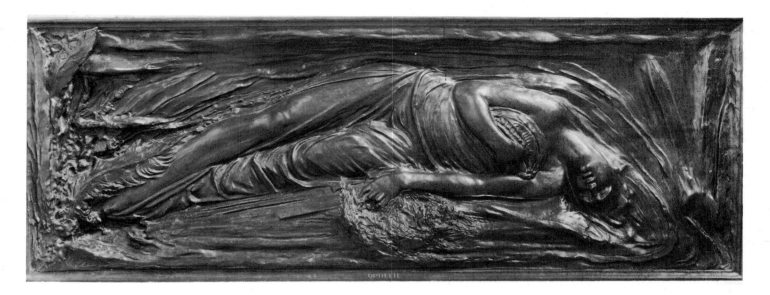

14 Préault was not permitted to exhibit at the Salon again until after the fall of the July Monarchy, 1848; he made his return with 'Ophelia'.

15 'Ratapoil', Daumier's caricature of the agents who organised the return of Louis-Napoleon; the original was conceived in 1850 but not cast until 1890.

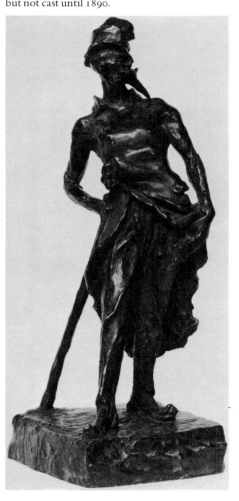

clay was matched by no other artist until Degas turned to sculpture in the late 1870s (51).

The brief republican interlude from 1848 to 1851 was too short and too chaotic to have lasting stylistic force other than to bring the republican sculptors out in their true colours, to be followed speedily by their fall on the election of Louis-Napoleon as President in 1852, when even the ageing masters David d'Angers and François Rude were forced to flee into exile. The young Napoleon, however, was determined not to allow republicans like Daumier to poison the triumph of his overwhelming election, and he immediately set about realising his ambition to make Paris the foremost modern capital of Europe. In 1852 entry to the Salon was relaxed by the introduction of the mixed jury system and throughout the Second Empire commissions flowed from the court for the decoration of the new boulevards and squares of Haussmann's Paris, and no longer could the sculptors complain of lack of work. But although much was gained by this surge of activity there were also some crucial losses, losses that 'Ratapoil' foretold and which became all too evident to the progressive sculptors shortly before the revolution of 1870.

For the emphasis of the Second Empire was on pure decoration [p. 89] which gainfully involved the final annihilation of classical severity by the forces of movement and invention; it unhappily meant that sculpture lost much of the depth and distinction of the intellectually motivated advances of Rude and Préault. At its best, with Carpeaux, French sculpture from 1852 to 1870 established the formal freedom on which the modern movement depended; at its most typical, with Carrier-Belleuse, it existed as a mere decorative extension of the revivalist techniques of the 1830–50 period.

Albert Ernest Carrier-Belleuse (1824–87) brought all the good and the bad elements of the Second Empire together in his prolific activities, encompassing a host of styles and techniques. On arrival in Paris in 1840, Carrier-Belleuse enrolled under David d'Angers at the École des Beaux-Arts for a short period until the restrictions of classical study became too much for him and he left to pursue his private romance with the French

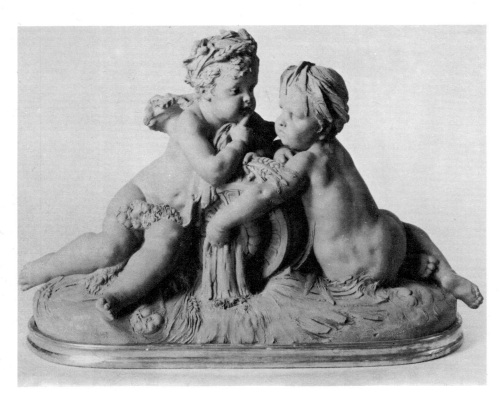

16 Carrier-Belleuse favoured a revival of decorative eighteenth-century ideals, and his terracotta 'La Source' of 1864 clearly revealed this interest.

eighteenth century. At that stage the young sculptor's interest in the relaxed style of the eighteenth century showed a healthy independence, as did his decision to spend the years 1850 to 1854 in England working with the modeller's materials under Leon Arnoux at Minton's porcelain factory; these early interests served as the firm basis for all his later work in which the combination of the modeller's relaxed, flowing style with Rococo forms can be so clearly seen in his terracotta group 'La Source' (16). Carrier-Belleuse extended this pleasing small-scale technique into whole architectural decorative schemes that delighted the Emperor, who introduced him proudly as 'notre Clodion', but sickened intellectual critics like the Goncourts who described him as 'that junkman of the nineteenth century'.

The lack of rational argument in all Carrier-Belleuse's sculpture still precludes him from universal popularity, but there will always be admirers of his technical competence in many media, exemplified in his pleasing 'La Liseuse' (17). Carrier-Belleuse was at his best when using his experience of numerous technical methods in the production of sumptuous decorative interiors like the Hotel Paiva, now the Travellers Club in the Champs Elysées, where he worked from 1865 and designed marvellous sculptural staircases and mantelpieces incorporating newly invented electroplating into his already complex constructions of luscious marbles, pristine porcelain and satanic bronze. His own work showed little sympathy with the modernist movement in operation during the last decade or so of his life, but he had in fact been an early supporter of Rodin, employing him on the Hotel Paiva and in Brussels during his retreat from the Communards in 1870, and indeed had been instrumental in securing the first important commission for his young friend, 'La Porte d'Enfer'. So Carrier-Belleuse must be admired for his decorative energy and his success in transporting sculpture from the cold classical gallery to exciting new decorative involve-

17 'La Liseuse', by Carrier-Belleuse, gained the Grand Prix at a Belgian Salon, probably in the early 1870s when the sculptor was exiled in Brussels.

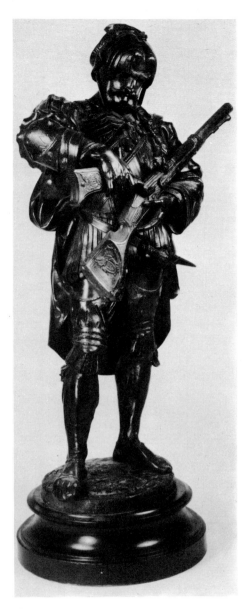

18 Carrier-Belleuse was highly versatile and his 'Musketeer' represented another contemporary fashion, historicism.

ments; but at no stage did his work really contribute directly to the development of the Romantic Bronze, for his bronze statuettes seldom advanced beyond the literary historicism of his 'Musketeer' (18).

In order to cope with his vast output, Carrier-Belleuse relied on competent assistants many of whom, like Mathurin Moreau (1822–1912), were highly successful in their own right, and this practice of employing the best young sculptors busily in the old-fashioned commissions of their elders was a major reason why pure decorativeness lasted in French sculpture till almost 1900. Charles Cordier (1827–1905) was one of the few decorative sculptors of the Second Empire who managed to retain the Romantic spirit, and the bust of a native (19) executed in Algiers in 1856 was a limited sculptural acknowledgement to studies of similar subjects by Delacroix and other Romantic painters. Cordier specialised in exotic studies of natives and produced some magnificent busts in mixed media with bronze heads set in onyx, marble and porphyry drapery, the best of which consummated that rare happy marriage of the decorative and Romantic ideals.

But none of this splendid decoration of Paris would have been possible without the rapidly advancing technical sophistication of French bronze founding, the leading practitioner of which was Ferdinand Barbedienne (1810–92). Barbedienne opened his foundry in 1838 and his early successes came from the exploitation of an invention by his friend and partner Achille Collas (1795–1859) which allowed the accurate reduction of classical [p. 126] and contemporary marbles for the purpose of reproduction in bronze. Barbedienne's business sense told him that money could be made from top-quality reproduction in bronze, and his foundry's techniques reached a point of perfection where a Barbedienne cast of, for example, Dumont's 'Milo of Croton' (20) was scarcely distinguishable from a contemporary cast from the original model of 1772.

The Barbedienne foundry, employing up to three hundred skilled labourers, handled the casting of numerous national monuments and architectural schemes, and the delicacy of its work also led to commissions for bronze and ormolu decoration of domestic interiors, such as the Hôtel de la Ville on which it worked continuously for four years from 1850 to 1854. Ferdinand Barbedienne himself also took an active part in the promotion of contemporary sculpture and became one of the founders for David d'Angers' medallions as well as much of Rude's sculpture, and then Clesinger figured prominently in the firm's catalogue of 1867. More important in the long run was Barbedienne's personal interest in the revival of *cire perdue* casting, the craft process that brought to the collector a feeling of intimate involvement with the actual creative process. Indeed Barbedienne participated to the full in the energetic developments of his period, a perfectionist in the newly fledged 'Industrial Arts' and thus a key contributor in the rapid progress towards modern society; he also revived the concept of private patronage on a Renaissance scale which later gave the artist impetus towards the individuality of modern expression.

In the hands of the energetic but mediocre Carrier-Belleuse, Second Empire sculpture seems to lack persuasive powers and thus doubts are raised about the aesthetics of the whole period; in the hands of a sculptor like Jean-Baptiste Carpeaux (1827–75), whose genius was tailored to his

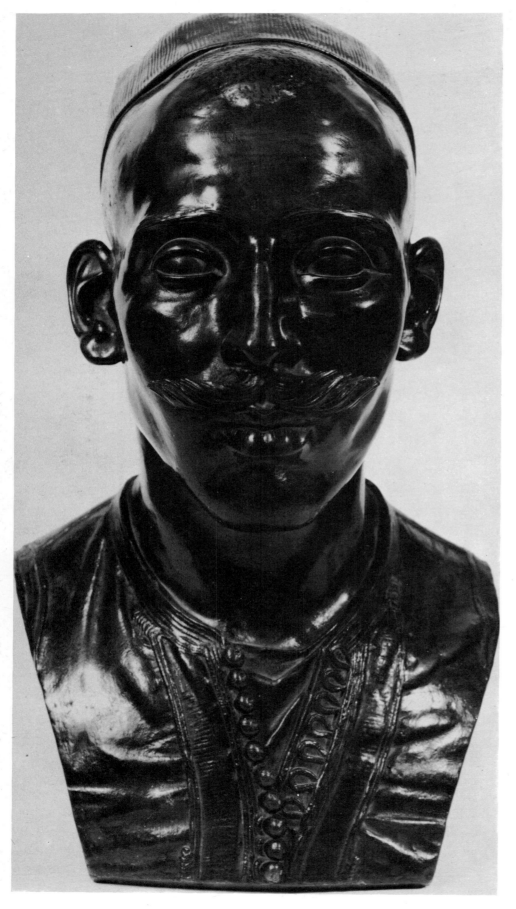

20 The quality of French commercial bronze founding was outstanding, exemplified in Barbedienne's 1840s reduction of Dumont's 'Milo of Croton' of 1772.

19 Charles Cordier specialised in exotic busts of natives executed in various coloured marbles and patinated bronzes; this bronze of an Algerian was produced in Algiers in 1856.

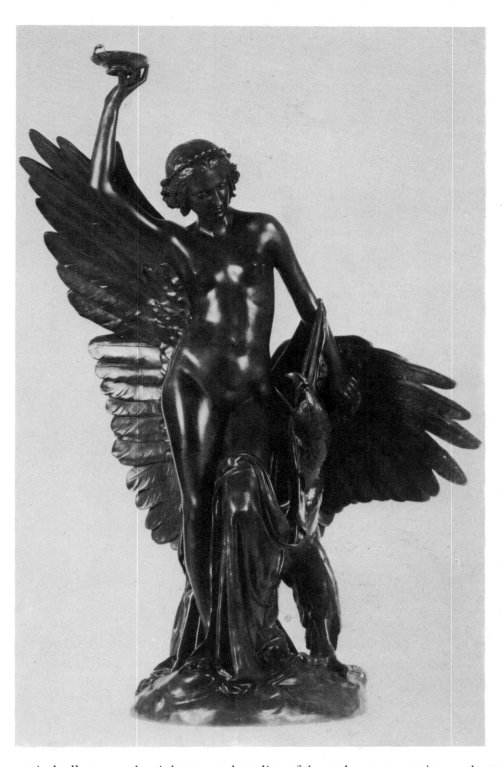

21 (*above right*) There was considerable rivalry between nineteenth-century bronze founders, for although most of François Rude's sculpture was founded by Barbedienne, 'Hebe and the Eagle of Jupiter' was cast by Thiébault Frères.

period, all at once the rightness and quality of the style appears unimpeachable. In discussion of Carpeaux's achievements it is necessary to return yet again to François Rude under whom Carpeaux received his early training from 1844 until 1850. Indeed he parted company from his admired master with great regrets through fear for his career, because he felt that Rude's advanced emphasis on nature, if followed, would make it impossible for him to gain the Prix de Rome from the antagonistic École. However, as soon as Carpeaux achieved this ambition and arrived in Rome in 1856, he

found inevitably that the École ideals meant little or nothing to him and he spent truant days in admiration of the power and energy of Michelangelo. And, no doubt remembering his nature study with Rude, Carpeaux worked from life on a subject that his master had produced from his imagination, 'The Neapolitan Fisherboy' (22); the two bronzes make interesting comparison, with Rude's boy (7) adopting if anything the more naturalistic pose while Carpeaux achieved greater realism in the actual anatomical description.

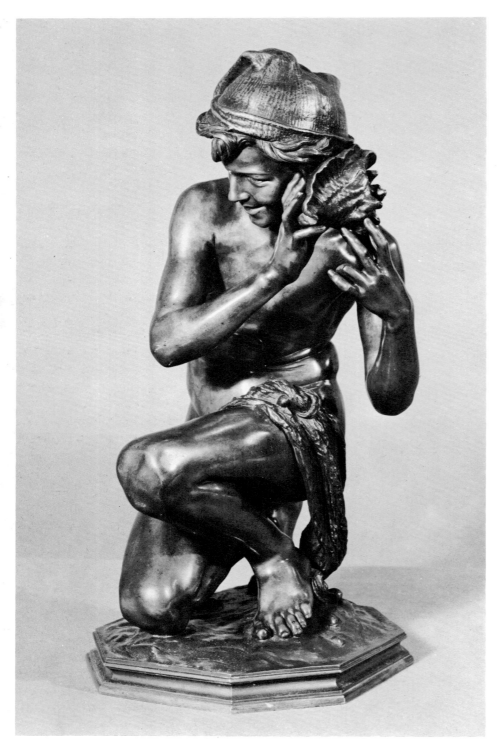

22 Jean-Baptiste Carpeaux is perhaps the best-known French Romantic sculptor, and 'The Neapolitan Fisherboy', executed in Rome during the late fifties, was one of the corner-stones of his success.

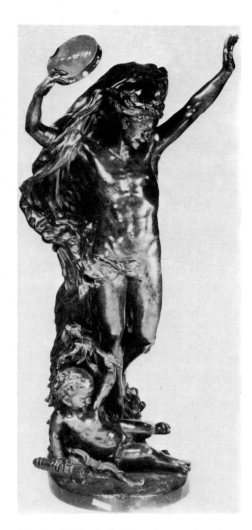

23 'Le Génie de la Dance' was taken from Carpeaux's group, commissioned in 1865 for Garnier's Opera, but its so-called wantonness caused consternation amongst Parisian critics at its unveiling in 1869.

Carpeaux returned from Rome for the Salon of 1863 with 'Ugolino and His Starving Sons' [p. 72], a group which categorically stated his allegiance to the example of Michelangelo and immediately established him as the sculptural star of the Second Empire. It seems that Carpeaux had been working on this theme since 1857 and persuaded the Minister of Fine Arts to extend his scholarship in Italy so that he could complete what he considered to be a work of monumental significance. For its time this sculpture was certainly sensational as no one had attempted to introduce such strength of form and feeling into an uncommissioned non-political group, and his services were required forthwith for society portrait busts, most of which captured in gay naturalism the spirit of the revived court circles under Louis-Napoleon. But, more important, Carpeaux was also called upon by the state for prestigious Paris commissions in which he gave national expression to the somewhat sinister gaiety of the last years of the Empire. The most notorious of these was his vision of 'La Dance', one of the monumental relief groups to adorn the façade of Garnier's Opera. The full abandon of the group can hardly be appreciated merely from the central figure of 'Le Génie' (23), but it is clear that Carpeaux had taken very seriously his self-appointed task of bringing monumented sculpture back to the French schools, and many of the comments he had made about Michelangelo in Rome turned out to be equally true about himself in Paris. 'The dominating factor of his genius is action. In reacting against the frigidity of antiquity he was carried away by his high spirit beyond nature' (Carpeaux on Michelangelo). Sadly, the majority of guests at the unveiling of 'La Dance' in 1869 were shocked by the figures which they felt were suggestively naked rather than classically nude, but eventually it was accepted for what it was, a genuine breakthrough in the sculptural expression of natural movement within the formal limits of monumental decoration.

But although 'La Dance' has an unchallengeable art-historical significance there is something about the hermaphroditic 'Génie' (23) which strikes discords with modern taste, and some of Carpeaux's less frenetic portrait busts therefore possess more lasting qualities. So, the bust of his friend 'Alexandre Dumas' (24) seems to stand up far better to purely visual analysis, with its simple naturalism giving sense enough of the inner man, combined with previously little-seen surface texturing in the dress and an extraordinary impressionistic life to the hair. No doubt Carpeaux would have responded splendidly to the new demands of the Third Republic just as he had captured the character of the Second Empire, but cancer cut short his life in 1875; in a restricted time Carpeaux had made remarkable changes and there can be little doubt that his work had more effect on stylistic progress in England and America as well as in France than that of any other single sculptor of the Romantic school.

Carpeaux inevitably overshadowed most of the other sculptors of his generation as individuals, but a particular group of his contemporaries began to hold their own under the collective title of Les Florentins. Carpeaux's great achievement was in the reintroduction of vigorous movement into sculpture and Les Florentins showed similar tendencies, although the movement of their figures tended towards stylised realism rather than full naturalism. Jean-Alexandre-Joseph Falguière (1831–1900) suffered the dis-

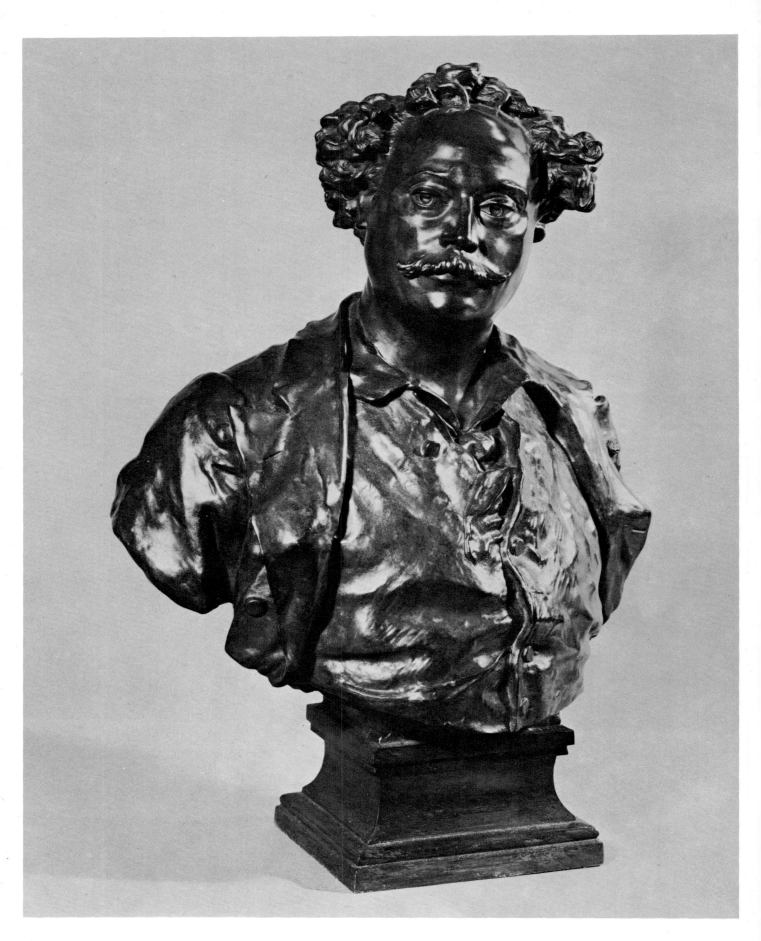

30

24 Carpeaux's public successes led to the establishment of a powerful private practice as a portrait sculptor, in which field he was noted for his lively naturalism, seen in this bust of Alexandre Dumas.

advantages of an education under the sickly classicism of Jouffroy but managed to shake almost completely free of these restrictions with his first Salon exhibition of note, 'The Winner of the Cockfight' (25), in 1864. This figure made a telling comparison with Duret's 'Dancing Boy' (11) of 1833, for although the aim of the two sculptors must have been similar, Falguière used the live model with more confidence, allowing himself to reproduce the pose and sinews without need of the idealising alterations of form and silhouette made by Duret. In fact Falguière had made noticeable use of one of the nineteenth century's most popular figures from antiquity, 'The Dancing Faun', which also received full acknowledgement in the same year, 1864, from Moulin with his equally relaxed and appealing 'Excavation Worker of Pompeii'.

Ostensibly Les Florentins aimed to draw attention from Rome to Florence where they found both visual and intellectual pleasures. Indeed Falguière was always praised for the traditional intellectualism which enabled him to produce the esoteric Christian emblems and complex Latin inscriptions at the base of his Salon exhibit of 1868, 'Tarcisius' (26), the overt romanticism of which would surely have been derided but for this academicism. But whether it was due to his easy-going nature or his historicist intellect, Falguière's style, like that of the school as a whole, remained strangely unmoved by the upheavals of the 1870 revolution, and this despite his securing numerous major monumental commissions such as 'Switzerland Welcoming the French Army' for Toulouse in 1875, and 'Lafayette' for Washington, which was cast in Paris in 1890. Certainly Falguière had moments when the early promise was fulfilled, but in general his sculpture disappointed both in the monumental with his bombastic 'The Triumph of the Revolution' for the Arc de Triomphe, and in the attempts at poetic statuary with 'Pegasus carrying the Poet towards the Regions of the Dream' (27), exhibited as a sketch in 1897.

After 1870, Falguière shared a studio with Paul Dubois (1829–1905) and both then took up painting, which may perhaps have affected their powers as sculptors inasmuch as the insipid qualities of some late Romantic French painting seemed to cling to their sculpture. Nevertheless Dubois produced in 1865 a bronze statuette that captured completely the principles of a whole aesthetic. This silvered version of 'The Florentine Singer' (28), now in the Louvre, was produced specially for the Paris International Exhibition of 1867 where its re-creation of the mood of Dante's Florence was seen as an ideal sculptural expression of the Romantic creed. In fact the figure relied heavily on Duret's more traditional treatment of a similar subject (12) and was also thought to have been taken from figures in Masaccio's frescoes in the Brancacci chapel; however, the important divergence in Dubois' work was the ability to treat an historical subject with total realism seen incongruously in the creasing of the tights at knees and ankles and in the concentrated playing of the lute.

Antonin Mercié (1845–1916) was the youngest and most dedicated of Les Florentins, being first a pupil and then an assistant of Falguière's. Mercié's exhibit in the first Salon of the Third Republic, 1872, was one of the few sculptures to ignore completely both the emotional excitement and the human tragedies of the revolution; instead his 'David' [p. 144] ex-

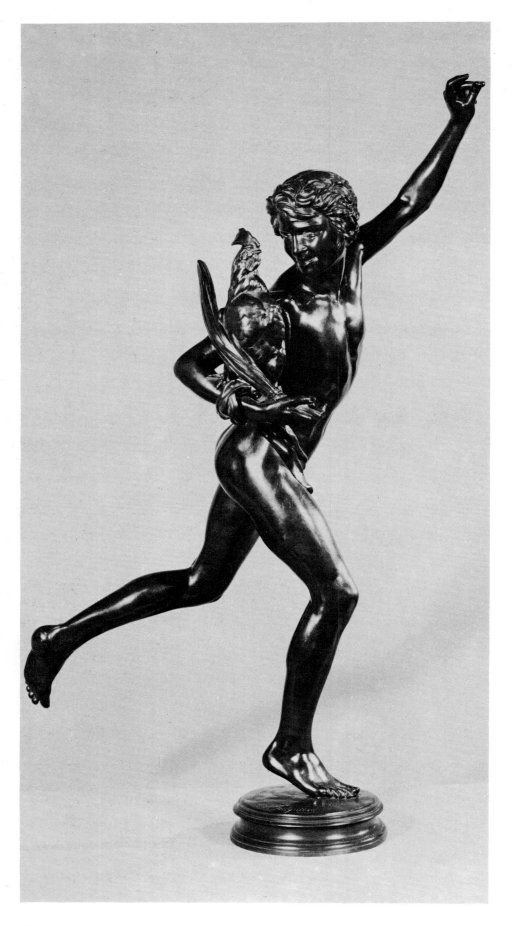

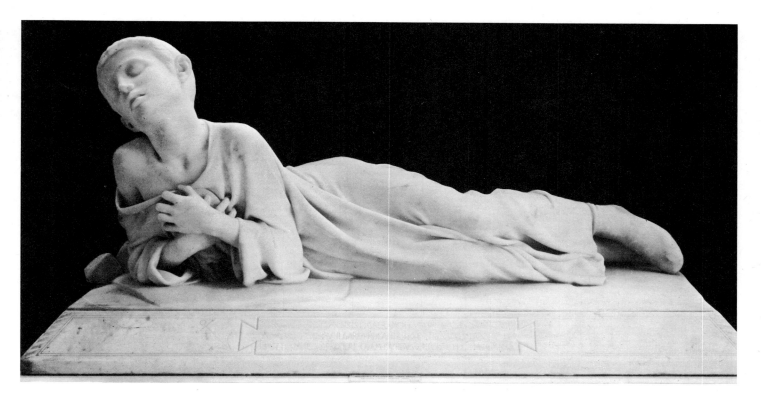

26 In the Salon of 1868 Falguière produced a work of full Romantic appeal, the marble 'Tarcisius'.

pressed an undramatic appreciation of Donatello, at the same time incorporating a muted discipleship of Carpeaux's experiments in natural movement. Mercié's other major early work, 'Gloria Victis' (29), drew upon the kind of mid-nineteenth-century symbolism that rapidly disappeared beneath the realities of republican life, but in 1874 its Florentine mannerist, twisting composition and heroic content still attracted admiring eyes, and in England were considered to be qualities of prime importance worthy of plagiarisation by the leading young sculptor, Alfred Gilbert and later by Frederick Pomeroy (30).

There was very little indication in the last years of the 1860s of the approaching dramatic assassination of the Second Empire by the fanatic Communards in 1870. On the surface it seemed that both Paris and the Emperor triumphed amid the unrivalled splendours of the Paris Universelle throughout 1867 and 1868, welcoming the visits of foreign heads of State and the milling tourists. However, the disappointments of the artistic circles in the fallen promises of the Second Empire were naturally magnified a thousand times in political terms, and the interests of the individual had become subjected to the vagaries of the regime; these general trends of the Empire were reflected in the way sculptural expression had assumed monumental decorative forms the iconography of which tended to ignore the nation's history on the one hand and the practical achievements of the individual on the other. The political revolution reinstated the rights of the individual with a commitment that defied contradiction from the artists, and indeed the sculptors of the Third Republic at their most daring attempted a revolution in style of similar individualism.

But before discussing the work of the outstanding republican sculptor Aimé-Jules Dalou (1838–1902), it is essential to realise that the French as a

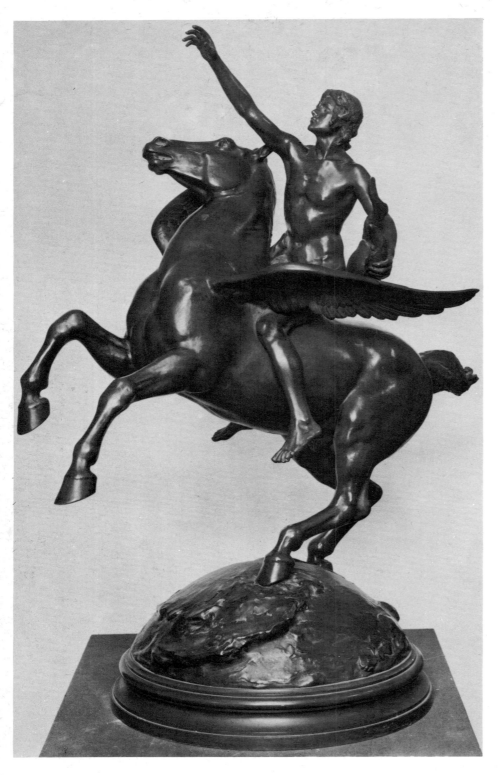

Gilbert Bayes was typical of the 'Arts and Crafts' sculptors in his ability to work successfully in various media, this relief being in glazed terracotta. (*Sotheby's Belgravia*)

27 Falguière's later work was less imposing, the most typical being 'Pegasus carrying the Poet towards the Regions of the Dream', a life-size version of which was erected on the Place de l'Opéra in 1897.

nation and as individuals suffered enormously from the horrors of civil war and then also from the ignominy of the Prussian occupation of Paris. Whether or not the sculptors chose to express their experiences in physical form, there was no possible way of return to the habits of the sixties, and although many sculptors tried self-protectively to maintain their pre-revolutionary styles, the mood and manner of actual creation had inevitably changed for everyone.

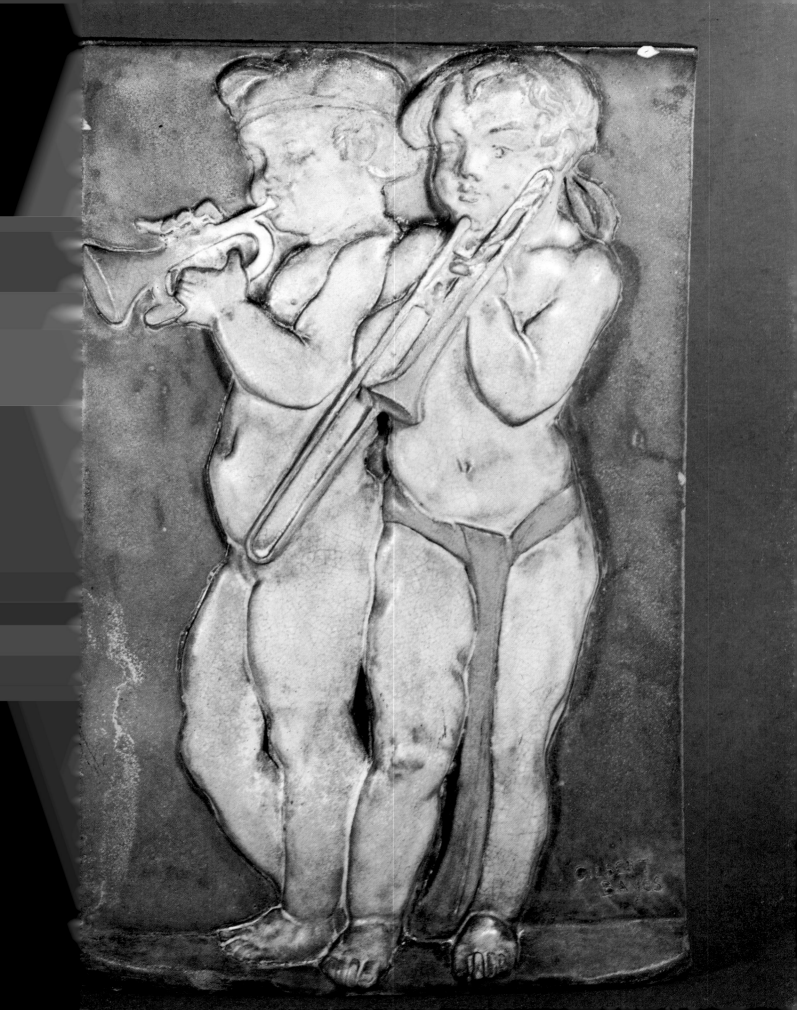

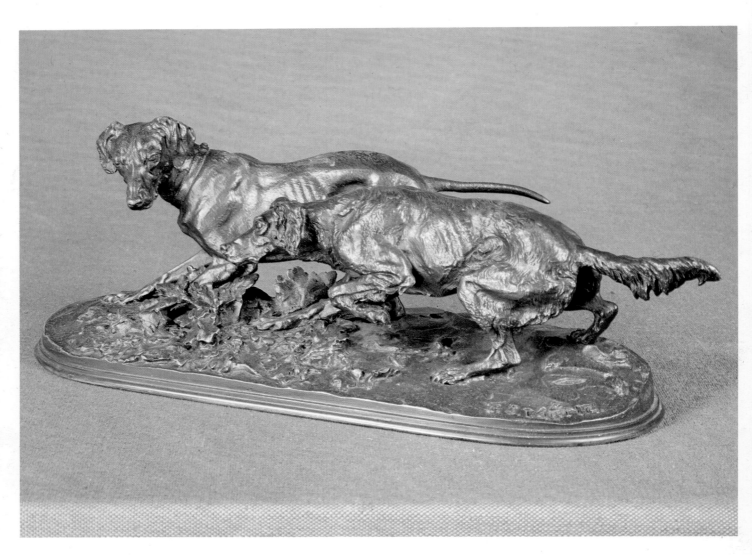

Few other animal sculptors could rival Mène in the study of dogs. (*Sotheby's Belgravia*)

28 Paul Dubois, another member of Falguière's 'Les Florentins', produced the fullest statement of their creed with his 'Florentine Singer', this silvered version being exhibited first at the Paris International of 1867.

For Jules Dalou the change was less abrupt than for others, for he had always been a fierce opponent of the old regime. Indeed, he made his initial official protest in 1861 by first sending work to the Salon des Refusées in that year, and although, out of loyalty to his hero Carpeaux, Dalou attended the École des Beaux-Arts from 1854, he eventually turned his back completely on academicism in 1866. The unsuitability of Dalou's genius to the ethos of the Second Empire is silhouetted in 'The Head of La Boulonnaise' [p. 90] of 1872, an early English work, in which simple humanity displaced monumental grandeur, and movement of form was extended into sensational surface life. In later years Dalou's philosophy brought him continuous responsibility in the design of suitable monuments to the Republic and, magnificent though these were, nothing could compare with the perfect control and simple magnetism of this bust of 1872.

It is ironical that Dalou first received critical acclaim in England, to which he had been exiled in July 1871 for his Communard activities by the Thiers–MacMahon Republic that he was to serve so faithfully after his return in May 1879. Dalou was fortunate with the friendship in England of his compatriot Alphonse Legros with whom he had studied at the Petite École, for the latter worked hard to secure Dalou influential patrons including Alexander Ionides, and eventually a professorship was actually created for him at South Kensington in 1878. Lanteri, another European teacher in England, went so far as to declare that Dalou 'revived a spirit where all before had been dormant', and indeed his sympathetic treatment of naturalistic, almost domestic subjects was a complete novelty and continued as the strongest single influence on the 'New Sculpture' in England (31).

On his return to France Dalou became entangled in the republican demand for more extrovert, monumental expression, but he still maintained a superb freshness, so that his Monument to Delacroix, for example, employed a highly energetic, twisting lower group leading to a sympathetic, simple portrait bust in contemporary dress. Jules Dalou worked prodigiously from the time of his return until his death in 1902 to the glorification of the Republic and some of his work inevitably lapsed into the kind of Louis XIV decorative grandeur of his 'Triumph of Silenus' and even a late work, the Monument to Leon Gambetta, adapted traditional concepts in the group 'Wisdom Supporting Freedom' (32). Leon Gambetta was the young lawyer hero of the revolution and receipt of the Monument's commission from the town of Bordeaux in 1901 was Dalou's last great honour; this allegorical group was originally modelled in 1889 and although Dalou's characteristic molten surfaces dominated there was far less freedom than in some of the other figures of the Monument, 'Désespoir' (33), for example.

Dalou's most impressionistic sculpture is found in the studies for a projected 'Monument aux Ouvriers' that had progressed no further at his death than 107 tiny terracotta figures. The founders Hebrard obtained permission for the casting of a limited number of bronzes from these, and others were cast by Susse Frères; these cire perdue casts (34) fulfil all the highest demands of sculpture, being complete with real movement as well

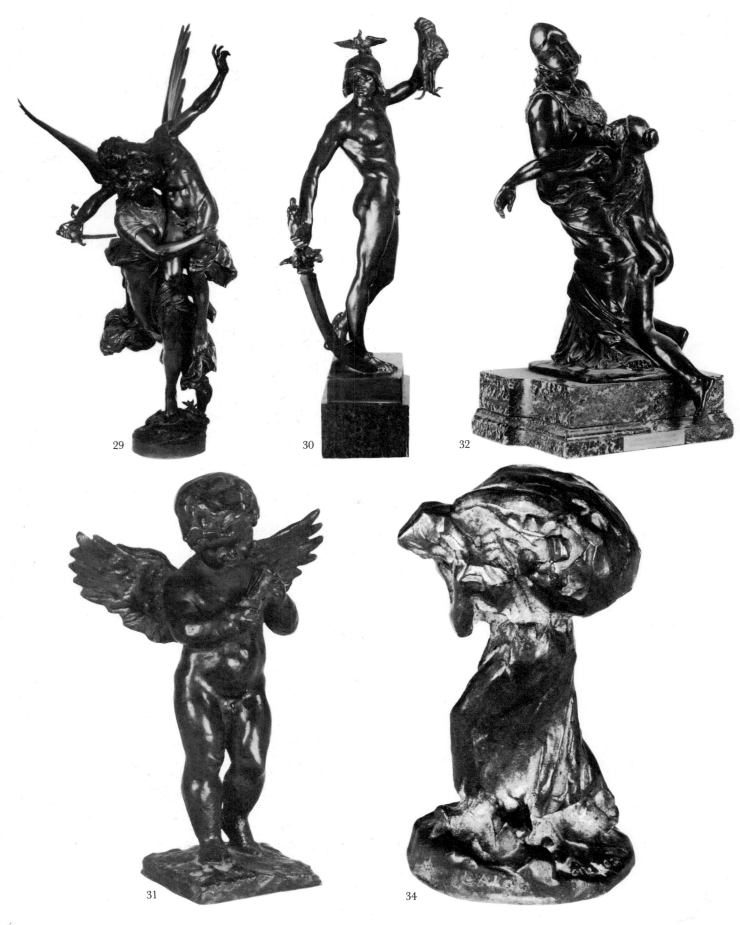

29

30

32

31

34

29 'Gloria Victis', exhibited by Mercié in 1874, was slightly old-fashioned for Republican France but was especially admired in England.

30 Antonin Mercié's 'David' [p. 144] of 1872 was still recalled by the English sculptor, and pupil of Mercié, Frederick Pomeroy, in his 'Perseus' of 1898.

31 But Jules Dalou had a greater influence than any other French sculptor on the English school, and superbly textured, small-scale work of this nature by Hamo Thornycroft would have been inconceivable without Dalou's teaching.

32 On his return to France in 1879 Dalou became the leading sculptor of nationalistic public monuments, this group, 'Wisdom Supporting Freedom', being designed in 1889 and eventually incorporated into the Gambetta Monument of 1902.

33 'Désespoir' was also incorporated into Dalou's Gambetta Monument in Bordeaux.

34 Some of Dalou's most appealing work was cast after his death in 1901 from tiny terracotta studies of working people for 'Monument aux Ouvriers' which he never executed.

33

as abstract formal invention, adventurous in surface treatment and, most important of all, inspired by an understanding of the human predicament. Only the Belgian sculptor Constantin Meunier (1831–1905) succeeded in reaching a similar pitch of sympathy in the sculptural study of the working man (35) and [p. 71], a subject so rare at this time.

French sculptors of the seventies, apart from Dalou, were strangely subdued and some of the most inventive work in fact came from a part-time sculptor, the painter and satirist Gustave Doré (1832–83). Doré produced a distinguished 'Monument to Alexandre Dumas' for the Place Malesherbes which incorporated a naturalistically composed group of readers at the base (36), but his most astonishing sculpture was in the study of 'Acrobats' (37) which was completely isolated from all other work of the period. Indeed, sculpture as a whole recovered slowly from the ravages of 1871. In the first place, the traditional systems of both private patronage and public commission had been shattered and sculptors were obliged to feel their way slowly, and in the second place most sensitive artists inevitably were disturbed by the revolutionary flow of events, whether they took part or not, and artists took time to rediscover the emotional stability necessary for creative activity.

Frédéric Auguste Bartholdi (1834–1904) never really recovered his earlier equilibrium as themes of patriotism and liberty continuously and anachronistically dominated his later work, and even as late as 1895 his prize-winning entry to the Salon was 'Switzerland Comforting the Anguish of Strasbourg during the Siege of 1870'. From July 1871 Bartholdi had actually taken refuge as far away as New York, and it was there that he produced what can claim to be the best known but least appreciated statue in the whole world, 'The Statue of Liberty'. The gigantic figure was presented by Bartholdi to the City of New York, the finances having been raised by public lottery in France, and the statue was shipped over in 214 crates to be erected amidst wild celebrations in October 1886.

But although Bartholdi's sentiments were strong his means of expression lacked sufficient force in the majority of his work, and the feelings of the Republic were perhaps better expressed by Louis-Ernest Barrias (1841–1905). During his lifetime Barrias was always thought of as the perfect academician and indeed his sculpture invariably impressed for its control and discipline; but fortunately the influence of his classical teachers Cavelier and Jouffroy did not dull his response to the republican spirit and he can be credited with many major Parisian commissions including the 'Defence of Paris' (1883) which was commended for the naturalistic, anti-heroic pose of the real soldier standing beside cannon and standard. Certainly some of Barrias' work such as the popular 'Young Mozart' of 1887 conformed to the retrograde revivalist styles of his masters, but then other statues like 'Nature Unveiling Herself before Science' (38) showed a considered awareness of the Symbolist developments of the end of the century. The original, exhibited at the Salon in 1893, was executed in a combination of bronze with coloured and tinted marbles, a technique which was in itself a modern development, but the statue also possessed the new didactic power of the progressives. A similar interest in the expression of an idea in sculptural form was shown by a younger sculptor, Alfred Boucher (1850–

35 The Belgian Constantin Meunier was the only other sculptor working on the labouring man in France at this time (see also p. 71).

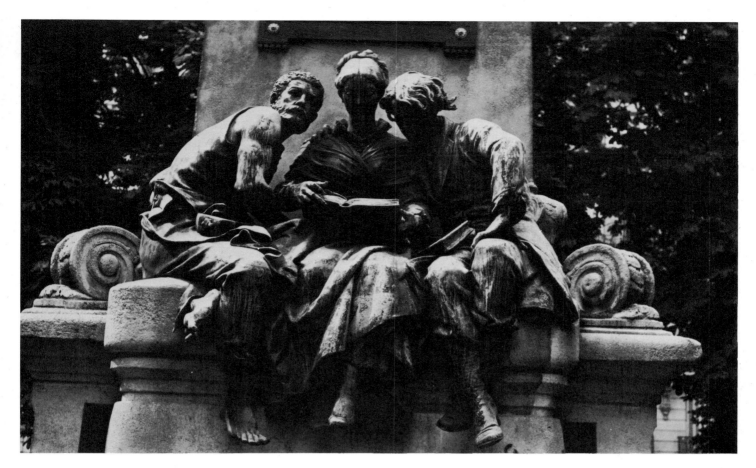

36 Gustave Doré introduced a pleasing naturalistic group into the base of his 'Monument to Alexandre Dumas' in the Place Malesherbes, Paris.

1934), and his 'Au But', depicting three male nudes balanced in an action that epitomised the precariousness of man's endeavour, understandably created a sensation in 1886. Boucher's figures (39) at the base of Ferdinand Barbedienne's memorial of 1892 were not so adventurous but the figure of the young girl was taken directly from a simple pose of the studio model and this in itself suggested a significant alteration of ideals.

Boucher shared this commission for Barbedienne's monument with Henri Chapu (1833–91), one of those adept but uninspired sculptors who carried the least forceful stylistic habits of both the July Monarchy and the Second Empire into the Third Republic. And no doubt the existence of vast numbers of decorative bronzes produced in this vein, along with the commercial reproductions from antique originals, has influenced present-day disapproval of nineteenth-century sculpture. Chapu's small private 'Memorial' bronze (40) of 1881 was an attractive enough work within its own classical background, but its lack of bite inevitably leads to its categorisation with the purely decorative works of the last decades of the century like the young 'Minstrel' (41) by Auguste Moreau (Salon exhibitor from 1861 to 1910). There were four sculptors of the Moreau family active in this later period, Auguste, Hippolyte, François and Louis, and the father Mathurin did not die until 1912 at the age of ninety; all these sculptors and many others like Adrien-Etienne Gaudez (1845–1902), Joseph Descombes Cormier (born 1839) and Joseph Lambeaux (1852–1908) tended to squander their talents in sculpture designed for commercial production, often reproduced in the inferior soft metals like spelter.

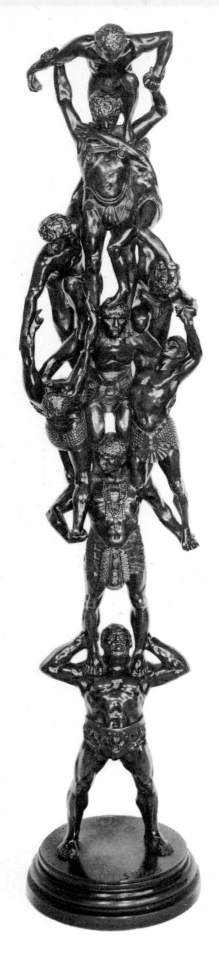
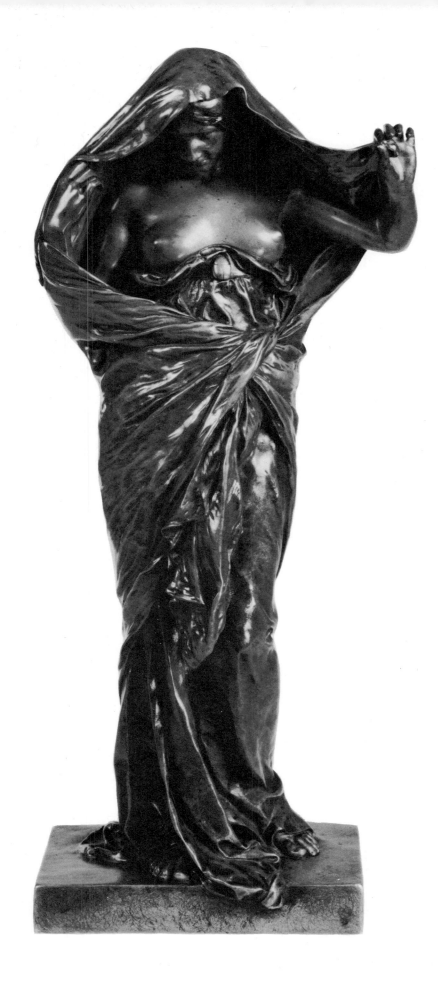

42

37 (*far left*) Doré is best known for his painting, but his sculptured study of 'Acrobats' broke new ground in its choice and treatment of subject in sculpture.

38 (*left*) Barrias exhibited his marble and bronze original of 'Nature Unveiling Herself before Science' in the Salon of 1893.

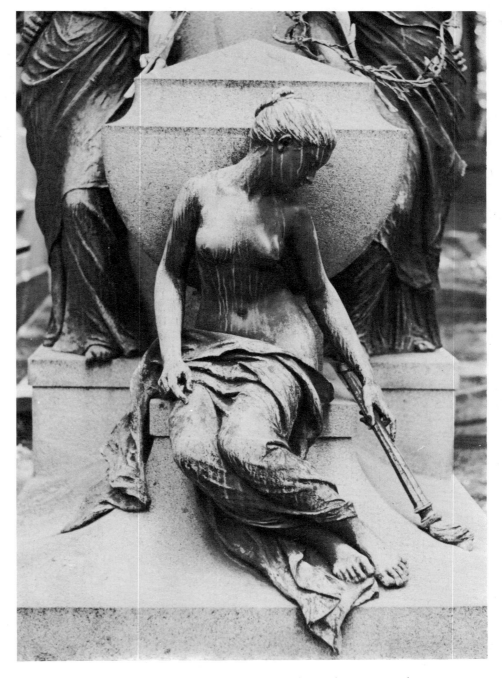

39 By 1892 Alfred Boucher's allegorical figures at the base of the Barbedienne Monument in Père-Lachaise cemetery had become basically naturalistic instead of classical.

Fortunately other secondary sculptors of this later period were more concerned with the integrity of their art form, and René de Saint-Marceau (1845–1920) was one of the few who maintained the superb technical traditions of the École. Saint-Marceau was capable both of attractive boldness in his Michelangelesque 'Genius Guarding the Secret of the Tomb' (Salon of 1879) and of fashionable naturalism in his 'Tomb of Abbé Miroy', which used the Dalou device of portraying the dead man lying fully dressed on the slab. Certainly the sculpture of Saint-Marceau or Laurent-Honoré Marqueste (1848–1920) was notably more academic and distinguished than that of an equally popular contemporary Émile Picault (Salon 1863–1909), whose anti-progressive, historical romanticism was typified by his 'Archer of the Thirteenth Century' (42).

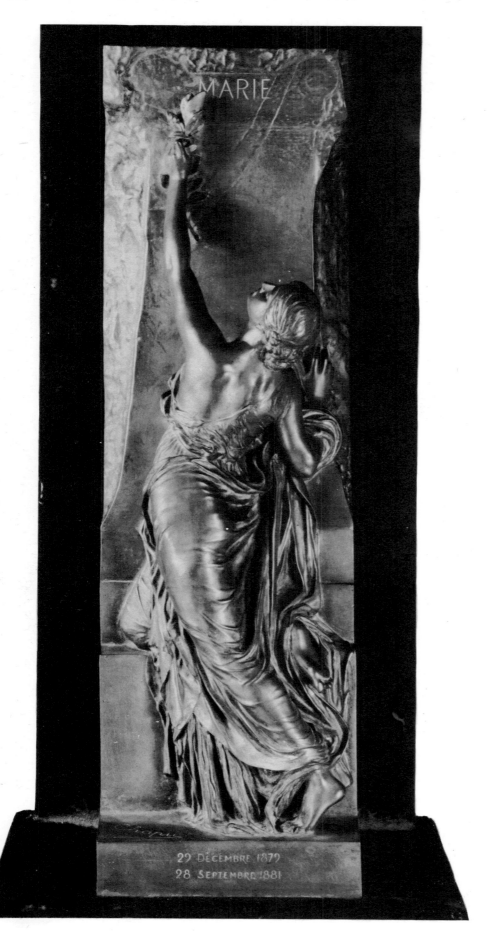

Left

40 Henri Chapu, however, carried his classical training right into the 1880s with this private Memorial, dated 1881.

Right

41 Auguste Moreau was one of the many commercial sculptors who continued the 1860s fashion for decorative rococo revivalism right up to the end of the century with works like this 'Minstrel'.

Far right

42 'Archer of the Thirteenth Century', by Émile Picault, prolonged another outmoded style, romantic historicism.

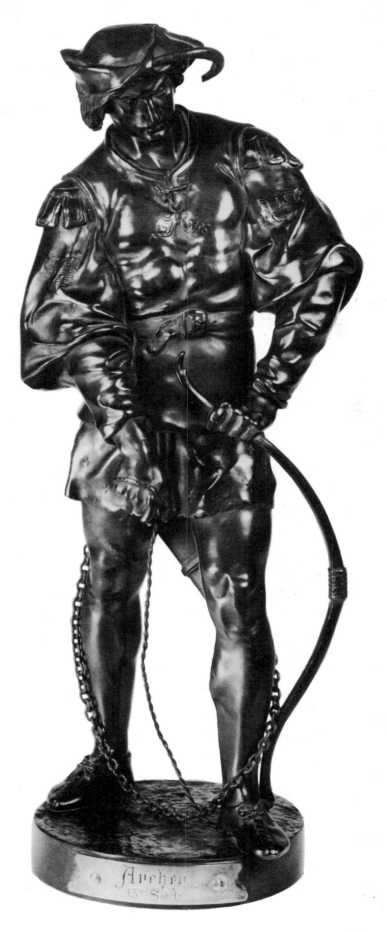

Up till now it has been possible to skirt surreptitiously around the phenomenon of Auguste Rodin (1840–1917), but it would be unrealistic to shy from his shattering achievements any longer, even though the definition of our present interest in Romantic Bronzes necessarily excludes a meaningful discussion of either his 'Expressionist' or Degas' 'Impressionist' sculpture. The nature of Rodin's explosive leap into modern sculpture is clearly illustrated in his 'Orpheus' (43), for in this he turned an essentially Romantic subject into a gruelling representation of the artist's need for abstract expression of inner motivations. In a sense this was a natural extension from the endeavours of the towering Romantic sculptors, Rude and Carpeaux, and indeed Rodin's working life in the 1860s and 70s as assistant to Carrier-Belleuse and competitor for the standard commissions of the Third

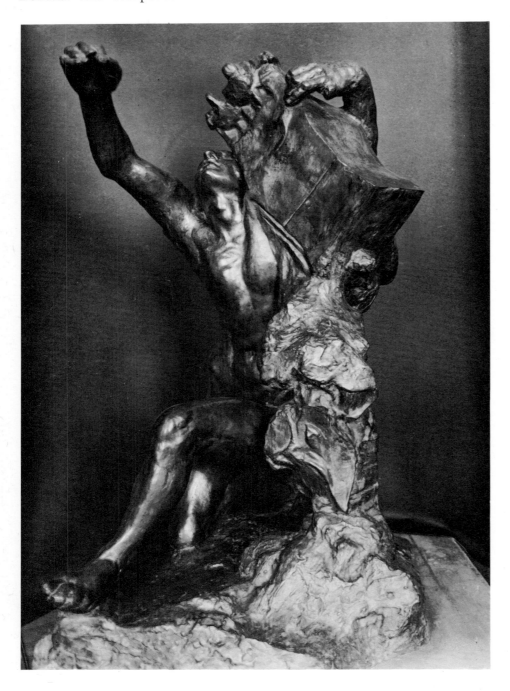

43 The romantic movement was terminated by the sensational work of Auguste Rodin, such as 'Orpheus', 1893, where power of personal expression overthrew the traditional restriction of sculptural formalism.

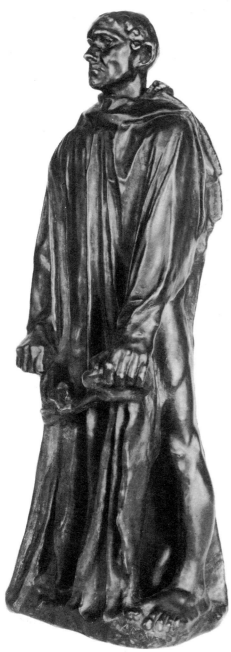

44 Even in the creation of a national monument with historical characters, the Burghers of Calais, commissioned in 1885, Rodin succeeded in giving 'Jean d'Aire' a timeless abstract spirit.

Republic did not in itself differ so radically from the norm. It was not until Rodin's successful application for the commission of the 'Gates of Hell' in 1880 that the nature of his revolutionary concepts became fully apparent, and from then on his reputation grew throughout the world until, despite the opposition of French Academicians, Rodin's became the first sculptor's name to reach truly international stature during its owner's lifetime. 'Jean d'Aire, Bourgeois de Calais' (44) was an historical character made into a modern man – thus Auguste Rodin translated nineteenth-century Romanticism into twentieth-century ideals.

Of course Rodin was supported in later years by pupils and young admirers like Antoine Bourdelle (1861–1929) who seemed scarcely conscious of the Romanticism that surrounded them when it was possible to produce in 1889 sculpture with the modernity of 'Beethoven aux Grands Cheveux' (45). So before he was thirty Bourdelle here sought to express the spirit of the composer's music in a monolithic head whose very form told of the vastness of Beethoven's talent. It also removes Bourdelle far beyond the horizons defined in this discussion.

On the other hand, some of Rodin's other followers turned towards another late-nineteenth-century sculptural movement which could still in a real sense be called 'Romantic', namely 'Symbolism'. For instance, Albert Bartholomé (1848–1928), having first been a disciple of Rodin and a friend of Bourdelle and Despiau, veered strongly away from their formal abstractions towards more intense personal symbolism. Bartholomé later degenerated finally into an unorthodox recluse, but his forms, although highly esoteric and often a little strange, stayed within the nineteenth-century realist idiom, unlike the expressionism of his master Rodin. This attitude can be seen in his 'Monument aux Morts' (46), designs for which were submitted to the Salons throughout the 1890s; this sculpture embodied much of the *fin de siècle* atmosphere in its personal message of sinister foreboding, and the great weight of grief bearing on the figures (47) communicated a depth of feeling inconceivable prior to the social upheavals of 1870. And of course although the figures remained naturalistic in themselves their gathering on the shelf of the bare block monument was designed specifically for its symbolic effect, and indeed the whole of Bartholomé's iconography in this work was extremely complex, for the young couple at the mouth of the mausoleum were somehow endowed with a sense of hope denied to those left living on the ledge. The 'Monument aux Morts' can therefore claim to be a prime Symbolist piece, despite its lack of the weirdness so often associated with Dampt and other leaders of the movement.

Jean-Joseph-Marie Carriés (1855–96) also succeeded in extending Romantic sculpture into Symbolist fields, the new development being that whereas Dalou, Rude and the traditional Romantics directed their symbolic content towards the representation of national ideals these later 'Symbolistes' aimed at the sculptural personification of purely personal thoughts. Thus Carriés chose in 1887 an established Romantic subject, 'Charles the First', but presented the bronze head in such an imaginative form, the head lying with closed eyes on a pillow formed of its own hair, that it took on a purely personal aspect. Carriés' best-known activity was

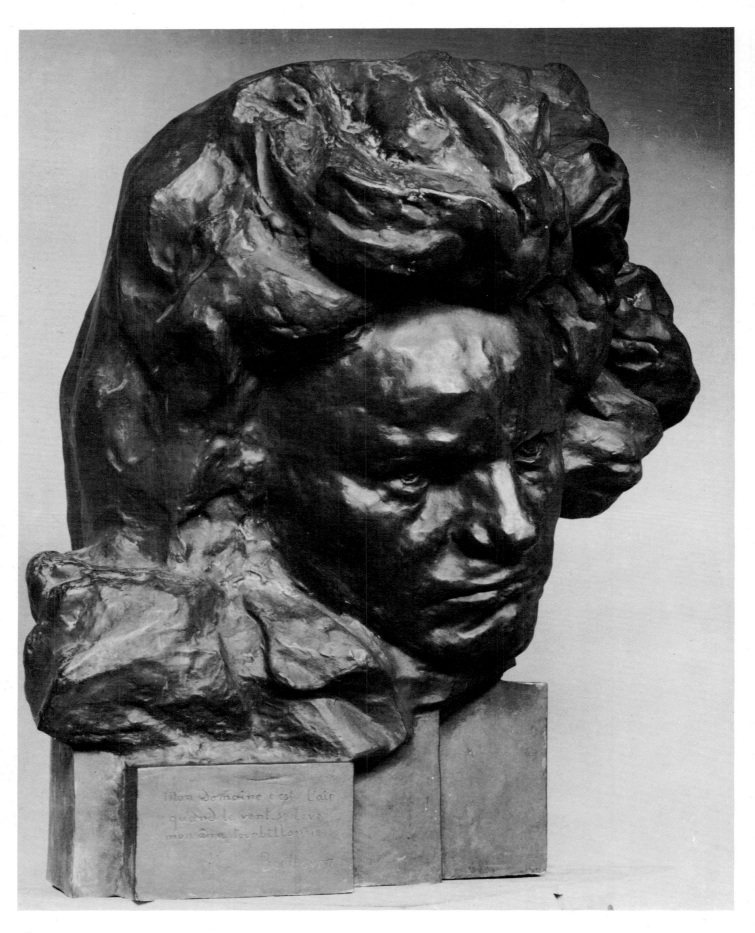

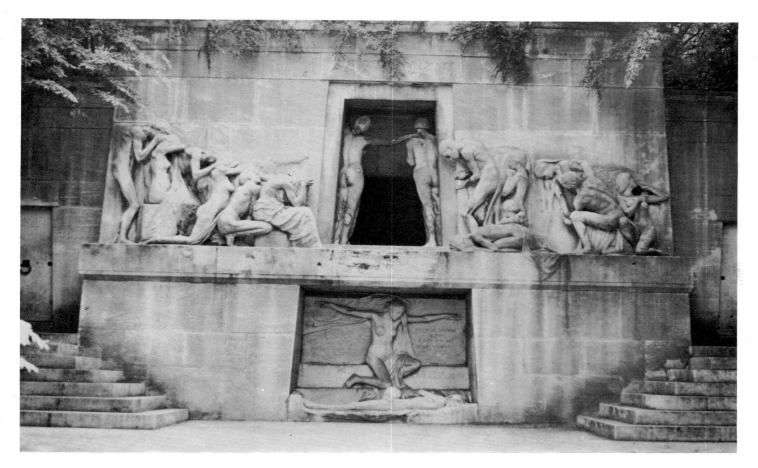

46 Another Rodin disciple, Albert Bartholomé, achieved a different but equally intense form of expression in his 'Monument aux Morts', raised in the cemetery of Père-Lachaise during the last decade of the nineteenth century.

45 Rodin's friend Antoine Bourdelle carried these ideas yet further in his sensational bust 'Beethoven aux Grands Cheveux' in 1889.

probably as a potter of gargoyles and masks, drawn from his prodigious dreams, but his own 'Memorial' (48), designed by himself, stood at the apex of late Romantic sculpture in its combination of realist statuary with nascent symbolism in the dream masks at the base. But the leadership of the new movement was left to younger sculptors of whom Dampt was the most significant.

Jean Dampt (1853–1946) was a most ingenious sculptor whose craft skills and design abilities in a variety of decorative fields compared closely with turn-of-the-century qualities in the Englishmen Frampton and Reynolds-Stevens, although content often differed radically. Thus the 'Baiser au Chevalier' was admired in England for its craft combination of silver and ivory but the typically continental symbolism of the fully armoured knight bending to caress the all too womanly ivory maiden was thought by the English critics to be inappropriate. The variety of Dampt's interests and abilities has great distinction, and most notable of his works were perhaps the commissions for the Countess of Béarn which included the design and execution of a carved wood panelled room, and a haunting ivory and wood bust of the Countess. Strangely, one of the most wildly esoteric Symbolist sculptures of the period came from a far older artist, Ernest-Louis-Aquilas Christophe (1827–92), who had been Rude's favourite and trusted pupil until the master's death. However, in contrast to Rude, Christophe was a highly educated intellectual, and one of his philosophical foibles interpreted the height of life's passion to be death in the embraces of the Sphinx; he had been working on this theme from the

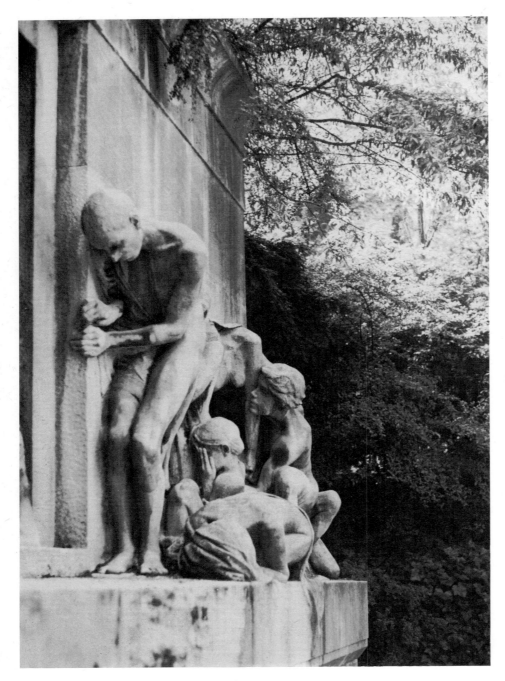

47 Bartholomé's figures in the 'Monument aux Morts' were realistically portrayed in their form, but their surreal grouping gave abstract power to the expression of overwhelming grief.

1870s and it culminated in his sculpture the 'Supreme Kiss' of 1892 where the Sphinx knelt on a rock behind a nude poet and dug her claws realistically into his chest in the throes of a loveless last embrace.

Theodore Rivière (1857–1912) was one of Dampt's cleverest followers and his multi-media 'Salammbo chez Matho' (49) became a star attraction at the triumphant Paris exhibition of 1900; this group of Rivière's has suffered from the plethora of commercial reproductions, of which the illustration is an unusually good example, but nevertheless the conception of the bronze can be seen as a direct continuation of the decorative sculpture of the Second Empire, whereas much of his and other Symbolists' later work was to become unrecognisably esoteric. However, most English critics at the Paris Exhibition of 1900 found contemporary French sculp-

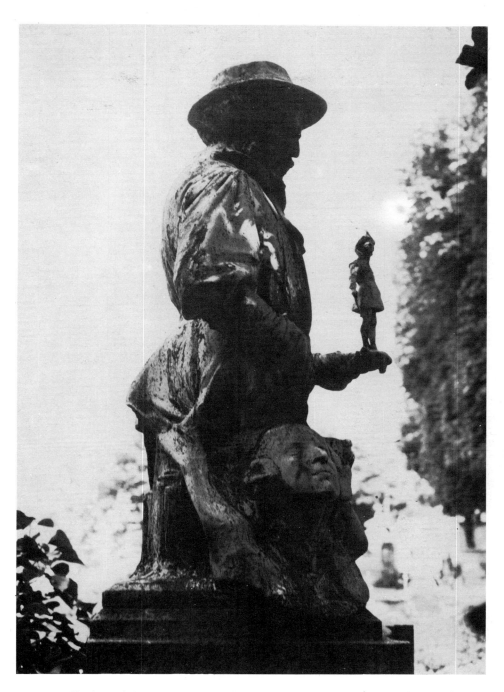

48 The 'Memorial to Carriés' in Père-La-chaise, designed by the sculptor himself, who died in 1896, combined realism with the direct symbolism of the artist's model and the more esoteric period symbolism in the base masks.

ture totally bewildering compared with the Romantic naturalism of their own 'new sculpture', and failed completely to understand that the other dominant style, so-called Art Nouveau, also had clear roots in their cherished nineteenth-century romantic ideals. Space allows no more than a passing mention of these companion *fin de siècle* styles, Symbolism and Art Nouveau, but a glance at one of the most typical of all the bronzes, 'Loie Fuller' (50), by Raoul Larche (1860–1912) reveals the reliance of these sculptors on the previous inventions of Carpeaux, translated into a new atmosphere of freedom and individuality of expression.

It is always with a dissatisfying feeling of incompleteness that a chapter in art history hastens to a close, for in reality of course the story of stylistic development has no end, and there is always more to write about what was

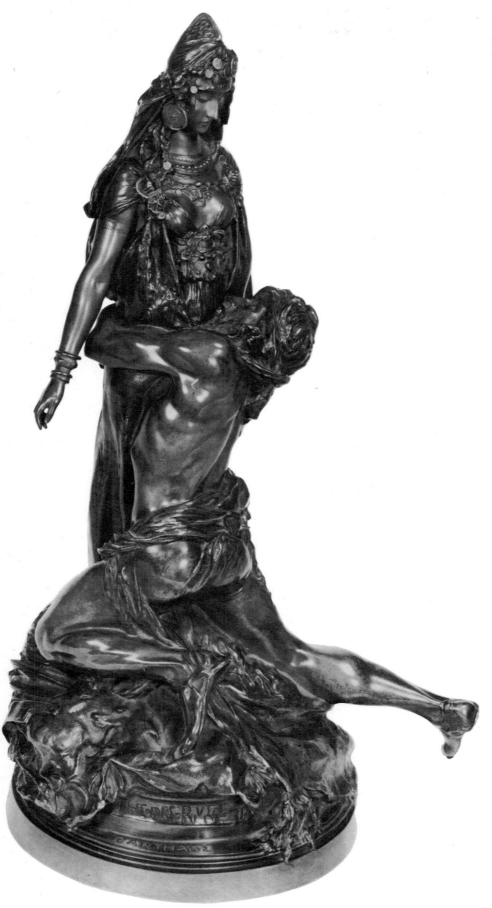

Herbert Heseltine was born in the USA but spent much of his life in Paris, where this study of a picador was executed in 1914. (*Sotheby's Belgravia*)

49 The Symbolist movement was founded on Romantic principles clearly visible in Rivière's 'Salammbo chez Matho', one of the movement's key exhibits in the 1900 Paris Exhibition.

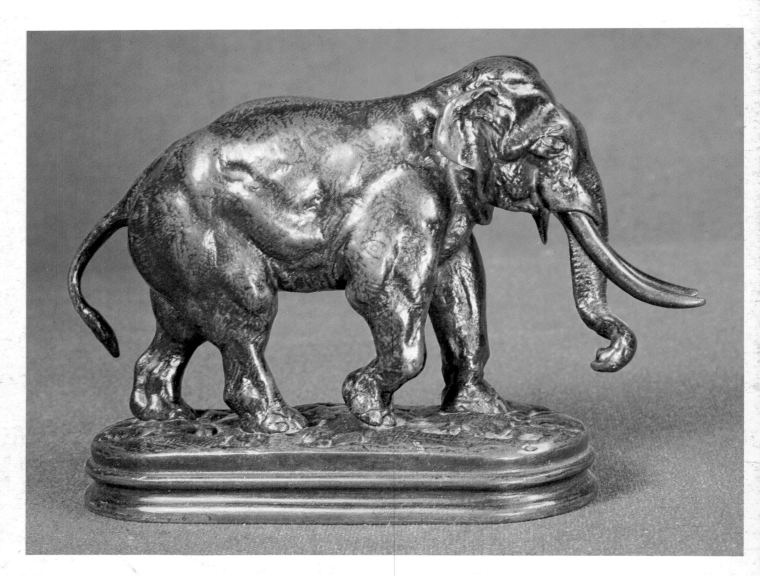

Both Antoine-Louis Barye and his son Alfred were able to endow their sculpture with a superb sense of movement. (*Sotheby's Belgravia*)

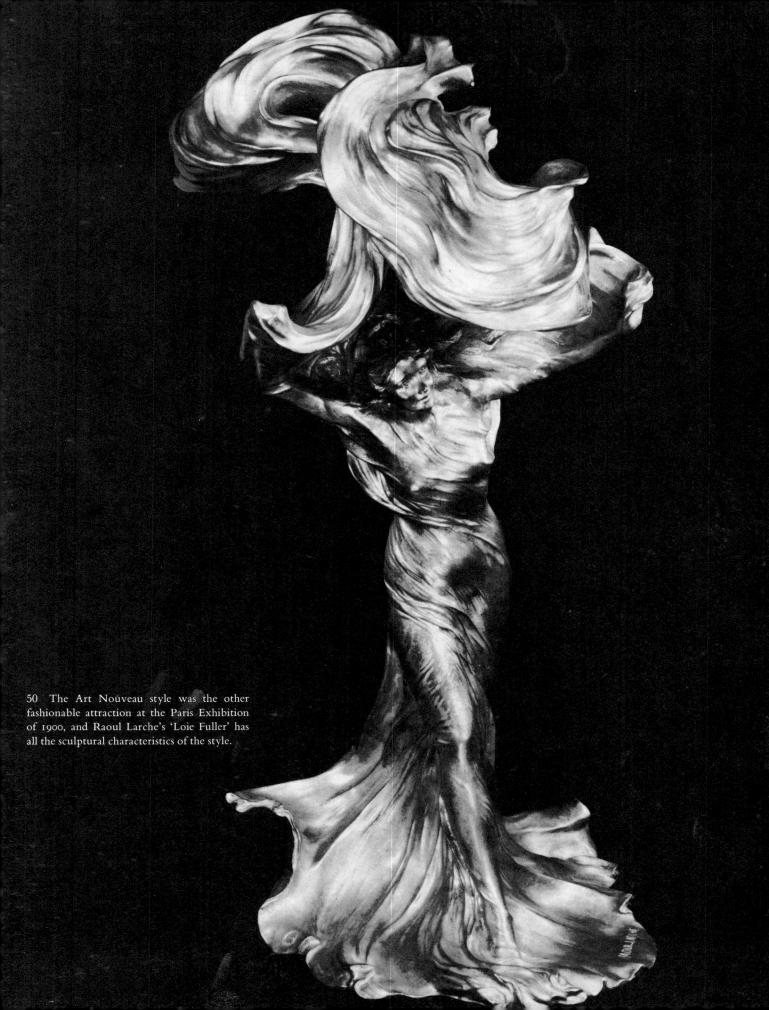

50 The Art Nouveau style was the other fashionable attraction at the Paris Exhibition of 1900, and Raoul Larche's 'Loie Fuller' has all the sculptural characteristics of the style.

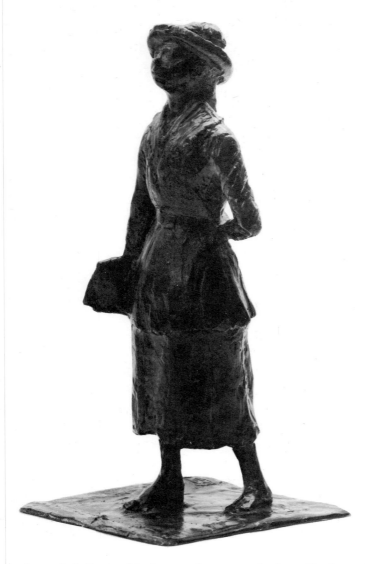

coming and much left unsaid about what went before. Rather, therefore, than reach a specific conclusion it is better to leave with an image in the mind, an image in this case of Edgar Degas' 'Schoolgirl with a Satchel' (51). As Degas' sculpture remained unknown to the public until after the artist's death in 1917 it coincides with the terminal point chosen for this study, World War I; but his work has more than mere temporal appropriateness for his was perhaps the last creative 'Romantic Bronze' to be published, and it marked clearly the dividing line that placed Rodin and indeed most of the advanced Symbolists in the modern movement.

There were certain characteristics that the 'Schoolgirl' lacked which have been seen as essential to Romantic sculpture, namely a driving intellectual, if not political, force; but other qualities reached the heart of Romanticism, particularly Degas' delicate sympathy with the feeling of the moment and his lively, movemented use of the bronze itself. The romantic movement in sculpture as a whole was one of such complexity that there can be no simple definition of its character or description of its ultimate aim, but the isolated creation by the painter Degas of this personal little sculpture presents in this context an ideal final image of the spirit of the French Romantic Bronze.

2 The 'New Sculpture' in England

In England the development of sculptural style in the nineteenth century followed markedly different paths from the turbulent history of French sculpture. Again the political background played an important part, albeit in a negative way, for the reign of Victoria marked an era of such remarkable internal peace that extraneous influences on the arts in England were minimal. This meant that any impetus for change in sculptural dogma had to come from inside the established system, and creation of the energetic romantic style of expression in bronzes was thus decades slower than in France where the Institut had been constantly bombarded by the external pressures of political upheaval and ideological challenge.

In effect, English sculpture remained almost uniformly dull, traditional and positively unromantic until well into the 1870s, and this chapter must therefore concentrate on the last quarter of the century when leaders of the 'New Sculpture' first produced small-scale bronzes with a degree of emotional commitment and naturalistic freedom comparable to the work of Préault, Barye and Rude in Paris in the 1840s. Prior to 1870 the combined dominant influences in England had been the work of Canova, Flaxman, and Chantrey, a concoction which tasted of sickly classicism sprinkled with a coating of muted rococo decorativeness; and although many popular sculptors from 1830 to 1870 – notably John Gibson, Foley and Boehm – possessed considerable technical skill and sympathetic integrity in their ideals, the work of this period in England was confined to sentimental marble statuary, characterless classical portraiture and unimaginative bronze monuments, the excuses for which are few.

But despite arriving late the romantic revolution did change the whole face of English sculpture in a most exciting manner. One of the principal reasons why the eventual reaction in England was so widespread concerned the united qualities of this 'New' group of young sculptors, for they acted as a composite body to storm and capture all fields of the sculptor's activity, ranging from teaching at the Schools, through exhibiting at the Academy, to private patronage. By 1885 firm supporters of the group like Edmund Gosse noted with satisfaction that attitudes had completely changed as the success of Hamo Thornycroft and Alfred Gilbert had engendered a public interest in sculpture unknown since Flax-

man's heyday, and Academy sculpture at last attracted the eye of the critic with a power equal to that of contemporary painting. The visual contrast to mid-Victorian sentimentality could not have been greater. In the first place, the scale and material had been reduced from the stylised lifesize movemented bronze statuette, and in the second place the classical or heroic subject had been exchanged for a naturalistic representation of the personalities and feelings of the sculptor's individual imagination.

So although English Romantic bronzes were produced over a markedly shorter period than in France, from perhaps 1875 to 1920, they have an equal charm and depth of quality, for the new ideals in England quickly permeated all levels in all directions whereas in France, despite the adventurousness of some sculptors, the decorative inconsequentiality of the middle years was still in popular evidence in the last decade of the century. Naturally the example of the French had been crucial, especially in the early stages when Leighton battled single-handed against officialdom's blindness to the stylistic achievements across the English Channel, but once private and then public patronage did begin to take notice of the new school, English sculpture marched along its own independent paths.

The stylistic development of this post-1870 period followed a rapid yet clear course, but in order to appreciate the overall significance of these achievements it will be necessary to outline the mid-century background.

To high Victorian taste the sculptor who most closely approached the 'ideal' was John Gibson (1790–1866), and a glance at his life and work will reveal the nature of their purpose. In sculptural terms Gibson's life began in 1817 as he journeyed to Rome armed with letters of introduction to Canova, the father-figure of Neo-Classicism, and from this date Gibson made his home in Rome, returning to England on occasions merely to oversee the emplacement of some of his continuous commissions. Gibson's approach was controlled entirely by his academic desire to parallel the achievements of the Greeks, and the fullest expression of his art was made public in the International Exhibition of 1862 in London with the unveiling of 'The Tinted Venus' (52), a marble Venus wax-coloured in accordance with the Semper and Hittorf interpretation of polychromy in antiquity, and placed in a 'Greek' temple specially designed by Owen Jones. The public popularity of this strict classicism is indicated by the success of mechanical portraitists such as E. H. Baily (1788–1867), and in the pallid works of the 1850s the artist's moral stature counted for more than his imagination, a philosophy presented in the *Art Journal* obituary in 1863 of Alfred Gatley: 'Seldom has it been our fortune to meet with an artist of higher truth and honour, or with an artist so single-minded in his devotion to his Art.' It was the presentation of such lacklustre ideals by the *Art Journal*, itself conceived as the weapon with which to force taste on the British public, that led to the sinking of sculpture into 'the lowest depths of desuetude' (Edmund Gosse, 1894).

Admittedly not all mid-century sculpture was classical in iconography, witness the crisp bronze cast of Robert the Bruce (53) by William Beattie (exhibited 1829–64), which certainly achieved a kind of Romanticism, comparable perhaps with the Gothic novel although not as stylish as the

52 (*far right*) 'The Tinted Venus', a wax-tinted marble figure by John Gibson exhibited at the London International Exhibition in 1862.

53 A bronze statuette of 'Robert the Bruce' after a marble original of *c* 1840 by William Beattie.

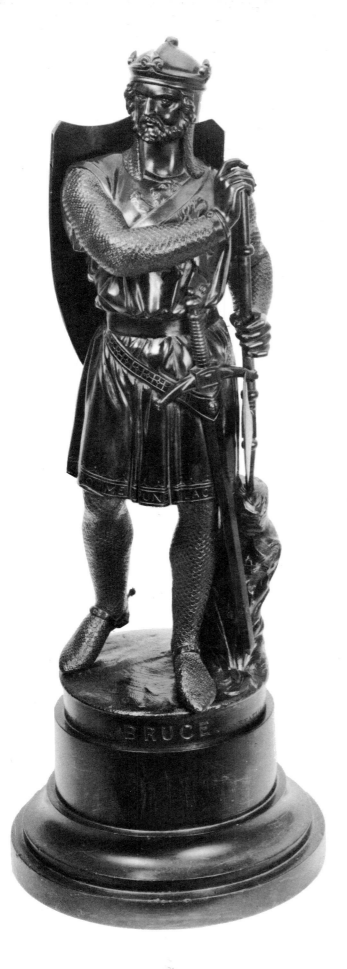

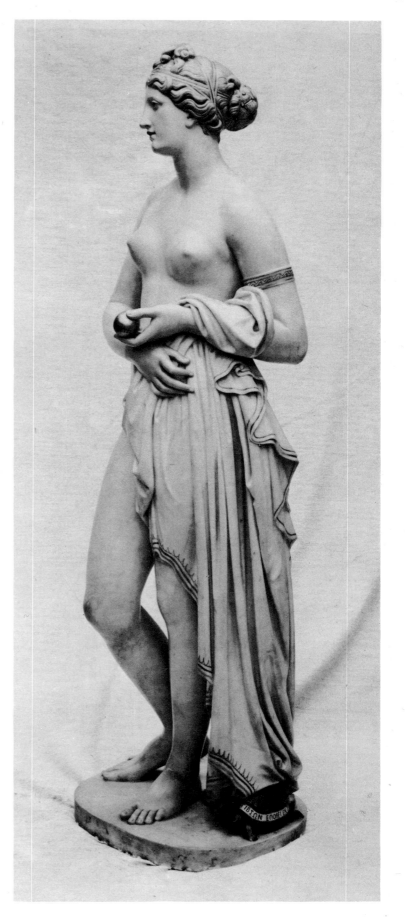

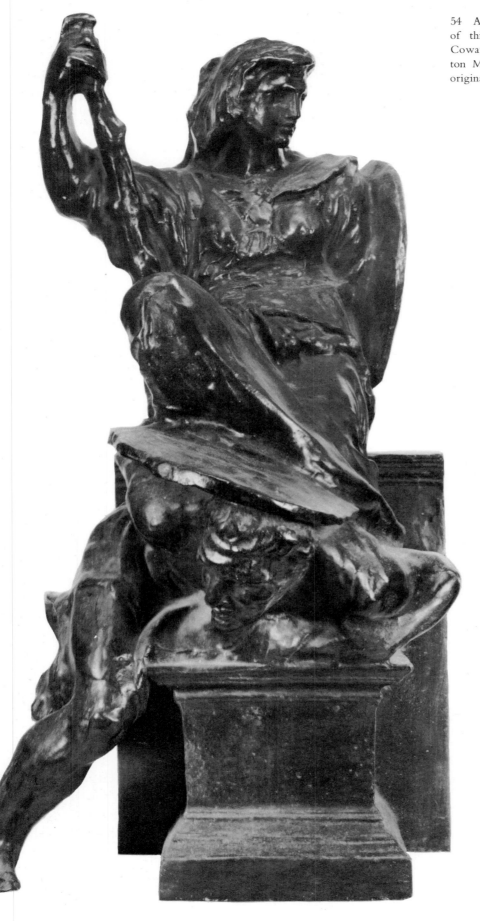

54 A number of individual casts were made of this monumental group, 'Valour and Cowardice', from Alfred Stevens' 'Wellington Monument' in St Paul's Cathedral, the original design being dated to 1857.

Gothic Revival in architecture; but although the literary subject of this statuette was a relief from normal classical severity, the formal concept remained totally traditional in its stiff, heroic pose. In the same way an artist like Thomas Woolner (1825–92), the principal Pre-Raphaelite sculptor, faced himself in the right direction in the choice of subjects like Puck in 1847 but unfortunately failed to advance beyond decorative linearity in actual style of execution.

The only man of this period to receive the whole-hearted approval of his revolutionary successors of the 1880s was Alfred Stevens (1817–75), whose sole major public commission, 'The Wellington Monument' in St Paul's Cathedral, was the cause first of his untimely death and then of his posthumous acclaim. Indeed the farcical ineptitude displayed in the organisation of this commission was merely one instance in a line of similar official mishandlings which must weigh as major factors in the failures of mid-century sculpture. After a chaotic series of competitions followed by a letter to the Press from twenty-three of the leading sculptors and subsequent resignations from the board of judges, in June 1858 Stevens was awarded the commission, which was still unfinished at the time of his death in poverty seventeen years later. Stevens turned out to be a difficult man to keep to his schedule, but then at every turn he was thwarted by lack of financial or directional support, and the tragedy should have been avoided.

It is easy to understand why Stevens attracted so many followers amongst the new generation when it transpires that the original conception of 'Valour and Cowardice' (54) appeared in the competition model for the Wellington Monument in the year 1857. The tremendous sense of physical force and sculptural power in this group testified to the Michelangelesque influence of Stevens' stay in Italy from 1833 to 1842, but the untutored creation of the marvellous rippling textures in bronze was achieved in complete independence from contemporary French discoveries, and was of course unique in style among English sculptors. The majority of Stevens' other work was for the ironfounder Hoole of Sheffield, with whom no doubt his 'Design for a Fountain' (55) was connected; and indeed the naturalness of physical expression and the lithesome texturing in this bronze were qualities more directly linked with the New Sculpture than the quickly outmoded allegorical massiveness of 'Valour and Cowardice'.

The fact that public and private patronage largely ignored the one native talent in sculpture of the period became a natural bone of contention for the later progressives, but even the ordinary English sculptor at the time felt a grievance against the system which made it so difficult to earn a livelihood as a sculptor. Chief villains in the piece were first, the Government Commissioners, and secondly, the two foreign artists who successfully insinuated their way into the valuable favours of royal patronage. The first of these interlopers, Baron Marochetti (1805–67), in fact typified the most tasteless in the mid-century 'Great Exhibition' demand for monumentality as an end in itself, and by 1861 even contemporaries suspected the genuine worth of this attitude as the *Art Journal* critic described the 'Richard Coeur de Lion', Marochetti's major work, as 'one of the worst London eyesores'. His successor, Sir Edgar Boehm (1834–1890) possessed

55 'Design for a Fountain', also by Stevens and probably associated with his regular work for the ironfounder Hoole of Sheffield in the 1860s.

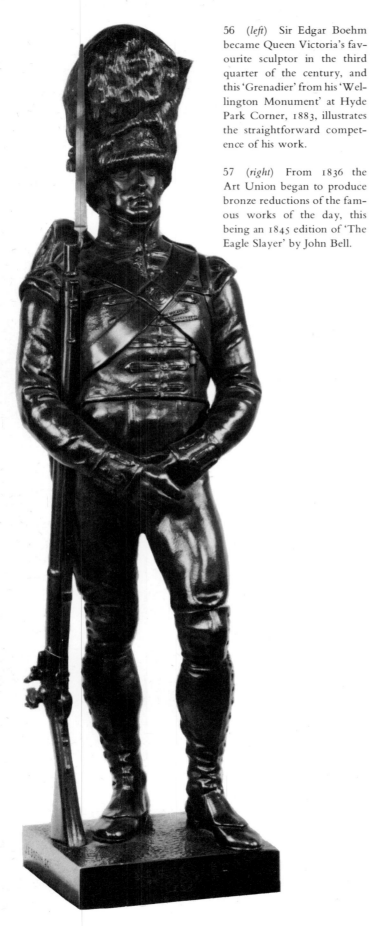

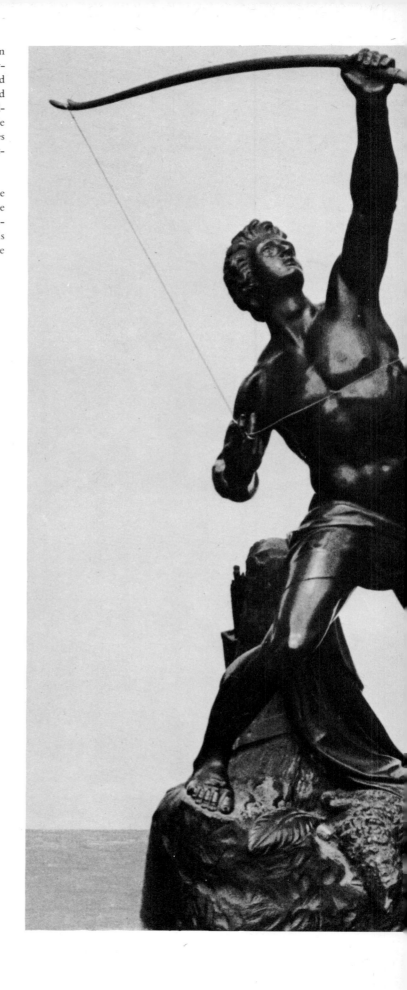

56 (*left*) Sir Edgar Boehm became Queen Victoria's favourite sculptor in the third quarter of the century, and this 'Grenadier' from his 'Wellington Monument' at Hyde Park Corner, 1883, illustrates the straightforward competence of his work.

57 (*right*) From 1836 the Art Union began to produce bronze reductions of the famous works of the day, this being an 1845 edition of 'The Eagle Slayer' by John Bell.

a more valuable talent and maintained a hard-working technical purity throughout the long and successful career he enjoyed after arrival in this country in 1862. Boehm's popularity with the Queen ensured him a large practice as society sculptor, a position which he made safe by employing most of the best young sculptors in his studio, along with his private pupil Princess Louise; all of which tended to shackle stylistic progress. The retrograde prosaicness of Boehm's style can be illustrated with emphatic clarity in the side figures for his own 'Wellington Monument', commissioned in 1883 for Hyde Park Corner (56), where the contrast with Stevens' conception (54) needs no elaboration.

Apart from Stevens, the actual stylistic antecedents to the New Sculpture were minimal in England itself, and the only important contributory development in England in the two decades prior to 1875 concerned a change in taste to accommodate the small bronze statuette as a central creative force in the sculptor's oeuvre. The delay in adopting this basically romantic medium was partly due to the fact that England suffered from a purely logistic disadvantage in the lack of a strong tradition in art metal founding, for throughout the whole century there were perhaps a hundred skilled craftsmen in all England compared with nearly a thousand in Paris alone. The first public propagation of the bronze statuette came through the Art Union scheme founded in 1836 to boost the public taste by offering bronze reductions of the best works of the day as therapeutic prizes in national lotteries; one of the earliest of these was 'The Eagle Slayer' of John Bell (1811–95), illustrated (57) in the 1845 edition by E. W. Wyon, which remained a lasting joy to contemporaries, having been first exhibited life-size in 1837 and still to be a star attraction in the Sculpture Court of the 1851 Great Exhibition.

In general, however, the casting of these small bronzes failed to compare with the work of French commercial founders such as Barbedienne (20), and the Art Union scheme tended merely to emphasise the inarticulate formalism of English sculpture. Thomas Thornycroft's Art Union version of his monumental 'Queen Victoria' (58) was an exception to this rule on two counts. First, each of the fifty casts was produced under the individual supervision of Thornycroft and therefore possessed a tactile personality seldom experienced in English sculpture of the period; and secondly, the style of the statue itself had a relaxed naïvety despite the tedious classical conventionality of the horse. Thomas Thornycroft (1816–85) followed an unassuming career along the accepted lines, and the family's fortune and reputation were supplemented by the activities of his wife Mary (1816–95) whose skill in capturing the royal children in sentimental similitude greatly endeared her to the Queen. Needless to remark, there was little common ground connecting their work with the revolutionary inventions from 1880 of their son Hamo (see page 66).

The only established sculptor of this generation to show any consistent dissatisfaction with the old-fashioned stylistic expressions of his time was Sir John Henry Foley (1818–74), and an instructive work in this category was his 'Norseman' (59), originally exhibited at the Royal Academy in 1863. This figure certainly offered a visual protest against 'the bald generalities' of the sixties, for the attitude of the figure suggested an emotional

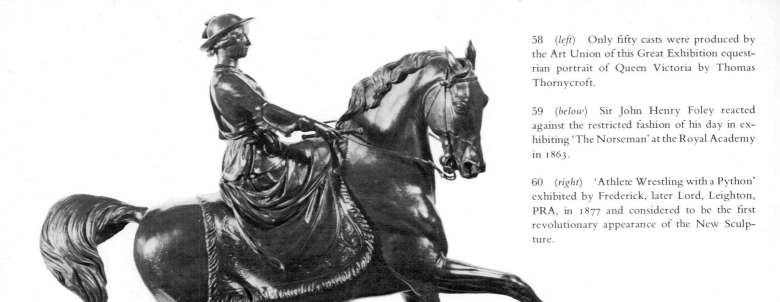

58 (*left*) Only fifty casts were produced by the Art Union of this Great Exhibition equestrian portrait of Queen Victoria by Thomas Thornycroft.

59 (*below*) Sir John Henry Foley reacted against the restricted fashion of his day in exhibiting 'The Norseman' at the Royal Academy in 1863.

60 (*right*) 'Athlete Wrestling with a Python' exhibited by Frederick, later Lord, Leighton, PRA, in 1877 and considered to be the first revolutionary appearance of the New Sculpture.

commitment of the artist not seen in the cool classicism of contemporaries. But although the choice of subject had an appealing romanticism, the treatment of the bronze in its smooth correctness still separated Foley from the excitements that followed.

The 'Norseman' makes a nice contrast with what is usually considered to be the first work of the New Sculpture, Frederick, later Lord, Leighton's 'Athlete Wrestling with a Python' (60), exhibited at the Royal Academy in 1877, the smaller version illustrated being taken from a sketch model. Immediately the real, active qualities of the Athlete condemn the Norseman's gesture to the stage of a comic opera; not that Leighton either aimed at or achieved true realism, but in the generalised treatment of the surfaces and in the anatomical accuracy of the energetic pose an Englishman at last showed a critical awareness of the marvellous French *couleur* of the 1860s. The manner of the figure's original conception is also important, for it began as a clay model made to aid in the composition of a painting and was cast in bronze only at the insistence of Legros; it therefore actually began public life as a small bronze statuette rather than as a marble later reduced for commercial reproduction in bronze. The novel foundation of sculpture on the unaffected study of the human form was emphasised even more strongly in another work by Lord Leighton (1830–96), 'The Sluggard' [p. 125], which was taken from the haphazard relaxed pose of a painting model and created with the statuette directly in mind. With Leighton's pioneering work the English Romantic Bronze became a reality.

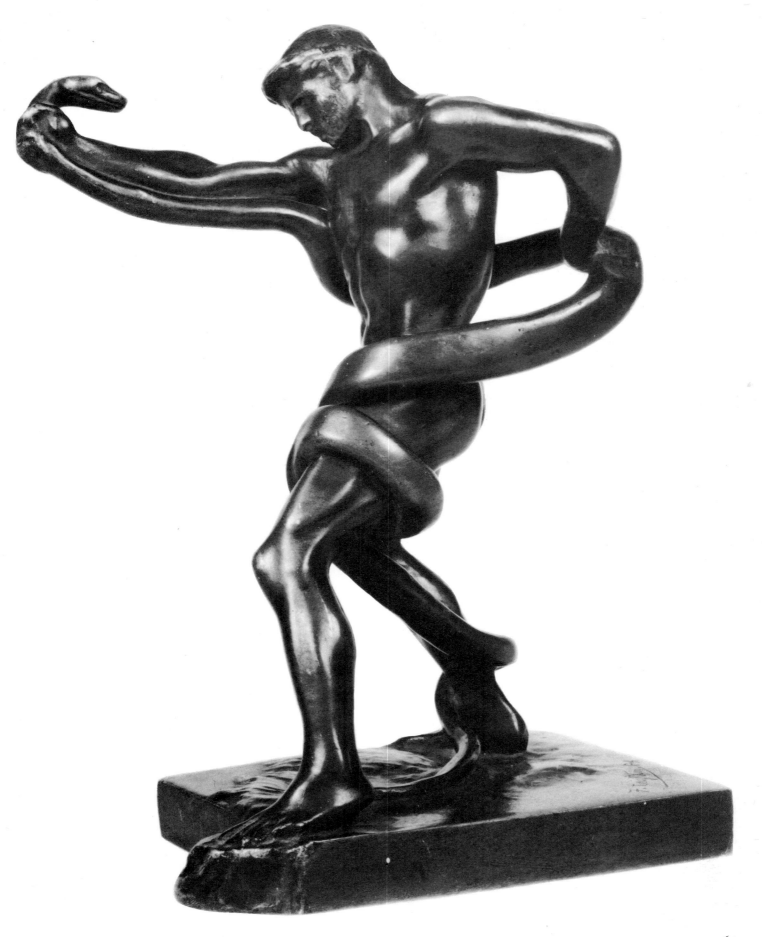

For the sake of clarity the New Sculpture has been, and will continue to be, treated as though a self-defined entity, when in practice the term was invented only out of convenience by Edmund Gosse in a series of articles written in 1894 in an attempt to explain how this stylistic revolution had occurred. By 1894 a composite body of young sculptors existed who were indeed united by 'their loyalty to a common ideal', but there was never any question of their acting as a cohesive group. This meant that the novel characteristics of the last quarter of the nineteenth century appeared in an attractive variety of forms, and in this limited space it is easiest therefore to discuss the stylistic principles of the New Sculpture by taking each sculptor separately in chronological order of appearance.

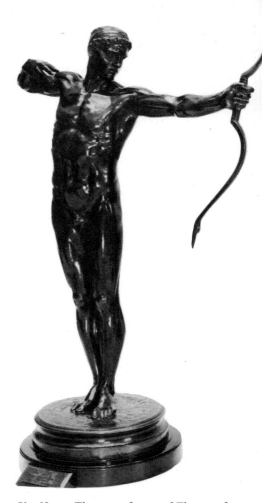

61 Hamo Thornycroft, son of Thomas, first came to public notice in the early eighties with RA exhibits such as 'Teucer' of 1881.

Of course Leighton was primarily a painter so could not be expected to take a permanent lead in the field of sculpture, and Hamo Thornycroft (1850–1925) was the young man who rapidly forced his way into the public eye as the centre of this revival of faith in English sculpture. In Gosse's dashing narrative, couched in the flowing terms of his age, Thornycroft was cast in the hero's role, where, as will be seen, Marion Spielmann writing in 1901 gave the part to Alfred Gilbert (1854–1934). Spielmann was probably correct in the wider context, but the important point here is that Thornycroft was undoubtedly the first to attract attention in the Academy with his 1880 and 1881 exhibits, 'Artemis' and 'Teucer' (61) respectively. Both these classical characters were handled with a physical naturalism unprecedented in English sculpture, yet, despite this implied criticism of the Establishment, were received with universal acclaim. At first sight 'Teucer' may seem only a small advance from 'The Eagle Slayer' (57) or 'The Norseman' (59), but although, as a young man, Thornycroft was obliged to pay court to the old academicism, he introduced into the standard themes a real muscular tension and also a new emotional involvement shown in Teucer's purposeful gaze after the last arrow speeding towards Hector's fate.

But although one essential ingredient, surface naturalism, had been successfully introduced, the New Sculpture remained a pallid reflection of the French for some time. Fortunately Hamo Thornycroft himself added another dimension with his exhibition in 1884 of a life-size plaster entitled 'The Mower', which went far in expressing the new ideals by taking a scene from nature, the mower halting at his work, and presenting this in a rationalised artistic form. The subject was in fact suggested by a stanza from Matthew Arnold's poem of the same title, and the bronze, like the poem, attempted to convey feeling and atmosphere over and above description of the actual scene in nature. Now that the expression of an abstract idea or an ephemeral sentiment is familiar in all the arts it is perhaps difficult to appreciate the significance of these first tentative steps in this direction by Thornycroft and others. However, it is obvious that his choice of subject matter in 'The Mower' (62) and 'The Iron Age' (63) make the most direct contrast with previous practice. In fact Thornycroft and Harvard Thomas in England, Jules Dalou (34) in France and Constantin Meunier (35) in Belgium were the only sculptors to tackle the working man in isolation, and so the rugged naturalism of 'The Iron Age' takes on an international significance.

62 (*above*) This bronze cast from Hamo Thornycroft's maquette for the 'Mower' of 1884 was far freer in style than the final, larger version.

63 (*left*) Thornycroft was the only Englishman to capture successfully the working man in bronze, and 'The Iron Age' is a fine example of his mature broad style.

After 'Teucer' Hamo Thornycroft, despite his comparative youth, began to wield considerable power in the establishment, where his ability to excite public interest in sculpture pleased even the most reactionary academicians, for they claimed that the new modes were firmly founded on the official teaching, and this brought a tremendous composite strength to English sculpture which thus managed to avoid the bitter internal struggles that racked French schools. This mood of enthusiasm encouraged experiment and freedom of expression and gave English sculptors the opportunity for the first time of exhibiting purely personal pieces, a prime example of which is the small portrait medallion (64) by Hamo Thornycroft, inscribed 'Oliver Thornycroft March 18 . . 1888'. This medallion was in every sense a private production, indicated in the rough sand cast and the intimate study of the child's personality, and it displayed, both in style and aesthetic, an unquestioning dedication to new ideals.

Naturally, many of the older sculptors who lived through this period of sharp transition found themselves in a more equivocal position. The oldest of these sculptors, H. H. Armstead (1828–1905), surprisingly was perhaps the most adaptable, for the breadth of his early experiences, which included painting and silversmithing, gave him a less dogmatic bearing. Throughout his life Armstead undertook a considerable amount of architectural work as a sculptor-decorator and the liveliness of his imagination

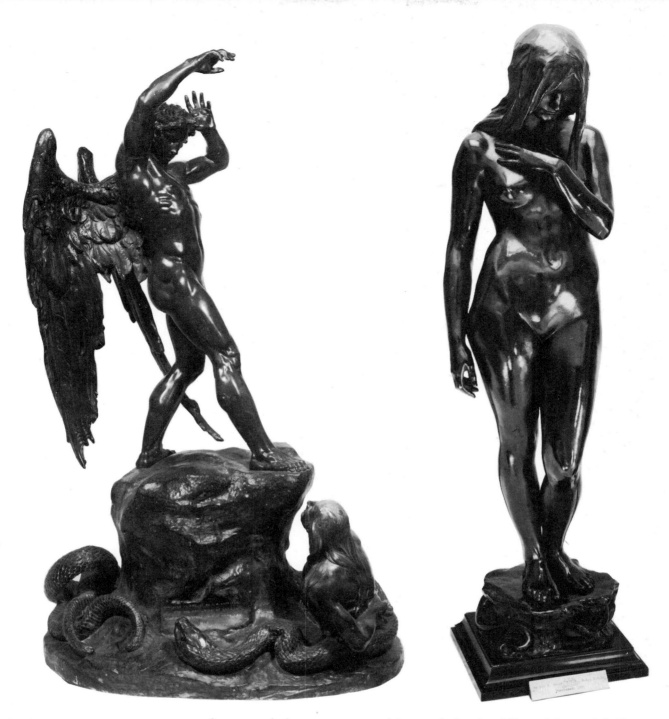

65 'St Michael and the Serpent', a reduction by the Art Union in 1852 of the original by H. H. Armstead, one of the old guard who later lent his support to the New Sculpture.

66 (*above right*) Thomas Brock changed radically under the influence of the new ideals, witness his imposing 'Eve' of 1898.

was first revealed on an eye-catching scale in the Albert Memorial. Even in an early work, 'St Michael and the Serpent' (65), reproduced by the Art Union in 1852, Armstead showed himself more adventurous than most contemporaries, and later in life, as the last of the old guard in the Academy, his examples in the Guards Chapel reliefs and his moral support were both of inestimable value to the New Sculpture. The same could not be said for George Lawson (1832–1904) and George Simmonds (born 1844), both of whom showed signs of genuine participation only to slip back later into old habits. Both Gosse and Spielmann praised Lawson for his distinguished early work which included 'Dominie Sampson' in 1868, 'a marvel of humorous realism', but he never really shook off the influence of his apprenticeship with Gibson in Rome, and 'Callicles' of 1879 became a

typical indecisive mixture of lifeless Greek severity with a genuine stylishness and charm. Similarly Simmonds spent long years of study in Rome where he produced his best-known work, 'The Falconer', for Central Park, New York; but on returning to London in 1877 Simmonds did contribute to the new movement with his study of the methods of lost-wax casting, and some of his exhibits at the New Gallery in the nineties possessed considerable power, notably 'Goddess Gerd', a sensuous nude with her hair expanding into a sunray – but this unfortunately was the exception rather than the rule.

Charles Birch (1832–93) and Thomas Brock (1847–1922), as pupils of Foley, were trained on English soil and therefore reacted differently. Birch seemed unwilling to advance beyond the monumental heroism of subjects like 'The Last Call' in which a brave hussar and his horse were shown struck dead while in full battle-cry, but at least its strong movement and naturalism of detail denounced the insipid classicism of the Rome School. Thomas Brock, on the other hand, made a complete transition to the new ideals, and indeed his 'Eve' (66), exhibited at the Royal Academy in 1898, succeeded in fashioning that delicious combination of naturalism and spirituality found at the core of the New Sculpture. Brock continued to work prolifically for himself after first completing those commissions left to him by Foley, and his most successful monuments were probably the Leighton Memorial in St Paul's and the Victoria Memorial outside Buckingham Palace, both of which were prestige commissions and marked a stylistic continuation of the Stevens tradition with their robust rhythmic forms flavoured with the additional qualities of naturalism and emotional association.

Perhaps it was the fact that Alfred Gilbert (1854–1934) was the only sculptor who refused to help Gosse with information in the writing of 'The New Sculpture' articles in 1894 that influenced this amiable critic to play down Gilbert's achievement, when in reality after his return to England in 1884, Gilbert became the accepted leader of his generation. Gilbert first demanded attention in 1882 with 'The Kiss of Victory' at the Royal Academy and 'Perseus Arming (67), at the Grosvenor Gallery, which were initially heralded as England's answer to two similar works by the Parisian Mercié, 'Gloria Victis' (29) and 'David' [p. 144]. Of course, favourable comparison with the French was always flattering, but Gilbert had arrived at this means of expression independently of the French through his own studies in Florence and Venice, and speedily advanced beyond it to small statuettes such as 'A Tribute to Hymen' (68) of 1886. In the Perseus, Gilbert produced some remarkable detail in the description of muscles and veins, and also superb surface texturing, but the pose and subject-matter were still traditionalist and slightly affected, whereas 'The Tribute' was totally unaffected in its naturalism and filled with a strong sense of personal fantasy; and it was this fantastical yet ordered imagination of Gilbert's which led to the totally unprecedented work of the nineties, such as the Clarence Memorial in Windsor Castle, where he employed a wealth of revolutionary ideas, forms and materials.

Gilbert's distinctive qualities immediately earned him patrons, for Leighton himself commissioned 'Icarus' of 1884, and by the end of the

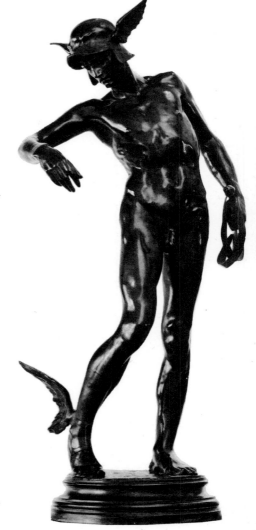

67 Alfred Gilbert laid claim to the leadership of the New Sculpture with his first public exhibition, 'Perseus Arming', at the Grosvenor Gallery in 1882.

This bronze figure of a harvester was executed by the Belgian sculptor Constantin Meunier, who called the figure 'Juin'. (*Sotheby's Belgravia*)

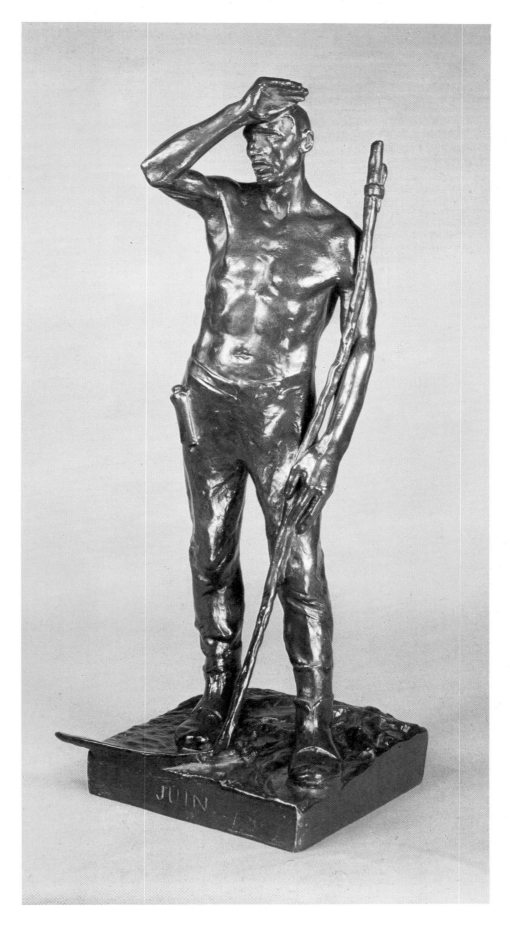

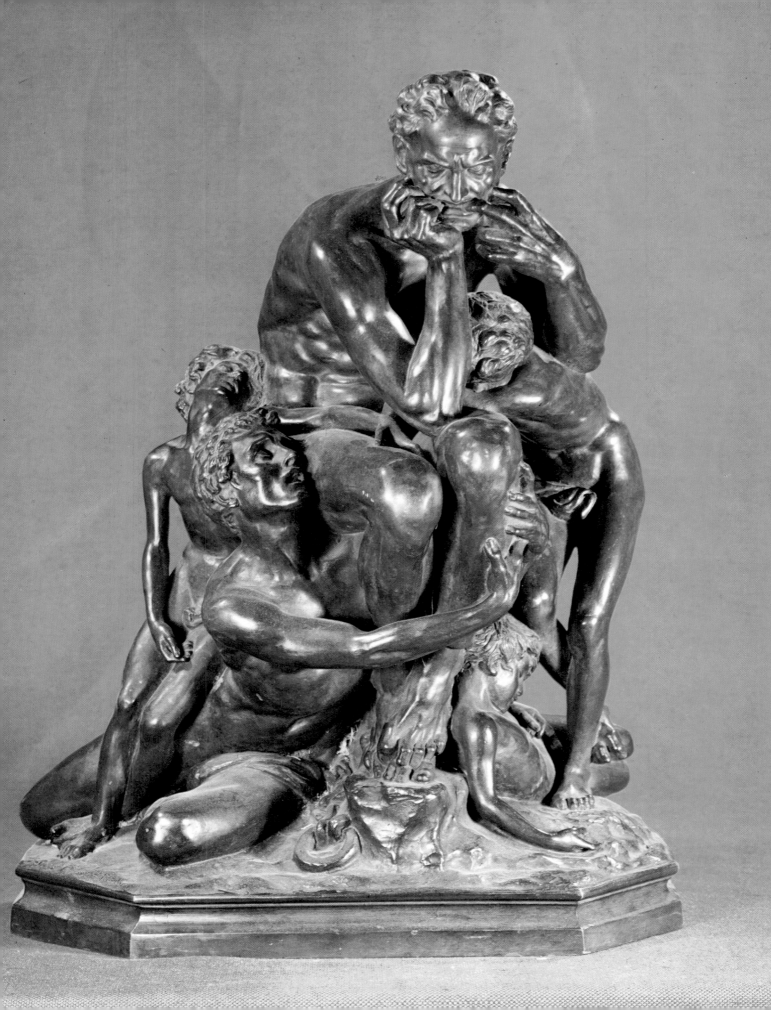

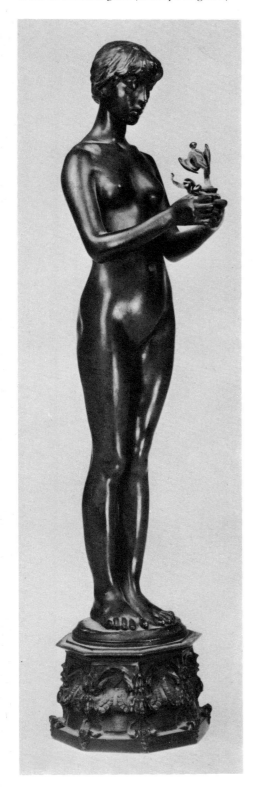

Jean-Baptiste Carpeaux returned to Paris in 1863 with the sensational 'Ugolino and His Starving Sons', showing a novel interest in the work of Michelangelo. (*Sotheby's Belgravia*)

68 Gilbert quickly progressed to the naturalistic fantasy of 'A Tribute to Hymen' exhibited in 1886.

decade Gilbert had been entrusted with the Eros statue for Piccadilly Circus and a Queen Victoria Monument at Winchester, the base of which was full of intertwined romantic figures and foliage, considered to be altogether undignified by the reactionary critics. But the Queen must have been pleased enough, for at the Duke of Clarence's death in 1892 she gave Gilbert the commission for the tomb in Windsor, in which Gilbert extended his experiments of the Fawcett Monument of 1887 into full polychromy and fantastic foliate forms to envelop the sleeping figure in Gothic mourning. But bankruptcy followed, and from 1903 to 1926 Gilbert exiled himself in Bruges, and England lost its first sculptor of European stature since the early nineteenth century.

Although Gilbert's most imposing successes were in monumental works, the magic of his achievements can be appreciated with the fullest poignancy in two bronze portrait busts – figures 69 and 70. The small bust of G. F. Watts (69) was first produced in about 1890 and exhibited a true naturalism enlightened by a direct sympathy with the sitter. No more than four inches high, the lost-wax casts of this bust which Gilbert produced from time to time indicate the complete freshness of approach that characterised the best of the New Sculpture. Later in life Gilbert became far more complex both in technique and in iconography, and so the bust of Ignatius Paderewski (70) showed a modernity comparable with Epstein, where quiet realism was sacrificed to urgent abstraction in Gilbert's intensification of expression. The attraction of Gilbert, as with the whole group, is that he was always looking for a personal solution to the sculptural expression of the thoughts and figures of his imagination, and in the hands of consummate artist-craftsmen this adventure never ceased to thrill.

But of course artistic creativity, however personal, depends to a certain degree on the cultural ambience of a period, and the prosperity of the New Sculpture was founded on sensitive public and private interest. Although the ultimate student goal still remained the Royal Academy schools, a highly respected tradition also grew up in South Kensington at the National Art Training School, now the Royal College of Art; this tradition was enhanced yet further with the creation in 1878 of a special professorship there for the exiled French sculptor Jules Dalou (1838–1902). Dalou's regard for simple naturalism [p. 90] had been largely ignored in Paris and so the immediate acclaim from some quarters of one of his first English works, 'La Paysanne', encouraged Dalou to impart his naturalistic feelings to the group of enthusiastic young followers. One might imagine that the vision of La Paysanne suckling her child at the breast would have maddened officialdom in the early seventies, but under the protection of fellow countryman Alphonse Legros (1837–1911) Dalou remained free to give English sculptors their first taste of French romantic-naturalism. Legros himself was also influential as Slade Professor of Drawing from 1876 to 1892 and first President of the Society of Medallists, but Legros' traditionalist feeling for strength of line became progressively less applicable (71) and the Dalou inventions were really carried on in teaching by his successor at South Kensington in 1880, Edouard Lanteri (1848–1918). Lanteri possessed an admirable dexterity in the handling of clay and produced some pleasing work himself (72), but his truly unique talent was as

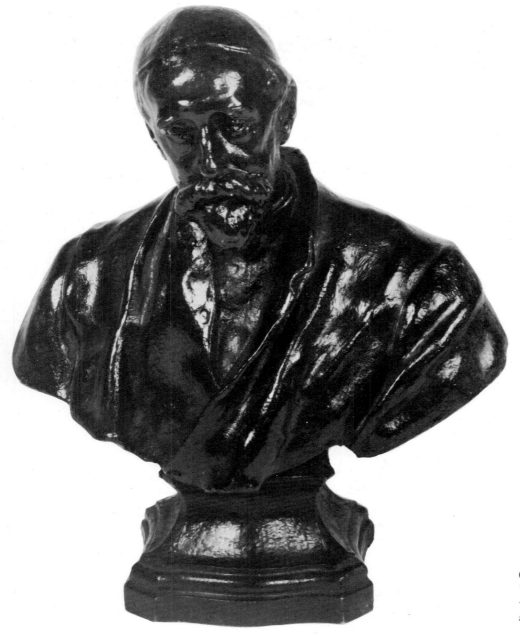

69 A small portrait bust of the painter G. F. Watts by Alfred Gilbert, unsigned casts of which were produced by the lost wax process at irregular intervals by Gilbert.

a teacher where he insisted on 'an accurate and sympathetic study of nature' combined with the developing and perfecting of the individual feeling of the artist. Such ideals matched perfectly the ambitions of New Sculpture.

Before returning to France in May 1879 Dalou also taught briefly at the Lambeth School of Art which had opened sculpture classes in 1878, financed by the City Guilds of London Technical Institute. The school had been founded in 1854 by Canon Gregory principally to instruct the local potters, and it thus maintained strong craft and applied arts associations in the training of its newly acquired sculpture students under the admirable William Frith from 1880. At the opposite end of the scale, encouragement to the sculptors was unexpectedly forthcoming from a private source when Sir Coutts Lindsay and Comyns Carr founded the Grosvenor Gallery in 1877. The gallery invited certain artists to exhibit with the aim of giving an alternative emphasis to the official Academy; in practice many

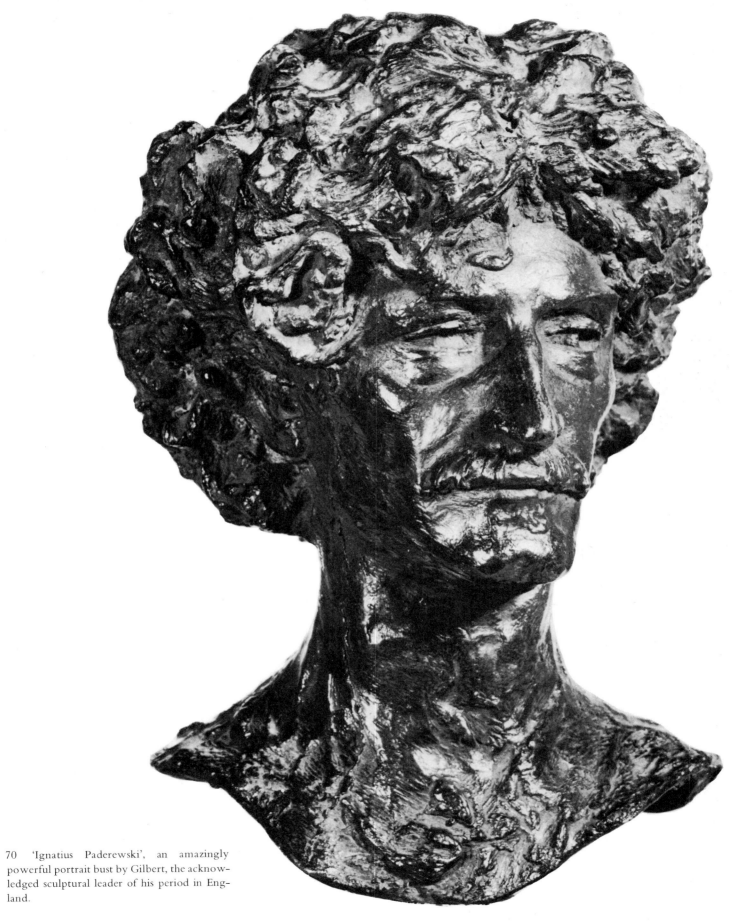

70 'Ignatius Paderewski', an amazingly powerful portrait bust by Gilbert, the acknow-ledged sculptural leader of his period in Eng-land.

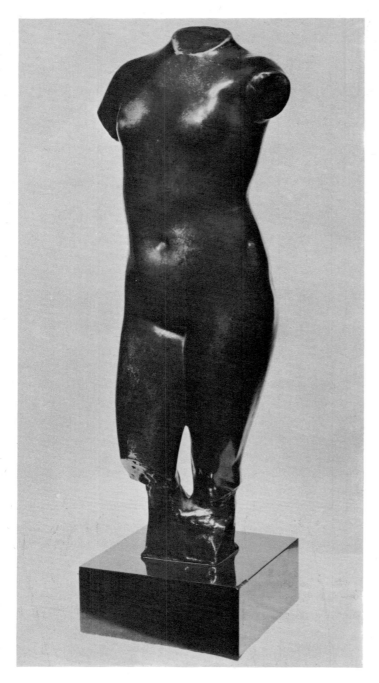

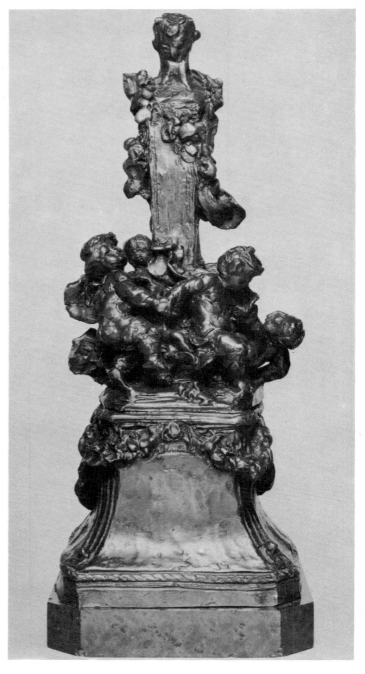

gifted amateurs and even such professional tyros as Watts and Burne-Jones refused at one stage to exhibit anywhere else. But not only did the Grosvenor Gallery give the New Sculpture a home of its own, it also boosted Dalou's French persuasion by bringing over popular sculpture from Paris, the work of Delaplanche and Dubois being most noticeable at the opening exhibition, according to Gosse. When the Grosvenor began to falter, the New Gallery stepped in with its opening Summer Exhibition in 1888. Some of the works in 1888 by sculptors like Simmonds and J. W. Swynnerton (1848-1910) seemed extremely dull, but Gilbert and Onslow Ford were on the consulting committee and later exhibited themselves, so standards improved, and anyway the fact that everything was for sale automatically put Romantic Bronzes into circulation.

71 (*above left*) Alphonse Legros maintained pleasing associations with Renaissance classicism in bronzes like 'Female Torso', finally exhibited in 1902.

72 (*above right*) Like Legros, Edouard Lanteri was a highly influential teacher of the period, but this terracotta design for a 'Garden Decoration' shows him to be a sculptor of considerable quality.

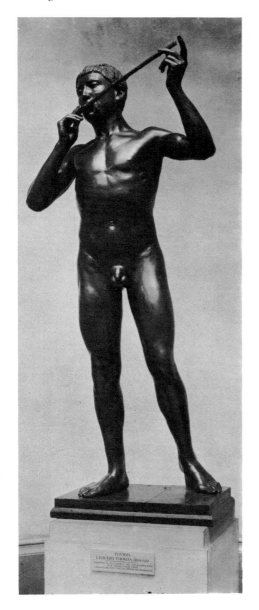

73 'Thyrsis' revealed James Harvard Thomas'
desire to match his admiration for Greek purity
of design to the new ideals.

In addition to all these supporting factors, the Academy itself reorganised its Summer Exhibition plans in 1881 to give the new-style sculpture a viewing space appropriate to its considerable qualities and growing public following. One of the side effects of the improved teaching and showing of sculpture was the sudden proliferation of good but minor sculptors like Thomas Stirling Lee (1857–1916). In 1880 Lee had secured the Gold Medal and Travelling Scholarship at the Academy and followed Gilbert into the studio of Cavelier in Paris, where he became devoted to the French School, and on return to England helped Gilbert, Behnes and Thomas in the revival of the lost-wax process of casting, the most sensitive method of producing fine small bronze statuettes. Lee's own work was careful and controlled with his recumbent nude 'Dawn of Womanhood' in 1883 being almost too realistic. However, his relief panels for St George's Hall, Liverpool, gave tremendous suggestions of colour in the subtle control of lights and shades, and induced Spielmann to write that there were 'those who would doubt if anything in modern times has been done in any country to excel them'. James Harvard Thomas (1854–1921) also studied under Cavelier, from 1881 to 1884, but his sympathies really turned towards re-capturing the purity of Greek statuary, the guiding principle of his Tate Gallery bronze 'Thyrsis' (73); and in 1889 Thomas left to work in southern Italy using models from the honest, simple scenes around him. But although the figures he sent back to England for exhibition displayed technical excellence in the direct cutting on marble, the sadly sentimental handling of subject-matter showed nothing new.

The painter G. F. Watts (1817–1904) must necessarily rank also as a peripheral figure in the field of sculpture although his 'Clytie' of 1868 was in every sense a pioneering work in its broad, bold treatment of the female bust. The major sculptural concern of Watts' life was the Hugh Lupus statue for Eaton Hall on which he worked twenty years or more, and eventually he also incorporated the model into his 'Physical Energy' in Kensington Gardens; the reduction illustrated (74) reveals the schematised power and idealism of Watts' artistic personality. The work of this part-time sculptor throws the tentative forms of another peripheral figure, Edwin Roscoe Mullins (1848–1907), into uneasy relief, for diligence, not talent, was the most striking characteristic of this sculptor's generally in-consequential work.

The French School of Animalier Sculpture was of such size and stature that it requires a separate chapter, but very few English sculptors devoted themselves to this study despite the traditional sympathies of the nation with animal subjects. However, England did produce one outstanding 'Animalier', John Macellan Swan (1847–1910), and early product of the Lambeth School who then naturally made his way to Paris and the studio of Fremiet. Swan was an amazingly dedicated artist who purposely paced his development slowly while he mastered all aspects of the anatomy and movement of the animal; indeed he began as a painter, exhibiting at the Academy from 1878 with numerous detailed studies of animals, and delayed exhibition of his first sculpture till 1889. But Swan achieved more than mere mechanical excellence, as is revealed in his bronze of a lioness (75), in which naturalism was enhanced by a poetic understanding of the

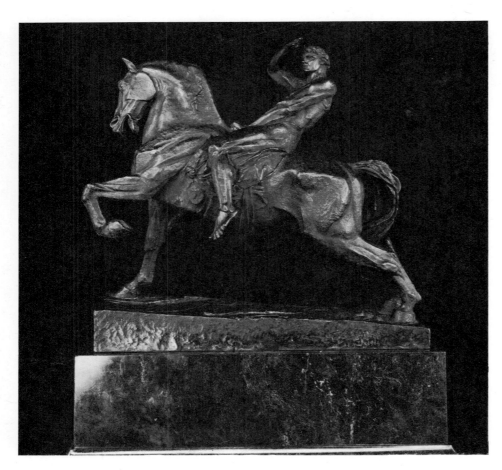

74 The painter G. F. Watts was an occasional sculptor of considerable powers, as is seen clearly in this reduction of 1914 from his 'Physical Energy' in Kensington Gardens, on which he had worked for over twenty years.

qualities of the metal. None of the other English Animaliers matched Swan, but Harry Dixon, J. H. M. Furse and Robert Stark had all produced attractive, if prosaic, animal sculpture by the turn of the century.

The organisation of art-historical development into an ordered narrative must always involve a degree of simplification of the complex truth, and in a movement as widespread and as fast-growing as the New Sculpture, these artificial divisions into stages and groups of sculptors naturally distort reality. But as long as one remembers that although treated separately the work of each individual sculptor interacted with all the others, then it is genuinely beneficial to break down the development into simple stages.

So the next section in the narrative concerns the bridging of the gap between the pioneering achievements in the early eighties of Gilbert and

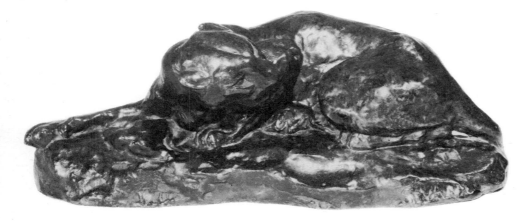

75 The only English Animalier sculptor of significant talent was J. M. Swan, whose 'Lioness' showed a deep understanding of the textural qualities of bronze in conveying movement.

Thornycroft and the great surge of activity in the nineties. Onslow Ford (1852–1901) was the key figure in supporting this hypothetical bridge. The enchanting equivocality of Ford's work perhaps stemmed initially from the absence of any formal training as a sculptor, for after studying painting under Wagmuller in Munich in 1872 Ford immediately began his career as a portrait painter. As a sculptor he developed slowly and his many admirers were forced to wait until 1886 for a work of the real quality shown in 'Folly' (76), into which the sculptor instilled all at once the three principles of the New Sculpture, naturalism, idealism and symbolism,

76 Onslow Ford developed slowly, and not until 1886 did he exhibit a bronze of genuine merit, 'Folly'.

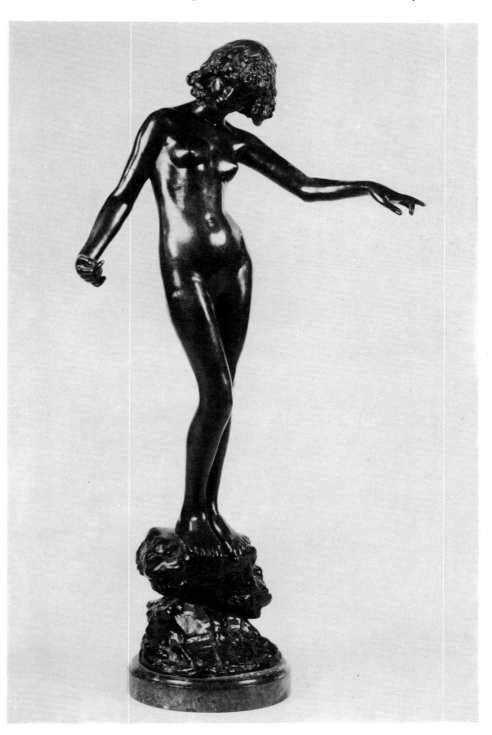

fashioned with a craftsman's technical awareness. Ford was one of the first, with Gilbert, to employ the techniques of polychromy in bronzes and his 'Singer' and 'Applause' of 1889 both made exciting use of champlevé enamel, giving a positively exotic taste where Gilbert turned more towards a personal medieval romanticism.

Frequently Ford found himself returning with fresh insight to the original naturalistic principles of the New Sculpture with works like 'Peace' (77) of 1890, where the ungainly pose of the girl marked an unchallenging acceptance of the truth of nature. At his best, however, Onslow Ford journeyed beyond the conceptualism of 'Peace' to the pure sculptural poetry of 'A Study' (78), which must be placed amongst the finest European bronzes of the century. The use of the bust in this way was inspired by the Florentine Renaissance, also a favourite source of Gilbert's, and indeed the revival of this kind of full expression in the hand-cast bronze has a natural precedent only in the fifteenth and sixteenth centuries. Although Ford used his young daughter as a model, the bust implied a generalised grace and beauty without allowing the physical reality of flesh and feeling to be lost in stylised idealism. As this essay concentrates on small-scale bronzes, there is a danger of misrepresenting an artist's mien and it must be remembered that Ford was also capable of producing the Shelley Monument, the powerful Romanticism of which caused a sensation at the exhibition of the model in 1892.

Harry Bates (1850–99) was hardly a 'young blood' when he came to public notice in 1885, but he had been a late recruit to the fine arts, having graduated via the Lambeth School in 1879 from an apprenticeship at Farmer and Brindley. The 'Homeric' reliefs of 1885, however, caused a considerable stir, for their low-relief sweeping contours anticipated important things to come, their distinction being the foundation on pure Greek principles 'instinct with the vitality of modern feeling' (Gosse). While working in Paris between 1883 and 1885 Bates had studied under both Rodin and Dalou, and although his work could never compare with these great masters the French influence was often strong, as in 'Peace' (79) of 1888 in which the roundness of the faces and the strength of physical composition had a specially continental character. But, like many contemporaries, Bates maintained a refreshing variety of interests, producing in 1889 a modern-antique, vociferous 'Hounds on a Leash', contrasting with his lively carving of the façade of the Institute of Chartered Accountants with art-nouveau scrolls surrounding romantic busts.

Not all the young sculptors who responded early to the wider range were able to sustain their growth, but nevertheless sculptors like Henry Pegram (1862–1937) did help bridge the gap into the nineties by their ardour. From 1887 to 1891 Pegram had the good fortune to be working with Hamo Thornycroft, but nevertheless his 'Ignis Fatuus' (80) was a distinctive personal triumph on its Royal Academy début in 1889, when it was purchased for the nation with the Chantrey Bequest. This kind of turbulent relief work had been taken up with advantage by Gilbert with 'Post Equitem Sedet Atra Cure' in 1887, but Pegram always retained his individualistic symbolism – one of the reasons, no doubt, for his gaining of a silver medal at the Paris 1900 exhibition.

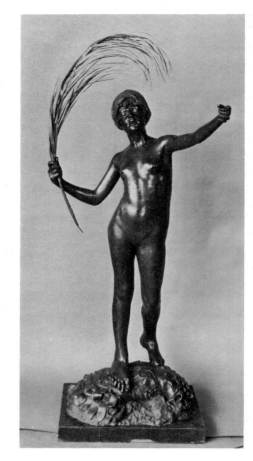

77 Ford then quickly became a leading figure in the revival of the naturalistic bronze, but, as in 'Peace', never without the expression of an ideal or a personal feeling.

78 'A Study', exhibited by Onslow Ford in 1897, was one of the most successful works of the whole period in its perfect combination of realism with idealism.

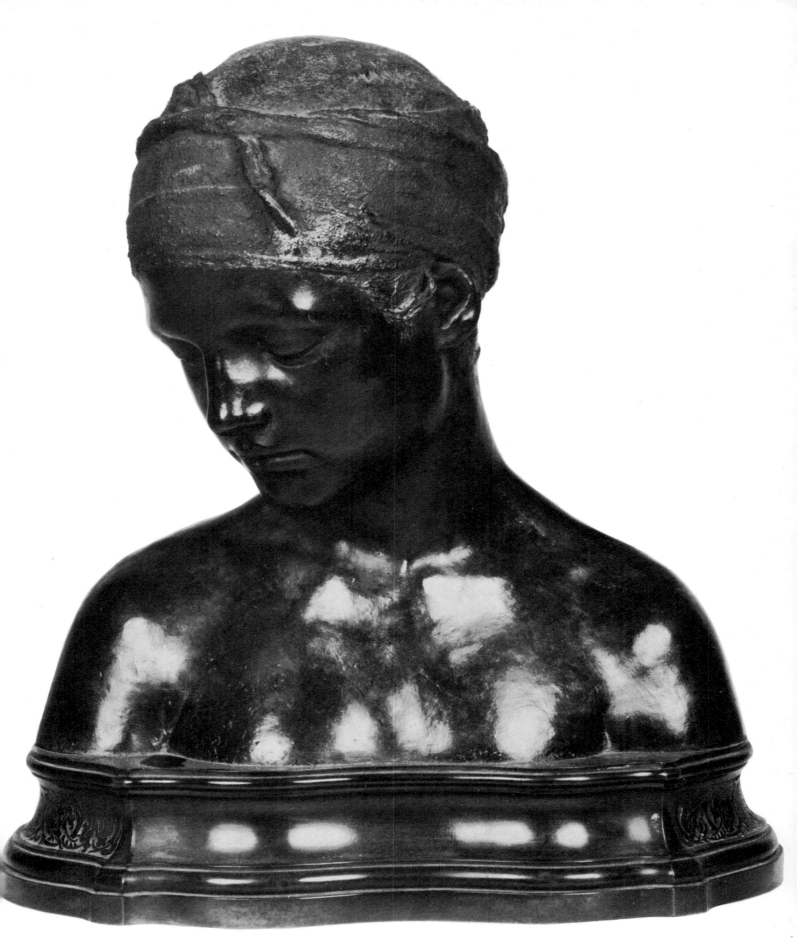

By 1890 the New Sculpture had begun to consolidate its activities along certain defined paths, many of which no doubt stemmed from Alfred Gilbert but progressed faster in the hands of sculptors most closely involved with one particular aspect or another. Gilbert himself had been an energetic campaigner for the revival of craft involvement by the sculptor, and according to Gosse his 'Icarus' of 1884 was the first revival of lost-wax methods for the casting of a major work in England, but George Frampton (1860–1928) was to become the actual leader of the craft sculptors. Arguments for the value of craft standards in the fine arts can be traced far back into the century to Ruskinian philosophies and their practical resolution by William Morris and his associates from 1860 onwards. The establishment of modelling classes at the Lambeth School, previously devoted entirely to the crafts, was a significant move, and then the foundation of the Art Workers Guild in 1884 really set the movement firmly on its feet. Sculptors and metalworkers studied and worked together to give sculpture in bronze a true technical quality and to increase the variety of materials and methods used by interested sculptors.

George Frampton's interest in mixed materials was fostered during the years spent in Paris with the Royal Academy Travelling Scholarship of 1887 where he also imbibed the novelties of French Symbolism, and the breadth of his catholic taste was revealed finely in 'Mysteriarch' (81) at the Academy in 1893. This polychrome plaster still exerts that haunting presence often achieved by an artist like Frampton who worked slowly towards chosen ends; the same kind of impression was given by 'Mother and Child' of 1895 but with yet greater sophistication. The latter was a quite sensational object, being fashioned from silvered bronze against a copper plaque with a white enamelled disc in the centre, and as well as the combination of materials Frampton achieved a fusing of styles as the dashing realistic portrait group assumed mystical airs through its exotic forms and materials.

Frampton always maintained strong links with the craft movement in England, becoming joint principal with the architect W. R. Lethaby of the LCC Central School of Arts and Crafts in 1894, and often contributing to the Arts and Crafts exhibitions. Typical of such pieces were a pair of silver relief panels, 'Music' and 'Dancing' (82), which were later exhibited as door panels in composition in 1895 although they had originally been conceived in 1894 in these delicate flowing forms of silver relief where Frampton's pure craftsmanship flourished in the intricate details in the bodices of the two dancers. As with many talented sculptors, Frampton's work regularly defies confinement to narrow stylistic definitions. Although he was renowned for craft-orientated decorative schemes, he can also be linked securely to the Symbolist movement in Europe, for much of his work involved the visionary expression of personal dreams. His Symbolist character can be seen clearly even in 'Dancing', and particularly in the right-hand figure which has a dreamlike quality in the facial expression and silky, airborne body.

But then again Frampton was capable of marvellous character studies such as his memorial plaque to the actor Charles Keene (83) in which direct naturalism took the place of personal fantasy, and Symbolist sym-

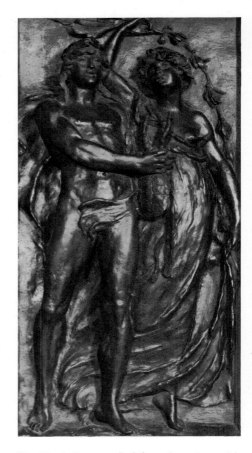

79 Harry Bates studied for a short time with Rodin in Paris and brought a European flavour to 'Peace' of 1888.

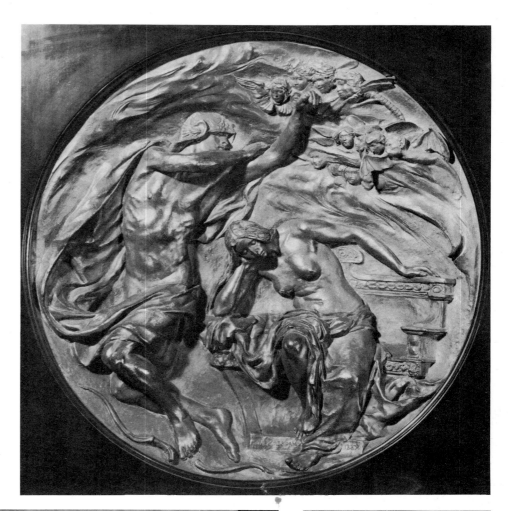

80 'Ignis Fatuus', 1889, by Henry Pegram, successfully followed Gilbert's experiments with this turbulent high relief style in bronze.

81 (*right*) George Frampton was one of the few English artists to take part in the Belgian Symbolist movement, a taste which he brought to his 1893 RA exhibit, the polychrome plaster 'Mysteriarch'.

82 (*far right*) Frampton also forged strong links with the Arts and Crafts movement in England and was capable of exquisite technique, as in the silver relief of 'Dancing'.

CHARLES KEENE

BORN AVG 10 ...
DIED JAN 4 ...

83 This relief portrait of the actor Charles Keene showed Frampton in a more straightforward but equally imposing mood.

pathies were confined appropriately to the small figurative finials. Frampton's best-known work is probably the Peter Pan statue by the Serpentine in Kensington Gardens, the bronze statuette illustrated (84) being a reduction of the central figure; even as late as 1921, the date of this cast, Frampton preserved his association with early principles of the New School, namely poetic realism, seen most clearly in the soft gangling legs of the young boy. In fact the spirit of the whole composition looked backwards towards the 'faery' themes of the 1860s rather than forwards to the fierce symbolism of more modern movements.

One of the earliest sculptors to join the Arts and Crafts movement had been Frederick Pomeroy (1856–1924), who had exhibited at their first exhibition in 1888, and indeed experimented widely in craft activities

84 Frampton's best-known and best-loved work is the 'Peter Pan' statue beside the Serpentine in Kensington Gardens, from which this is a reduction dated 1921.

85 William Reynolds-Stevens was the other leading craft member of the New Sculpture group, and his 'Guinevere's Redeeming' dwelt on a favourite Arthurian theme.

including in 1896 the production with H. Wilson of a Gothic Revival lectern. In the 1880s and 90s Pomeroy designed numerous architectural decorative schemes for J. F. Sedding, an occupation which led to a certain amount of independent polychrome plaster figures, although he later turned to more traditional sculptural roles with a Gilbertian bronze Perseus (30) in 1898 and a number of idealised female figures similar to those of Lucchesi.

But by 1900 there was a tendency to specialisation even in craft circles and so the amazing variations in styles and techniques of Sir William Reynolds-Stevens (1862–1943) became something of a rarity as well as a constant delight. Like Swan, Reynolds-Stevens was a late developer, concentrating initially on painting, and in 1887 he carried off Academy prizes for both painting and sculpture; but in the nineties his interests wandered yet further afield as his exhibited works included a stylish dining table full of Mackintoshian invention, a flowing art-nouveau altar front and a silver bonbonière. His first significant piece of sculpture to be exhibited was 'Youth', seen at the Royal Academy in 1896 and rightly considered to be the only rival to Frampton's similar work, being executed in bronze and copper inlaid with silver. Frampton had led the English into the European Secession movement, but few followed, and so it was a significant distinction for Reynolds-Stevens as a young man to be awarded a gold medal in Vienna for 'Youth' and election to honorary membership of the Viennese Academy.

Reynolds-Stevens was praised in a *Studio* article of 1899 for his stylistic independence and sensitivity in avoiding intellectual indulgence in his iconography, one of the principal English criticisms of the European Symbolistes. Nevertheless, 'Lancelot and the Nestling' of 1899, in bronze and ivory, had much in common with sculpture of Jean Dampt's such as 'Le Baiser du Chevalier' where the medieval romanticism was given a similar strongly personal interpretation in mixed media. The companion pieces 'Guinevere and the Nestling' and 'Guinevere's Redeeming' (85), received an even better reception in England, for they were imbued with a glowing humanity that transcended the inherent mysticism of the subject.

In discussing the Craft branch of the New Sculpture it is difficult to know exactly where to stop, for so many artists in the field qualified as sculptors; however, our attention here is focused on sculptors in bronze and so the marvellous enamel creations of Alexander Fisher (1864–1936), the popular pottery groups of George Timworth (1843–1913) and the polychrome plasters of R. Anning Bell (1863–1933) must sadly be ignored. But although the craft tradition grew strong through the agencies of the Lambeth School of Art and the Art Workers Guild, this discipline was by no means all-consuming, for a number of sculptors reacted against its less idealistic decorativeness, which in a certain sense had diverted the main stream of the New Sculpture.

W. Goscombe John (1860–1952) was perhaps a surprising rebel against craft emphasis, for his creative training started in assisting his father with the carved decoration of Cardiff Castle under the direction of the medievalist William Burges, and after this he was sent to the Lambeth workshop of Thomas Nicholl in 1882. But this humble background did not

prevent young John becoming one of the best historically educated sculptors of his generation, for his Royal Academy training was combined with extensive travel-study throughout Europe. Marion Spielmann in 1901 particularly admired John's 'love of purity and refinement of nature' and no doubt 'Muriel' (86) of 1896 was in his mind, for the quality of this bust approaches Ford's 'Study' (78) as both bronzes captured the human essence of their models. Like all the best sculptors of this period, Goscombe John was at ease in a number of techniques and the small relief portrait of his artist friend Eva Roos Vedder (87) also gave a delightful feeling of intimate communication both between artist and sitter and between artist and public. His first significant Academy exhibition had been the purely naturalistic 'A Boy at Play' in 1895, and the two works illustrated here might suggest a total dedication to naturalism, but John was also capable of broad romantic composition such as 'A Drummer Boy' (88). The illustrated reduction from a war memorial to the King's Liverpool Regiment (1904) possesses an appealing romantic pathos, and the technique itself is far freer, reflecting for once John's period of study under Rodin from 1890 to 1891.

Andrea Carlo Lucchesi (1860–1924) made a similar rejection of a craft upbringing, for by the time he left the RA schools in 1887 there was little trace of his earlier activities on the decorative craft side for the silversmiths Garrard and Elkington. On the contrary, Lucchesi took up New Sculpture ideals with enthusiasm in the 1890s and is reported in the *Magazine of Art* (1899) to have said 'nature for everything . . . I also consider the female

86 Goscombe John came from a craft background but turned towards more classical expressions, although his 'Muriel' of 1896 retained a great natural charm.

87 The same kind of intimacy was achieved by John in his relief portrait of the painter Eva Roos Vedder in 1898.

88 Like other sculptors of the period, Goscombe John was capable of wide variations of style and sentiment, including the simple emotionalism of the 'Drummer Boy' of 1904.

figure nature's masterpiece'; unfortunately much of his sculpture involved an insipid idealisation of the female form and only when the Gilbertian influence was at its strongest, as in 'Destiny' (89) of 1895, did his work really impress.

All the same, remarkably few sculptors of distinction seemed to survive without competing for the financial benefits of training at the Royal Academy; Albert Toft (born 1862), Charles John Allen (1862–1955) and William Colton (1867–1921) were three exceptions. Toft is an interesting sculptor, for the quality of his work remained so inconsistent, although as a young man he was considered to have real promise after serving an apprenticeship with Wedgwoods and studying under Lanteri at South Kensington. Indeed some of his work was most imposing, with his 'Mother and Child' (1897) being one of the few English answers to Dalou, and then 'The Spirit of Contemplation' of 1900 achieved real distinction in the beautiful, brooding nude girl with Mucha-like head, seated on an arresting art-nouveau throne. After 1900 Toft's work too often degenerated into hack portraiture or weak symbolism, but he could always sur-

prise with a powerful work such as the marble 'Peace' (90) of 1920. Charles Allen's principal training was received at the Lambeth School where he arrived after apprenticeship with Farmer and Brindley, in whose service he was involved in producing the wood carvings for Eaton Hall and for the liners *Britannic* and *Majestic*. In 1894 Allen became Teacher of Sculpture at Liverpool School of Art and naturally held much sway locally, and many of his statuettes had a genuine artistic grace in the Gilbertian mould.

William Colton did not study at the Royal Academy but he brought his Lambeth experiences to the RA as Professor from 1907 to 1910 and 1911 to 1912. Colton was often thought to have a Parisian spirit, and certainly 'The Girdle' of 1898 possessed the sensuality of fashionable French sculpture. On the other hand, 'The Image Finder' of 1899 and 'The Spring-Tide of Life' (1902) both carried the stamp of individual naturalism peculiar to the New Sculpture in England. However, some English sculptors openly professed allegiance to the French principles, and none more than Alfred Drury (1856–1944), who actually followed Dalou to Paris to work by his side from 1881 to 1885. Drury was perhaps over-reliant on inspiration from Dalou in the early days, as his 'Triumph of Silenus' (1885) even copied the Frenchman's subject as well as style, but in England he gradually

A large painted spelter Nubian figure, inferior in quality to the bronze original but typical of French decorative taste of the period 1850–1880. (*Sotheby's Belgravia*)

89 (*below right*) Andrea Lucchesi considered the female figure to be the highest natural form, and 'Destiny', 1895, was typical of his work.

90 (*below left*) Albert Toft was looked upon as a promising young sculptor in the 1890s, but this promise was only occasionally fulfilled in later work such as the marble 'Peace', of 1920, part of a war memorial.

Jules Dalou first found the freedom to develop his simple naturalistic style while in exile in England from 1871, one of his earliest works of this period being 'La Boulonnaise', from which this bust was taken. (*Sotheby's Belgravia*)

built his personal reputation for graceful competence in the fields of portraiture and decorative statuary; only occasionally, however, did he live up to his master's example with works such as 'A Young Bacchanal' (91), which exhibited great formal strength controlling a confident freedom of expression.

Drury's 'Circe' (92) could not compare therefore with the handling of the same subject in 1893 by another Francophile, Bertram Mackennal (1863–1931). The latter's 'Circe' (93) received honourable mention in the Paris Salon of 1893 but the prudish RA Committee insisted that, for the sake of propriety, the base be covered for the exhibition the following year, and even then it 'drew wondering and admiring eyes'. Mackennal was born in Australia but spent most of his working life in England where his five

92 (*right*) Alfred Drury's 'Circe' was originally exhibited in plaster in 1893 and in bronze in 1894; this large version was purchased at the time by the City Art Gallery, Leeds.

91 The French influence in England after Dalou's departure in 1880 was carried on by his assistant Alfred Drury, whose 'Young Bacchanal' showed inevitable indebtedness to the master.

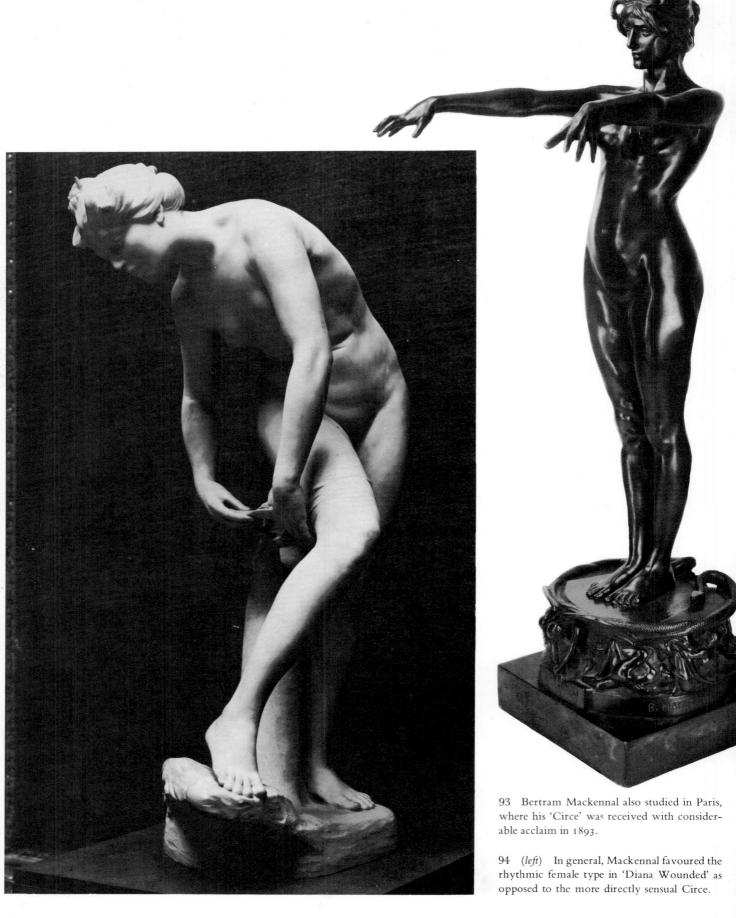

93 Bertram Mackennal also studied in Paris, where his 'Circe' was received with considerable acclaim in 1893.

94 (*left*) In general, Mackennal favoured the rhythmic female type in 'Diana Wounded' as opposed to the more directly sensual Circe.

years of study in Paris in the 1880s distinguished him from most of the native sculptors. Indeed 'Circe' communicated an open sensualism that was better appreciated in Paris. However, the threatening symbolism of works such as 'Circe' and 'She Sitteth on a Seat . . . in the High Places of the City' was exceptional, and Mackennal turned more often to robust female types such as 'Diana Wounded' (94), a type he even used in allegorical subjects such as 'The Metamorphosis of Daphne' [p. 143]. Indeed the maintenance of links with Europe was by and large left to minor figures like H. C. Fehr (born 1867) and F. M. Taubman (born 1868) who together with Frampton were the only English sculptors at the Brussels 'Libre Esthetique' Exhibition, where figures like Taubman's 'Snakegirl' (95) stood a better chance of success.

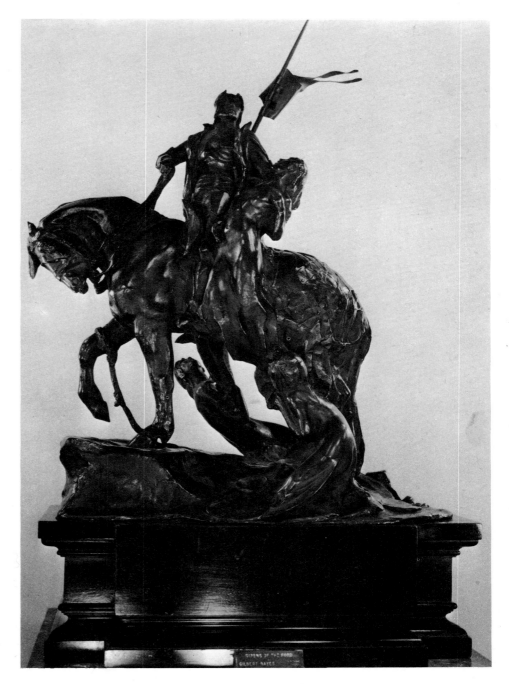

95 F. M. Taubman exhibited with Frampton and Fehr at the Brussels 'Libre Esthetique' where bronzes like 'The Snakegirl' were more successful than in England.

96 Gilbert Bayes may have received inspiration from Europe for his romantic 'Sirens of the Ford', 1899.

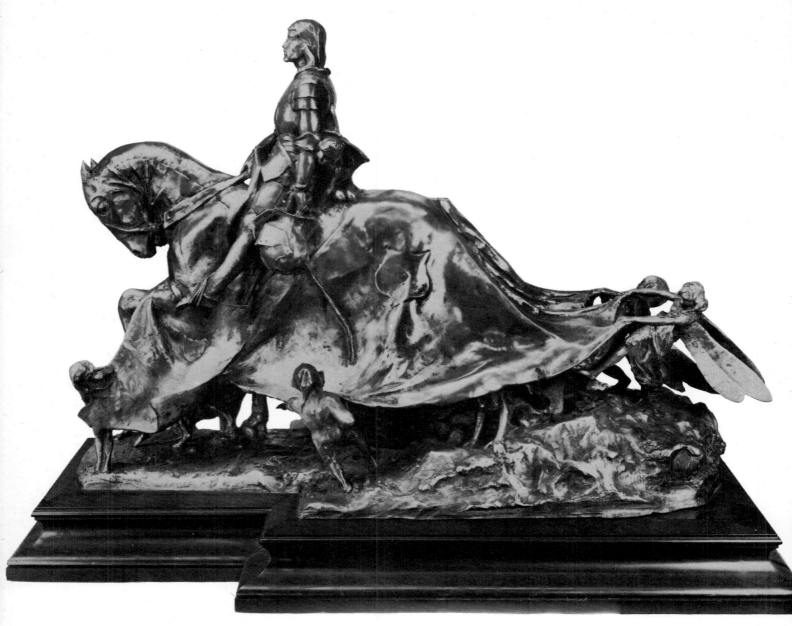

97 'Knight Errant', 1900, on the other hand, showed Bayes giving expression in sculptural silver to English fairy myths.

Gilbert Bayes (1872–1953) was also suspected of illicit continental sympathies, having followed his three years at the RA Schools, 1896–9, with intensive study in Paris and Italy, and certainly 'The Sirens of the Ford' (96) could not have been totally English in its stylistic origins, although the heavy modelling was more Belgian than French. But then again Bayes' silver 'Knight Errant', dated 1900 (97) partook wholly of English Romantic traditions as well as fitting in with craft concepts in the employment of a variety of materials; and at this time Bayes also executed a number of traditional works in silver and designed bronze- and copper-mounted furniture. Bayes' work [p. 35] was considerably more varied and individualistic than that of another young sculptor, Francis Derwent-Wood (1871–1926), whose exhibits in 1903 reminded a contemporary critic of one French master after another, a comment which suggested his slavish worship of the French while assistant to Legros at the Slade from 1891 to 1892 followed by a spell in Paris from 1895 to 1897. But despite acknowledged associa-

tions with the work of Rodin this bronze group of 'Motherhood' of 1905 [p. 17] had a forceful originality when set amongst English sculpture.

However, another artist, Charles Ricketts (1866–1931), in fact claimed to be the only English sculptor to understand Rodin, and this claim was substantiated to a certain degree in the bronzes produced during his short period of sculptural activity from 1901 until 1911. Ricketts was close to the centre of *fin de siècle* artistic society, and his designs for Oscar Wilde's poem 'The Sphinx' were the visual epitome of the age in their sophisticated forms and their esoteric, almost weird, iconography. The New Sculpture as a whole had a robustness that protected its principal members from the death-wish imagination of the full *fin de siècle* aesthetic, and therefore the work of Ricketts was left on a sculptural limb when following a favourite

98 Charles Ricketts claimed to be the only Englishman to understand Rodin, but his own sculpture often veered from the directness of Rodin towards esoteric fantasies like 'Salome'.

100 Wells was a highly independent artist and his 'Young Child' might almost have been modelled without any intention of public production.

Beardsley theme like 'Salome' (98). On the other hand, some bronzes exhibited at the Carfax Gallery in 1906 had real physical power communicated by impressionistic means. 'Laocoon and his Sons', amongst others, was a great deal more imposing than most of the bronzes of a more dedicated follower of New Sculpture ideals, Reginald Fairfax Wells (1877–1951), who preceded Ricketts with a one-man exhibition at the Carfax in 1908. Nevertheless, Wells improved rapidly and his 'Putting the Weight' (99) of 1908 was a true portent of the future; even his handling of a comparatively sentimental subject, 'The Young Child' (100), showed a liking for rough monolithic forms, in partial contrast to the basic tenets of the New Sculpture. Indeed the school did not really outlive World War I with any confidence, although an artist such as William Reid-Dick (born 1879) continued to work with considerable dexterity along the established lines with pleasing works like 'Boy with a Sling' (101).

Inevitably the life of the New Sculpture was short because it was founded on a rearrangement of ideals that had first been discovered at least two decades previously in Europe. Then the war came to break the continuity of development in all the arts over most of Europe, and by the time things had settled down again the arts had plunged irrevocably into abstract expression, and the modern movement had begun. But during its contracted thirty-year span the New Sculpture succeeded in transforming the attitude to sculpture of both the academics and the general public in England; it did this by returning to healthy naturalism as the formal basis for appealing personal fantasies, and by developing enthusiastically the qualities of the bronze statuette.

101 William Reid-Dick carried the 1890s traditions bravely into the post-war period with competent works like 'Boy with a Sling'.

3 American Romantic Bronzes

As a native American school of sculpture scarcely existed prior to 1825, a discussion of American nineteenth-century bronzes immediately assumes a completely different character to the previous chapters. The European sculptors, if they did not necessarily benefit from, were at least profoundly influenced by the powerful cultural traditions and visible sculptural record of their nations' history, but although American sculptors naturally relied on the example and teaching of Europe they largely began from different premises and proceeded with novel aims.

As ever, the social and political background forcibly imposed itself on the course of the aesthetic development of an art form which lived on the public display of its creations, and the whole ethos of nineteenth-century America was faithfully reflected in the work of her true sculptor sons. The United States has mantained a thundering pace of development from the establishment of a free political democracy in 1789, but until well into the twentieth century the public morality of the country remained relatively true to the original clauses of the Constitution. The overall impression of the artistically aware American of the 'Victorian' era involves a self-conscious, Lincolnian pride in the pioneering purity of the New World when compared with what they thought of as stagnant decay in the Old. Initially this morality expressed itself in visible form in the bold naturalism of their statuary and in the choice of contemporary subject-matter for public monuments, as opposed to the historical allegory popular in Europe.

If a single distinctive characteristic of 'American Romantic Bronzes' is to be chosen then 'naturalism' must be the choice, and this was of course one of the principal ingredients of the European Romantic movement.

In the first two decades of the nineteenth century all the public commissions for sculpture in America went to famous foreigners such as Canova, Chantrey or their followers, but few of these sculptors even visited the States, and those who did echoed the Frenchman Etex's opinion that 'il n'y a rien à faire en Amérique pour la véritable artiste'. But before the responsibility for these commissions could be given to native Americans, the sculptors required time to study the forms and aesthetics of the Neo-Classical masters whom they wished to displace. Horatio Greenough (1800–52) was the first American to take up the challenge and follow a

career in sculpture with a full understanding of the established concepts of his chosen art form, and indeed his undertaking of a monumental statue of Washington for the Capitol in 1832 was the first significant government commission given to an American. Regrettably, the unveiling in 1841 of his seated figure of the first President, bare-chested in Roman imperial pose, was greeted with bawdy jokes instead of deserved admiration for what can be seen now as a Neo-Classical image of heroic fortitude to compare favourably with the work of Houdon, Canova and the previous heroes of Capitol sculpture. Greenough had already visited Italy in 1824, but in 1828 he settled permanently in Florence, returning to America only occasionally to canvass for further commissions; however, neither his portrait busts nor 'ideal' or 'literary' works slavishly conformed to Neo-Classical strictures and a healthy awareness of contemporary man always enlivened his otherwise traditional marble sculpture.

But inevitably the small band of expatriates in Italy fell more and more under the spell of Canova, Thorwaldsen and their pupils; in the case of Hiram Powers (1805–73) this led to the establishment of an international reputation, but sadly the general effect on American sculpture was to draw off a substantial proportion of their talented artists throughout the nineteenth century into expressions of dull, marble classicism that ignored the main streams of sculptural development. At the time the success of Powers' 'Greek Slave' (102) at the Great Exhibition in London in 1851 added considerable prestige to American sculpture, and on its first visit to the States in 1847 the potentially offensive nudity of 'The Greek Slave' was excused by the Christian virtues thought to be shining through the image of innocence threatened by the heathen Turks.

The positions of Powers in America and Gibson in England were stylistically similar, but where Gibson was the last important English sculptor to gravitate permanently to Italy, Powers was one of the first Americans, and he was followed by a whole generation of sculptors; still working there in the third quarter of the century, their devotion to basically Neo-Classical expressions in marble disqualifies them both from inclusion in our discussion of Romantic bronzes and from participation in the real developments of the period's sculpture. People like William Wetmore Story (1819–95), Chauncy B. Ives (1810–94), Randolph Rogers (1825–92) and Harriet Hosmer (1830–1908) all worked in Italy, but back at home the demand for traditional portraiture kept even more sculptors like S. V. Cleverger (1812–43) and E. A. Brackett (1818–1908) busy producing naturalistic yet overtly classical busts right up till the end of the century.

In the context of the Romantic bronze, however, one of these sculptors commands a position in America almost equivalent to that of David d'Angers in France. In 1835 Thomas Crawford (1813–57) was the first American to settle in Rome, as opposed to Florence, and his highest aim always remained in the realm of ideal sculpture. Indeed, the special exhibition in 1844 at the Boston Atheneum of his 'Orpheus' marked the first public display of an ideal work by an American sculptor. But in order to earn a living Crawford was forced to undertake the more lucrative commissions for portrait busts, and these constitute the first body of work by an American sculptor to respect the spirit of Romanticism. Most notable

102 Hiram Powers' 'The Greek Slave' was begun in Florence in 1842 and the first of its many contemporary triumphs was at the Great Exhibition in London in 1851.

103 Thomas Crawford had settled in Rome in 1835 and executed this typical mid-Victorian piece, 'The Babes in the Wood', in 1851.

of these, perhaps, was the bust of his young patron Charles Sumner in 1839, which captured superbly the sensitive intellectual personality of the sitter. The only other bust of the period to rival this was Powers' portrait of President Jackson of 1837 with its deep-lined realism, but this naturalistic bust was unique in Powers' work, and in any case Crawford's 'Sumner' also characterised the inner man, an essential quality of Romantic portraiture.

As with many early Victorian European sculptors, Crawford's Romanticism sometimes keeled over into sentimentalism, although even then 'The Babes in the Wood' (103) of 1851 was an unusually imaginative subject for an American despite its clichéd popularity in England. However, it was two monumental projects of Crawford's that raised American sculpture into Romantic awareness, the Washington Equestrian Monument commissioned for Richmond, Virginia, in 1849 and the Senate sculptures of 1853, both of which remained unfinished at his early death in 1857. Neither the details nor the overall design of these projects are immediately outstanding, but two particular features drew these works beyond contemporary American sculpture, firstly the sheer monumentality of conception requiring a creative energy previously unknown amongst American sculptors, and secondly the fact that much of the work was cast by the German founder Von Muller in bronze, the new medium of the Romantic sculptor.

All the same, American Romantic bronzes have far earlier antecedents than Crawford, indeed the line of development came more directly from

the native American wood-carvers of the late eighteenth century and thence through the stay-at-home sculptors of the 1830s. For although those sculptors who had followed Horatio Greenough to Italy may have contributed by raising the tone of American sculpture to an awareness of loftier aesthetic possibilities, their actual stylistic contribution was positively retrograde in prolonging inapplicable classical dogma.

On the contrary, the best of American nineteenth-century sculpture had its roots firmly in its own 'New World', the most notable example of native wood-carving being the remarkable pine figure of George Washington executed in 1814 by William Rush (1756–1833). The robust self-confidence of this full-length, flowing figure was carried on in spirit by a group of artists active from about 1825 onwards whom A. T. Gardner irrevocably labelled 'Yankee Stonecutters'. John Frazee (1790–1852) was the influential leader of this group who, while preferring clay or plaster, did take the chisel to marble and developed an uncompromising directness in the execution of portrait busts and private funerary monuments. But even with Frazee, sculpture still remained a craft rather than an art form.

While from Italy Hiram Powers established American sculpture on an international footing, it was left to those sculptors who remained at home to translate the stylistic vitality of the Yankee Stonecutters into a true art form, and the task was begun magnificently by Henry Kirke Brown (1814–86), Erastus Dow Palmer (1817–1904) and Clark Mills (1815–83). The work of these three developed almost entirely free from Neo-Classical influences, and their outstanding achievements were two equestrian portraits, the first by H. K. Brown of Washington, the other by Clark Mills of General Jackson. The Washington, strangely, was commissioned jointly from Brown and Greenough in 1851, before the latter died in 1852. This statue was completed in 1856 in the novel medium of bronze by Brown, whose first experiments in bronze had been with the De Witt Clinton statue cast by the Ames Manufacturing Company in Chicopee in 1852. Ames were specialist arms founders, but with the help of visiting French experts they made a success of the enterprise and undertook the arduous task of founding the equestrian statue for Brown. Compared with Europe's heritage of such figures, the equestrian Washington appears stiff and unimaginative, but it nevertheless stood proudly as an image created in the grand Romantic manner. Clark Mills' 'General Jackson', although less famous was not only America's first native equestrian statue to be unveiled, in January 1853, but also totally 'original and American' in style with the bold, rearing charger controlled by the securely seated figure of the New Orleans veteran. Of yet further distinction was the energy with which Mills designed and built his own foundry in Washington to produce the group, and indeed by 1855 he was casting small bronze replicas of the General Jackson, these being amongst the earliest patented reproductions in bronze in America.

During the 1850s the Romantic bronze statuette finally began to take over in America from the plaster or marble copy, and indeed Thomas Ball (1819–1911) first came to the public's notice through C. W. Nicholl's publication of bronze reductions of his first full-length statue in 1853. Although Ball failed to endow Daniel Webster (104) with the universal

104 C. W. Nicholl's reductions from 1854 of Thomas Ball's 'Daniel Webster' were amongst the earliest American editions in bronze.

dignity intended, the result was nevertheless most encouraging for a young sculptor. Indeed, the general effect was as good as, if not better than, the similar contemporary work by Sir Edgar Boehm (56), Sculptor in Ordinary to Queen Victoria. Ball went on to become a prolific decorator of the American scene with monumental statuary in the 1870s and 80s, for his uncomplicated naturalism presented an inevitable appeal to the practical approach to life of the ever-advancing commercial and professional classes. John Rogers (1829–1904), however, concentrated almost entirely on the production of small genre groups in clay, designed specifically for mass manufacture in bronze.

Rogers had begun modelling small clay figures as pure relaxation in the early fifties but in 1858 he decided to extend his artistic horizons by a visit

105 John Rogers modelled specifically for commercial reproduction in bronze, and 'The Council of War', 1868, was typical of his contemporary subjects.

106 'The Indian Hunter' of 1864 was both
J. Q. A. Ward's and America's first successful
excursion into comprehensively Romantic
sculpture.

to Paris and then Rome, where he briefly entered the studio of the English
Neo-Classical sculptor Spence. But Rogers found little to please him in the
affected intellectualism of European sculpture and returned forthwith to
his own unique, yet quintessentially American handling of contemporary
genre, one of the most admirable being 'The Council of War' (105),
originally produced in 1868, but like most of Rogers' popular pieces re-
produced for many years after in plaster as well as bronze. Many of Rogers'
subjects, particularly the historical scenes, now seem worthless examples of
commercial sentimentalism, but at the time they were considered to have
been created, in the words of that leading political preacher Henry Ward
Beecher, according to 'the true and highest Artistic principles'.

During the third quarter of the nineteenth century, however, American
sculpture advanced along other lines more significant than the mere tech-
nical facet of bronze usage, for John Quincy Adams Ward (1830–1910)
succeeded in bringing a feeling for narrative drama and stylistic vigour to

the admirable but unimaginative realism of the native Yankee style. Ward, as H. K. Brown's assistant, had benefited from a share in the excitement of producing the equestrian portrait of Washington, but the completion in 1864 of his own first independent 'ideal' work was an event of considerably greater importance in the development of sculptural style in America. 'The Indian Hunter' (106) still holds some of the immediate appeal manifested at the time, for not even the over-idealised imagery can hide the true sense of movement and purpose which the group communicated. The impression of wider aims gained from Ward's work is confirmed by his forceful theoretical opinions, which supported whole-heartedly the native brand of American naturalism, opposing the stagnant academicism of European sculpture, but also insisted that 'the true significance of art lies in its improving upon nature' (J. Q. A. Ward in *Harper's*, June 1878). This attitude can be seen in the commissions Ward received for commemorative groups to wartime heroes, although his most successful public monument must surely have been the Beecher Memorial in Brooklyn of 1891 with the sturdy realism of the central figure and lively invention of the three supporting studies.

Although Ward and the other two best-known sculptors of this period, Anne Whitney (1821–1915) and Martin Milmore (1844–81), all worked on successfully into the last quarter of the century, they were overtaken by a younger generation of sculptors who brought to America the breakaway ideals of the post-Carpeaux French school. Despite such a short-lived ascendancy, however, Ward and his contemporaries had made the essential contribution of instilling external vitality into the Puritan naturalism of New World Sculpture and thus preparing the ground for the full romantic release of the eighties.

The development of American sculpture had continued along parallel paths to that in England, and indeed the work of J. Q. A. Ward and his contemporaries even improved on the English equivalent by its thoroughly healthy naturalism. And in the next stage the Americans, like the English, also turned to Paris for inspiration from the revolutionary example of Carpeaux, Dalou and eventually of Rodin also; if Augustus Saint-Gaudens was America's Gilbert, D. C. French her Hamo Thornycroft, then William Rimmer must assume the Stevens role of visionary hero, and it is to the latter we must turn first.

Although William Rimmer (1816–79) started modelling in the 1830s he did not take up the sculptor's profession exclusively until Stephen H. Potter, a Bostonian patron of the arts, discovered the revolutionary merits of his work and commissioned the 'Fallen Gladiator' from him in January 1861. As with Alfred Stevens in England, there was no sculptor in America who could be spoken of in the same terms as Rimmer, who with the 'Fallen Gladiator' and the 'Dying Centaur' (107) of 1871 made sculptural statements of a physical and emotional intensity that can only be compared with the work of Rodin himself. But although Rimmer was stylistically isolated his artistic theories reached a wide public through various publications in the 1870s, and then his magnificent record as a teacher and lecturer on anatomy in New York and Boston put him into direct contact with the young lions of the future.

Theodore Géricault, one of a series of portrait medallions of famous contemporaries produced privately by P. J. David d'Angers from 1828 until his death in 1856. (*Sotheby's Belgravia*)

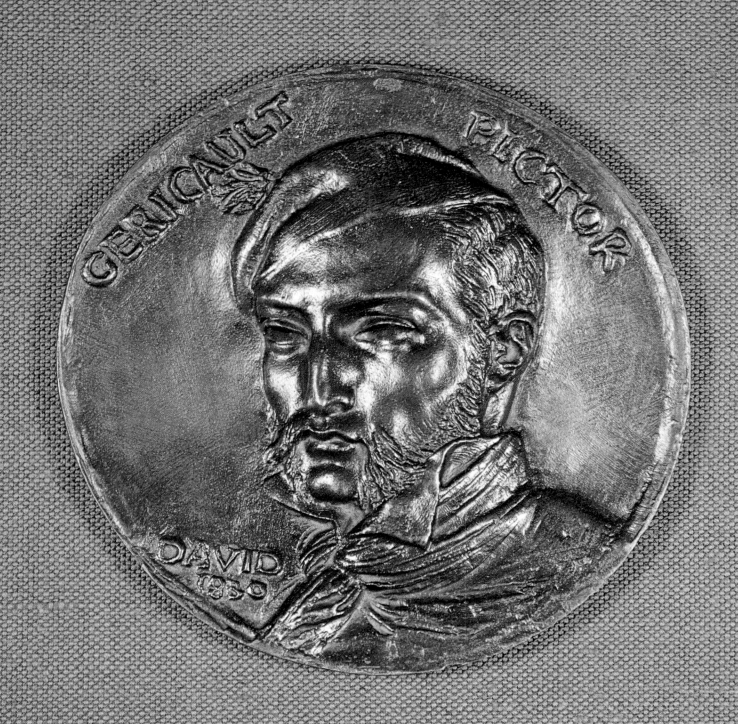

Entitled 'Le Cheval a La Barrière', this piece by
P. J. Mène was originally modelled in 1848.
(*Sotheby's Belgravia*)

107 William Rimmer was something of a visionary in American sculpture, and works like 'The Dying Centaur' of 1871 stand alone in their forcefulness of expression.

Although Daniel Chester French (1850–1931) spent only a few months in Boston with Rimmer he always admitted to the lasting influence of the latter's disciplined teaching, which may indeed have dictated French's decision to transfer his studies to the traditional base of Italy from 1875 to 1877, instead of to Paris which had already become the centre for the American sculptors' European pilgrimage. French's traditional yet notable success, the 'Minute Man' of 1874, was followed on his return home by a series of portrait busts and statues which clearly define the aesthetic transition which was also made at the same time in England by the practitioners

of the New Sculpture, a transition from fettered realism to the free-flowing inner expressions of the genuine Romantic bronze. This new aesthetic was admirably illustrated in Daniel Chester French's portrait of the writer 'Ralph Waldo Emerson' (108); on confrontation with the bust in 1879 Emerson was supposed to have remarked 'that is the face I shave', the inference of this much-quoted remark being that the bronze not only looked like him but actually felt like him. This, then, was the vital spark previously lacking in American sculpture, the spark of real inner life as opposed to mere external physical realism.

In 1886 French finally went to Paris which had already been his absent source for many ideas, to return a year later under the spell, almost inevitably, of the allegorical monumentality of Dalou, and for the next thirty years French worked continuously on public monumental commissions and private memorials which, while lacking the genius of Dalou, possessed more vigour and imagination than the work of others from that last generation of French sculptors who also lived on into the twentieth century unmoved by the modernism of Rodin. In earlier years the Americans had consciously dissociated themselves from any sculptural ideals of the Old World, but as European concepts had changed so radically to become concerned with the contemporary human predicament rather than the abstract heroics of classical dogma, so the New World felt able to share enthusiastically what was becoming an international sense of shared progress. The monumental works of D. C. French were certainly part of this, but, being mostly in marble, they lie outside our specific concern; nevertheless it must be acknowledged in passing that compositions such as the 'Milmore Memorial' of 1891 (109) possessed a grandeur and breadth of experience unknown in earlier American sculpture.

As Augustus Saint-Gaudens (1848–1907) was the best-known American sculptor in Europe during the late nineteenth century, he has subsequently received more critical attention than any other sculptor of the period, and all these studies confirm the international standing of this truly Romantic sculptor. The essential background experiences to Saint-Gaudens' style can be found first in Paris from 1867 to 1870 and later in Rome and Florence for the second time from 1874 to 1875; in this way Saint-Gaudens received the thorough grounding in all the techniques of his art that allowed him the relaxed freedom of expression natural to his lively imagination. In June 1877 he returned with his young wife to settle in Paris and immediately began experiments in relief sculpture which he was to use with such individualist effect in much of his best work. One of the earliest relief portraits was that of his painter friend Bastien-Lepage (110) in 1880, which bespoke a totally novel delight in the subtle surface lights of low relief, and indeed the whole idea was a great deal further advanced than anything thought of by English sculptors at this time. But from 1878 Saint-Gaudens had been working on a far more sensational use of relief in the monument to Admiral Farragut unveiled in New York in 1881; the monument was composed of a standing statue of the Admiral in, for once, totally convincing contemporary dress, standing on a shaped plinth designed by Saint-Gaudens' regular architect collaborator Stanford White, and relief-decorated with seated female figures surrounded by wispy contours en-

108 Daniel Chester French succeeded in making his bust of 'Ralph Waldo Emerson' both look and feel like the man himself.

THE MILMORE MEMORIAL

twining the imaginatively lettered inscriptions. At first glance the two parts of the monument seem separated by twenty years of stylistic development but in reality it constitutes a tremendously exciting combination of the two strains of Saint-Gaudens' art, namely sensitive, naturalistic portraiture and flowing technical and compositional freedom.

Even in an old-fashioned historical figure, 'The Puritan', for Springfield, Massachusetts, Saint-Gaudens instilled a considerable sense of real purpose into his figure, and of course the bronze itself possessed independent lively qualities of its own, as could be expected in the turn-of-the-century reductions (111) from the 1889 original. Between 1886 and 1891 Saint-Gaudens was engaged on the kind of commission associated more with D. C. French, the Adams Memorial, the brief for which stipulated that the figure should symbolise 'the acceptance, intellectually, of the inevitable'. The resultant bronze and stone monument had a quite remarkable poignancy achieved by the simplest yet subtlest of compositions. Nevertheless Augustus Saint-Gaudens' customary brilliance must be characterised

109 D. C. French was best known for his monumental sculpture of which the Milmore Memorial, 1891, is an outstanding example.

110 The technique of low relief portraiture was developed to perfection by Augustus Saint-Gaudens, one of his earliest experiments being 'Bastien-Lepage' of 1880.

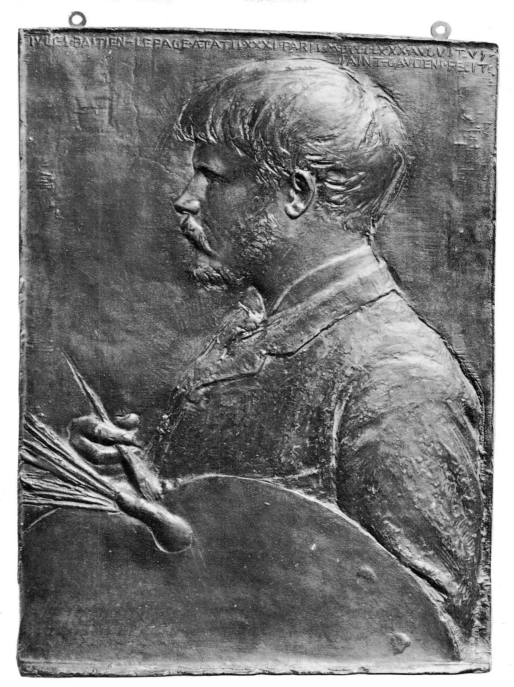

111 Although Saint-Gaudens was one of the first Americans to make Paris their centre, he did not ignore his native heritage, 'The Puritan' (original 1889) being one of his most popular works.

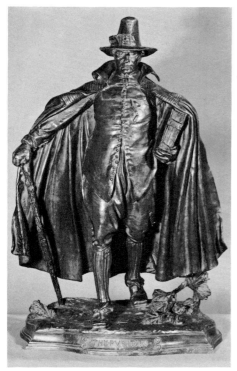

finally in his favourite oeuvre, the portrait relief. His 'Robert Louis Stevenson' (112) of 1887 stands amongst the very best portraiture of its kind, far outshining his popular Parisian contemporaries Alexandre Charpentier and Oscar Roty, and although David d'Angers' medallions gain distinction because of their period uniqueness these creations of the American possess an almost equal air of stylistic adventure and personal involvement.

Another American sculptor of the period also worked with success in the bronze portrait medallion, and indeed Olin Warner (1844–96) must be accorded an equal stature to French and Gaudens in the history of American sculpture, despite his lesser public reputation. In fact Warner was more thoroughly acquainted with contemporary French sculpture than Saint-

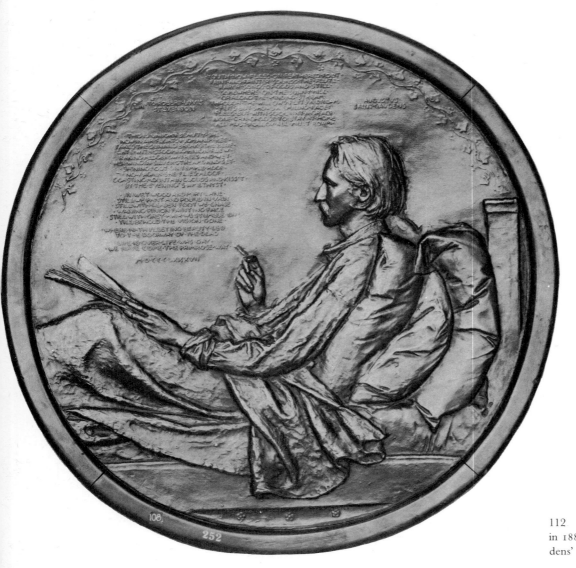

112 This plaque of 'Robert Louis Stevenson' in 1887 revealed the full flower of Saint-Gaudens' striking Romantic techniques.

Gaudens, for having joined the latter in Jouffroy's studio he then proceeded to gain further experience by working under Carpeaux, before returning to New York in 1872. Bur Warner always found commissions difficult to come by and his talent was largely confined to expression in small bronze relief medallions, which nevertheless reveal a marvellous natural vivacity, combined with a rigorous refinement of detail to the bare essentials required to convey an exciting sense of both form and character. Particularly memorable was his series of Indian portraits made during a trip to the Northwestern Territories in 1889, many of which appear to be a conscious up-dating of David d'Angers' style. Warner's first full sculptural work to attract considerable praise and attention was his 'Diana' (113) of 1884, in which old-fashioned classicism was skilfully displaced by some sensitive surface work and by the studio-realism of the figure itself.

Olin Warner wished to bring American sculpture closer and closer to the new French ways, and indeed his own handling of the nude figure in 'Diana' might be thought to show sympathy with the inventions of Aristide Maillol and thus take in modernist concepts far beyond the Romantic fields of his Parisian friends Falguière and Mercié. But Warner

died relatively young in 1896 without receiving any real support, and it was left to the younger generation of Paris-based Americans to extend the lively discoveries of French, Gaudens and Warner into a fully national understanding of the Romantic principles of sculpture in bronze. Unfortunately this Romantic revolution of the nineties in America came, in a sense, too late, for already in France sculptors like Rodin were beginning to enter a whole new sculptural world where the expression of character and emotions ceased to rely on naturalistic representation of human or animal forms. If 'Romantic Bronzes' are therefore loosely defined as the style intervening between Neo-Classical Idealism and Abstract Expressionism, then in America as in England this style had only just appeared in force by the 1890s, in time for the French to question the whole foundation of this means of expression.

This, however, can never nullify the achievements of sculptors like Frederick William Macmonnies (1863–1937) and the other young American sculptors who captured superbly the principles of the Beaux-Arts

113 In 1884 Olin Warner instilled a Romantic character into a classical subject, 'Diana', by realistic modelling and composition.

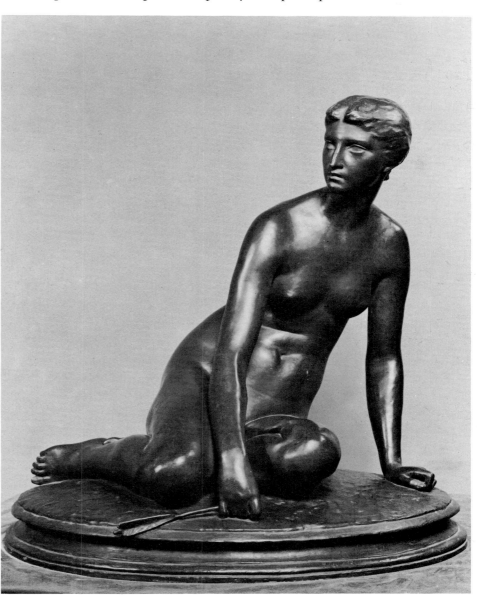

teaching in Paris in the eighties and returned to produce the country's most genuine Romantic bronzes. By the end of the century the moralistic separatism of the New World had ceased to hold artistic sway and therefore Macmonnies' self-exile in Paris for all but two of the years from 1884 until 1914 had no ill effects on his American reputation. Macmonnies' permanent popularity in the States was secured at the Chicago Columbian Exhibition of 1893 in which his gigantic 'Barge of State' was praised internationally, but in fact his talents had already been acknowledged in Paris with his Salon exhibits of 1889 and 1890, respectively 'Diana' and 'Young Faun and Heron' (114). Both these works reflected the influence of his masters Falguière and Mercié, but his fountain design 'Young Faun and Heron' possessed a quirkish abandon that outpaced his more formal French teachers. The 'Young Faun' was of course from the same sculptural tribe as Mercié's 'David' [p. 144] and Gilbert's 'Perseus' (67), but Macmonnies then emphasised his own peculiarly exuberant creation of sculptural forms with his sensational 'Bacchante and Infant Faun' (115) of 1893. The reactions in America to this unembarrassed nude were mixed, in contrast to the unequivocal enthusiasm of Paris; sadly, this powerful figure heralded a decade of frenetic over-production by Macmonnies, and little of his later work came up to these high standards, a career paralleled by the Anglicised Australian, Mackennal. However, during the early nineties Macmonnies' exciting creative energy had resulted in some highly inventive work, and 'Pan of Rohallion (116), for example, was an early experiment with themes and moods generally taken up much later by other sculptors, both English and American.

The early life of Paul Wayland Bartlett (1865–1925) was also totally orientated around the Parisian art world, his first exhibit at the Salon being at the age of only fifteen years, but at the same time he succeeded in maintaining an attractive stylistic continuity with the indigenous taste of his homeland. His first widely known work, 'The Bear Tamer' (117) of 1887, gives an abundantly clear indication of Bartlett's understanding of the American tradition, and indeed must be compared directly with Ward's 'Indian Hunter' (106). Although there are certain obvious differences between the two works, these are confined almost entirely to techniques of surface texturing, and the basic aesthetic purpose of both artists must have been practically identical, namely the realistic illustration of a native 'romantic' subject. As time went on the actual technical differences between Bartlett and his predecessors like Ward and D. C. French became more accentuated, but the basic sculptural spirit lived on unaltered. The inherent traditionalism of Bartlett's work no doubt contributed to his appointment to the task of producing the Lafayette statue, America's reciprocal gift to France for Bartholdi's 'Statue of Liberty' of 1886. Bartlett worked on this equestrian statue from 1898 until 1907, making numerous alterations that were never appreciated by the critics who already had marvelled at the lively costume piece they had been shown as the first model in 1900. The bust of 'Lafayette' reproduced here (118), a preparatory study, shows the way in which Parisian couleur added that essential breadth of emotional involvement to the original American brand of historical statuary.

114 Frederick William Macmonnies spent all but two years from 1884 till 1914 living in Paris, and exhibited this design for a fountain, 'Young Faun and Heron', in the Salon of 1890.

116 Macmonnies was a prolific and inventive sculptor whose imagination flourished on Parisian freedom and produced un-American works such as 'Pan of Rohallion', dated 1890 (pipe missing).

115 Then in 1893 Macmonnies received unstinting praise in Paris with his 'Bacchante and Infant Faun'.

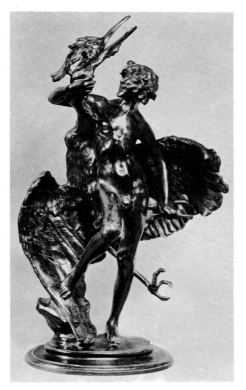

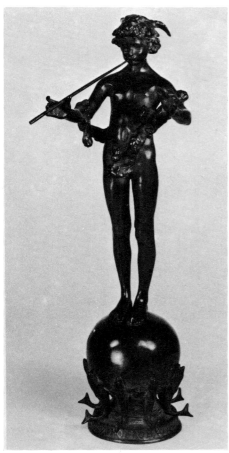

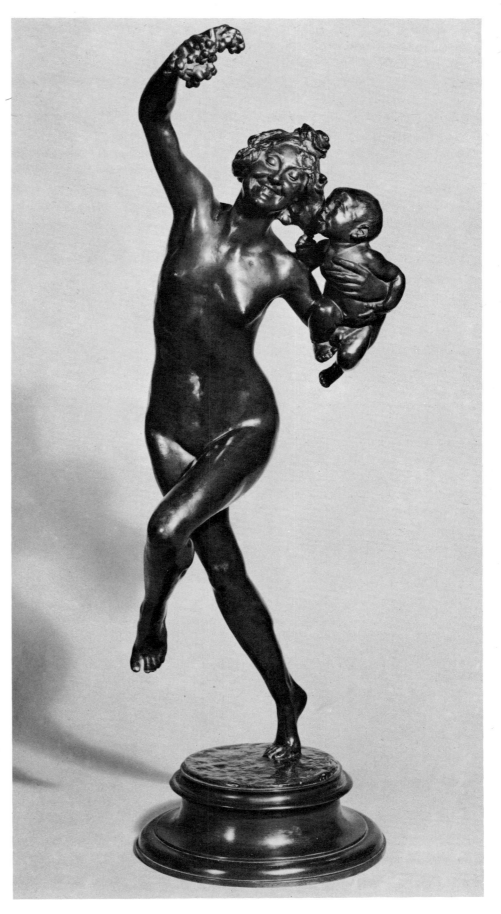

As in England, the Romantic release of sculpture at the end of the century gave American sculpture a tremendous injection of new blood and by 1900 there were a great number of Americans using bronze with a genuine Romantic awareness, and in a longer book people like Herbert Adams (1858–1945), George Grey Barnard (1863–1938) and Charles Niehaus (1855–1935) would command detailed attention. However, space must be made here for a brief look at the next generation of Romantic sculptors to make Paris their centre of inspiration.

Bessie Potter Vonnoh (1872–1955) was one of the few sculptors of the period to achieve Romantic expression without a Paris training, for she made only two short visits to Europe before marrying the painter Robert Vonnoh in 1899 and settling down in New York. Her work invariably contained a warmth and human familiarity that bears comparison with certain small-scale bronzes of Dalou, indeed 'Motherhood' (119) was foremost an intimate, personal creation in the best tradition of the Dalou maquettes for the 'Monument aux Ouvriers' (34). These studies of labouring people by Dalou also spring to mind in connection with the bronzes of Mahonri Young (1877–1957). Young came forcibly to the public's notice in 1904 with his 'Stevedore' (120), a most distinguished bronze in

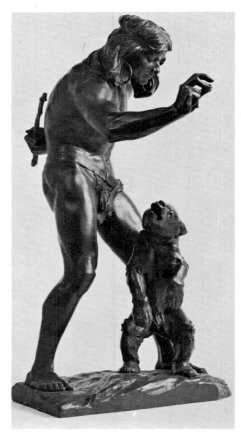

117 Paul Wayland Bartlett's 'Bear Tamer' showed how Parisian experiences had affected the techniques of the younger sculptors, when it is compared with Ward's handling of a similar subject (106).

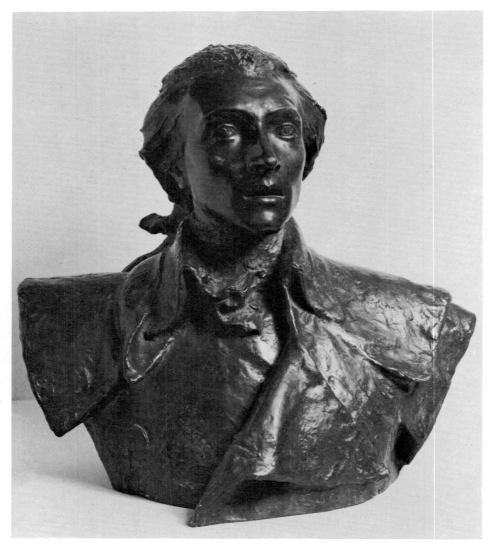

118 The city of New York presented an equestrian statue of Lafayette to Paris in 1907, and this bust was one of Bartlett's numerous studies for the commission.

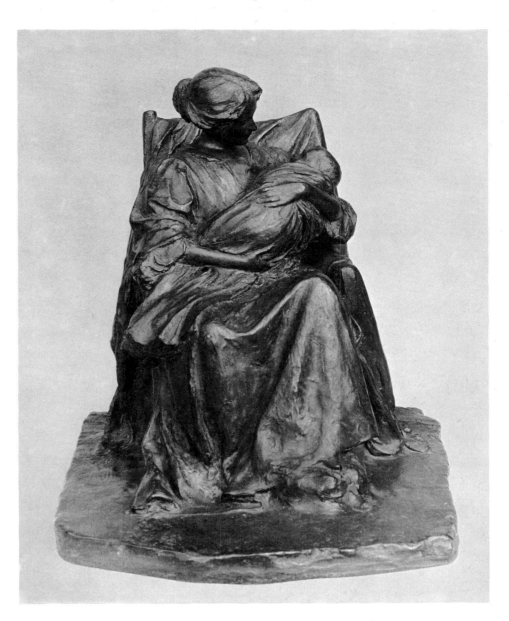

119 'Motherhood' of c 1910 by Bessie Potter Vonnoh communicated a marvellous sense of the warmth of human relationships.

which the matching strength and agility of the stevedore were realised in a sensational free-flowing sculptural technique; Meunier's achievement was only greater by being manifested earlier.

But those sculptors who attempted to take up again the strings of the Romantic style after the end of World War I inevitably found themselves out on a limb, fighting a hopeless battle against the alien abstract concepts of modern art. Malvina Hoffman (1887–1966) produced some most satisfying portrait busts during her long and successful career, but portraiture was one of the few areas of sculpture in which the lively naturalism of the 1890 Romantics still had meaning; and when Hoffman began in 1930 her nationwide studies for the 'Races of the World' commission the resultant sketches, like the 'Shilluk Warrior' (121), were immediately dated and undistinguished. The only old-school naturalist to continue with any inventive success was Paul Manship (1885–1966) who found a highly individualistic compromise in works like 'Indian Huntress with Dog' (122). This bronze was one of a series of studies in the 1920s for a large

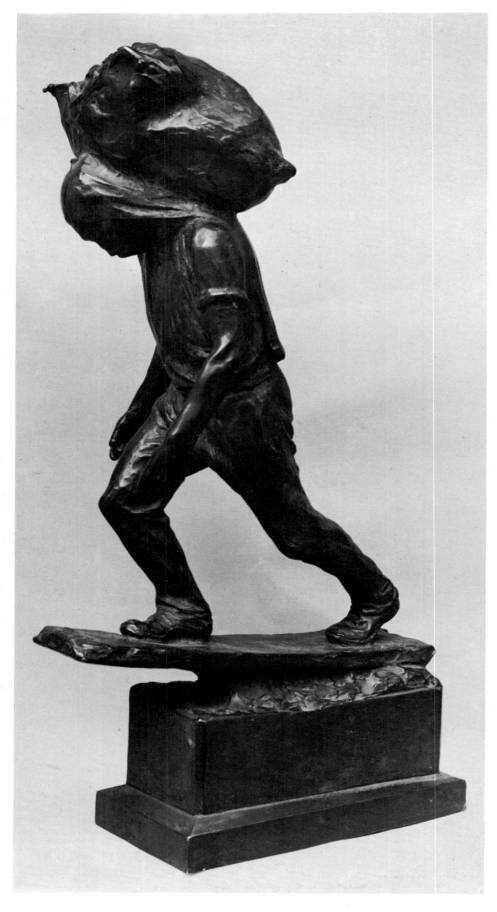

120 Mahonri Young was one of the rare sculptors of the period who concentrated on the subject of labouring men, and his talent for this theme is projected strongly in 'The Stevedore' of 1904.

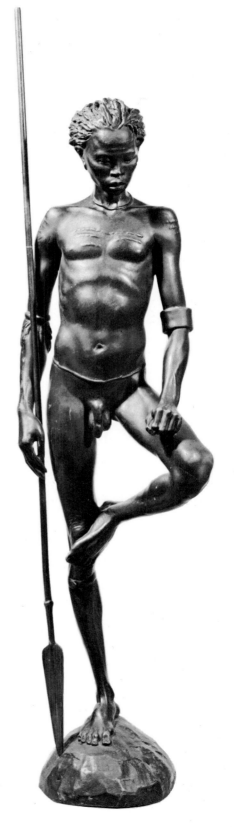

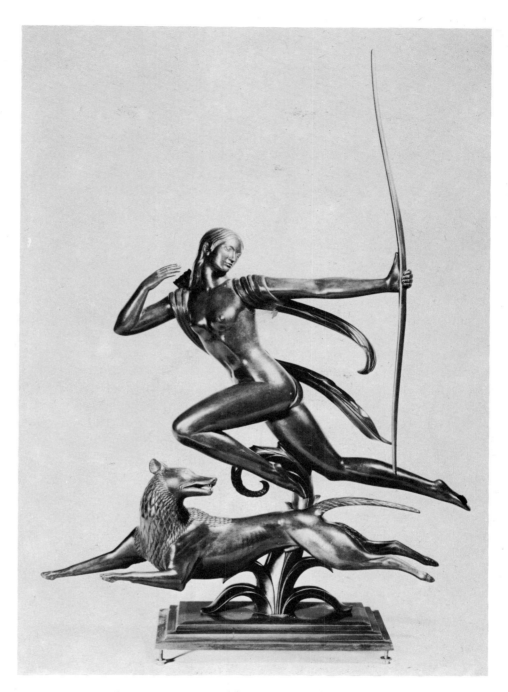

122 Paul Manship, while remaining loyal to the human form, adapted his work to 'Art Deco' principles of the late twenties with stylisations like 'Indian Huntress with Dog'.

121 (*left*) Malvina Hoffman attempted to carry turn-of-the-century naturalistic principles into the 1930s with studies for 'The Races of the World' such as this Shilluk warrior.

fountain in St Paul, Minnesota, and while Manship preserved his loyalty to the recognisable human form, he was able to make stylisations and re-finements that contrasted radically with the pre-war ideals of Bartlett (117) and other Romantics, and gave him a secure foothold in the 'art deco' of the thirties.

But it would be unrealistic to place undue emphasis on any overtly naturalistic sculptors working after the impact of Rodin had become internationally acknowledged by 1914. Far better here to finish with a sculptor who, while standing firm to his Romantic principles, nevertheless showed himself to be enthusiastically aware of the lead given by Rodin. Such a man was Charles Grafly (1862–1929), the healthy ambivalence of whose style was splendidly illustrated in the small bronze 'Aeneas and

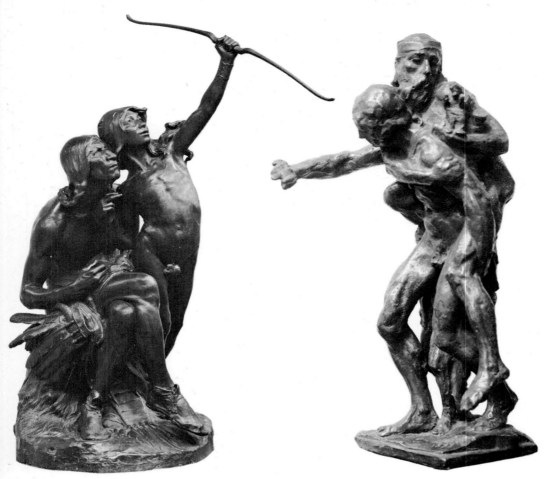

Anchises' (123), produced in the year of the Columbian Exhibition, 1893. Grafly's figures in this bronze group are certainly more accurately life-like than those of Manship's 'Huntress' (122) and therefore might appear less progressive, but this analysis ignores the crucial point, namely that Manship was an external stylist whereas Grafly followed Rodin in creating his sculptural forms from within, drawing upon a deep sympathy for the general human predicament. George Barnard (1863–1938) was the only other American sculptor of the 1890s to display true Rodinesque qualities, and he and Grafly must therefore stand alone at the height and at the conclusion of American Romantic sculpture in bronze.

The aim in these chapters has been to indicate the cross-fertilisations that occurred between English, French and American sculpture during the nineteenth century, and the last group of American artists to be discussed, the sculptors of the Cowboy and Indian scene, have here been set apart because their work has absolutely no European counterpart – their sculpture was purely American.

Certain writers and painters had been drawn exclusively to the theme of the 'Wild West', to the drama and romance of the Cowboy and Indian, right from the beginning of it all in the 1840s and 50s, but the subject received only passing acknowledgement from the sculptors until the Columbian Exhibition in 1893. In Chicago that year the public first became aware of a number of young sculptors who devoted themselves entirely to these native themes, and the most imposing work of all was a magnificent equestrian group entitled 'Signal of Peace' by Cyrus E.

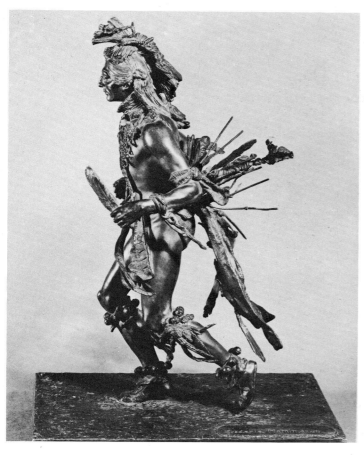

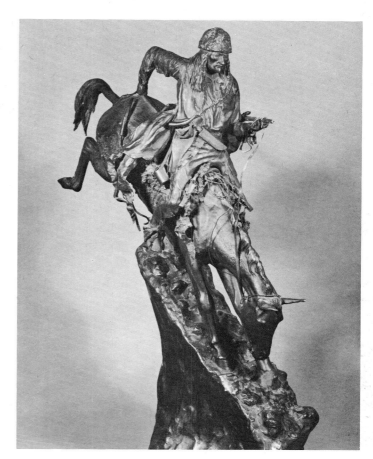

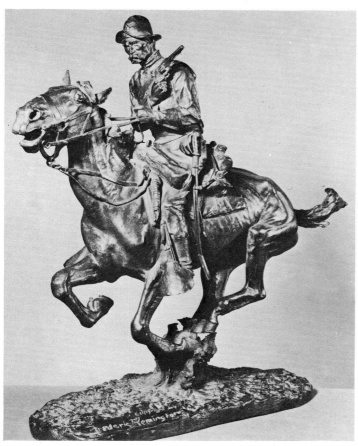

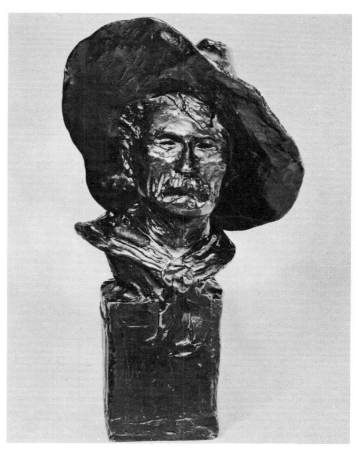

Dallin (1861–1944). Dallin was a passionate supporter of the Indian depicted in this, his first of a monumental series glorifying the character of this brave race, and visitors to the Exhibition could compare Dallin's sculptural image with the Indians themselves who visited Chicago to take part in Buffalo Bill's Wild West Show which had already thrilled audiences as far afield as St Giles Fair in Oxford, England. In fact by this time the frontier days had already slipped away into romantic legend and the young sculptor Hermon Atkins MacNiel (1866–1947) was drawn emotionally to Indian subjects by his personal experience of the plight of the Indian and through his regret at the passing of an irretrievable culture. Strangely, MacNiel's first two important Indian sculptures were produced during three years' study in Rome from 1895 to 1898, but then his approach was essentially romantic and not realist. One of these, 'The Sun Vow' (124), immediately appealed for its thrilling romantic qualities in the beautifully observed natural forms combined with a lucid understanding of the compositional and modelling requirements for bronze statuary. MacNiel worked in a similar vein until 1910 but seldom returned to these expressions of emotional association with the Indian after that date.

Frederic Remington (1861–1909) had a completely different approach, for he came to sculpture in 1895 after a lifetime's experience in the West, and throughout the 1880s and 90s had already delighted the nation with his drawings which had been published in *Harper's* and exhibited all over the country. Indeed Remington was an expert on his subject, and his sculpture, like his drawings, sprang from a desire to record the West as he remembered and loved it, and the undoubted artistic qualities of his work were therefore, in a sense, accidental. A meticulous attention to authentic detail was one of the principal reasons for Remington's popularity as a painter and this same characteristic appeared in much of his sculpture, notably in the magnificent studies of the 'Indian Dancer' (125). Indeed Remington's total lack of any sculptural training led to his treating modelling as though it were no more than a three-dimensional picture, and he thus succeeded with complex compositions like 'The Mountain Man' (126) that conventional sculptors would have deemed impossible. Remington was a man who had actually experienced the struggles of the West and his bronzes so often express the strength of his personal feelings about the people, none more so than his last work, 'Trooper of the Plains' (127) of 1909. In this, as in the less well-known bust entitled 'Rough Rider Sergeant' (128), Remington captured the hard realities of the tough pioneering life which he himself had always adored – any hint of storybook romance is in our own mind, not Remington's.

Solon Hannibal Borglum (1868–1922) also came from a genuine Western background and was brought from prairie life to art school in about 1895 only on the insistence of his elder brother Gutzon Borglum (1867–1941). Gutzon later rose to fame through exceedingly powerful works such as 'The Mares of Diomedes' of 1904, and the presidential portraits on Mount Rushmore, 1930 to 1941, but initially he was overshadowed by the speedy success of his younger brother Solon who had been sent off to Paris from Cincinnati Art School in 1898. Solon Borglum's earliest sculpture was strikingly simple and naturalistic, for example the

Lord Leighton's 'Sluggard' of 1886 was inspired entirely by nature as he captured the haphazard pose of a model he was painting. (*Sotheby's Belgravia*)

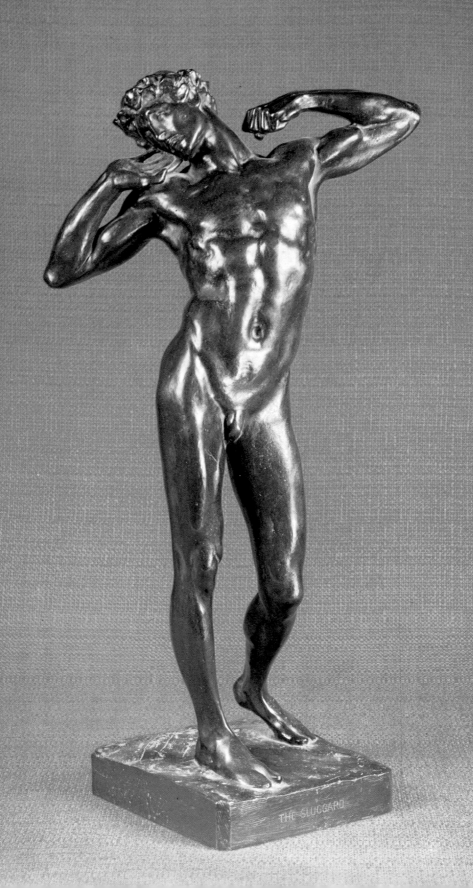

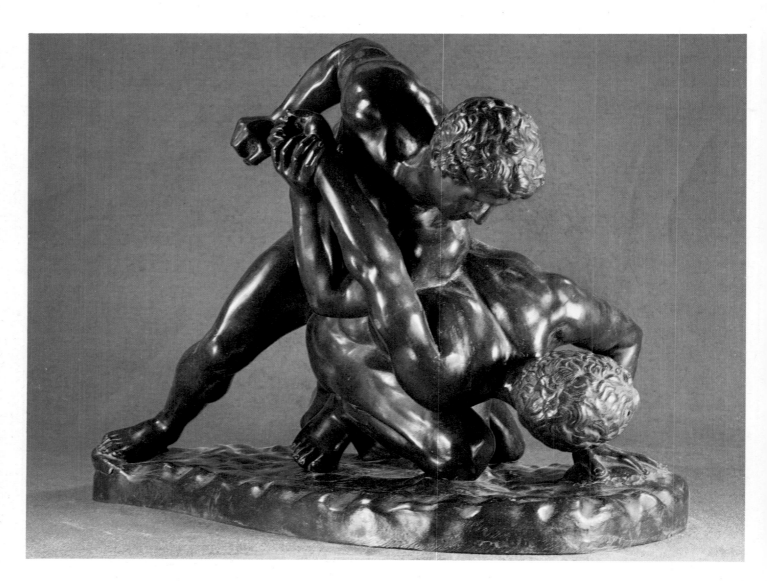

The commercial French bronze founders pro-
duced many high quality reductions from
antique marbles. (*Sotheby's Belgravia*)

'Little Horse in the Wind' (129), but even his more complex compositions usually preserved the same relaxed style of modelling and easy naturalism. Such was 'Lassoing Wild Horses' (130) which was exhibited in the Paris Salon of 1898 and together with the next year's 'Stampede of Wild Horses'

129 Solon Borglum's early works like 'Little Horse in the Wind', 1897, reflected the simple rancher background of the first thirty-five years of his life.

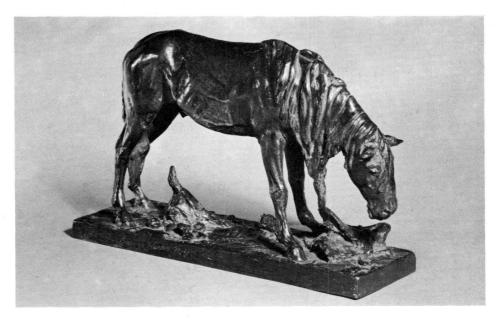

130 'Lassoing Wild Horses', exhibited by Solon Borglum at the Paris Salon of 1898, was Europe's first sight of Wild West sculpture.

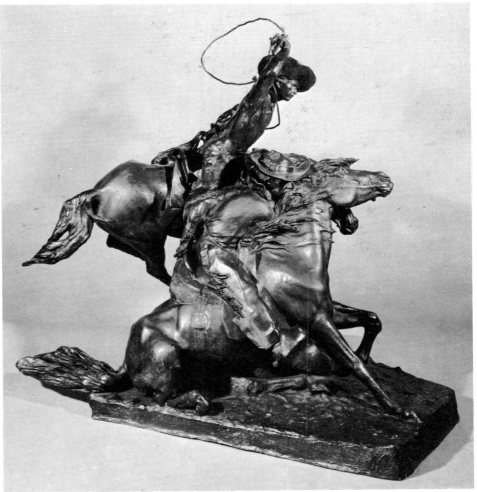

gained him a considerable reputation in Paris, as these were the first Wild West sculptures to be seen on the Continent.

Paris had of course long been the centre of pure animal sculpture, and Borglum's 'Little Horse' could never have merited the attention accorded the later authentic Western group. However, America could boast a native 'Animalier' of some distinction, Edward Kemeys (1843–1907). Kemeys was almost entirely self-taught and his sculptural creations were inspired purely by a simple interest in his country's animal wild life; none of his work can really compare with the breadth in the best French animal sculpture, for he lacked the technique, but the accuracy and originality of his subject studies were most satisfying. Other Americans who concentrated almost entirely on animal sculpture include Eli Harvey (1860–1957), F. G. R. Roth (1872–1944), Edward Clark Potter (1857–1923), Albert Laessle (1877–1945) and Herbert Heseltine (1877–1962) [p. 53].

Alexander Phimister Proctor (1862–1950) was one of the few sculptors to combine meaningfully the functions of Animalier and Cowboy sculptor. Proctor's first extensive commissions after a background in the wilder territory of Colorado were for sculptural decorations of the buildings of the Columbian Exhibition, and from 1891 to 1893 he produced more than thirty-five statues for Chicago. These included two equestrian groups and all received favourable comment, but the quality of Proctor's work is best illustrated in a bronze shown in the Fine Arts Section. 'The Charging Panther' (131), as this is usually called, revealed a remarkable understanding

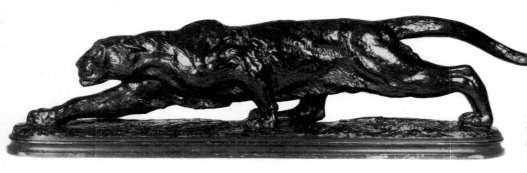

131 Phimister Proctor was almost the only American sculptor capable of pure animal studies to compare with contemporary French achievements, and 'The Charging Panther' of 1893 is an excellent example.

of the aesthetics of French animal sculpture and forged a rare link between America's thoroughly esoteric Wild West sculptors and contemporary European sculpture. It must also serve as a narrow but firm visual bridge leading to the next chapter's detailed study of 'Les Animaliers'.

4 French Animalier Bronzes

The extraction of the French Animalier School of Sculpture into a chapter of its own cannot by justified entirely by the general history of nineteenth-century sculpture, for at certain stages the stylistic inventions of 'Les Animaliers' affected the whole course of sculptural development. It is important therefore to relate this particularised discussion to the general artistic progress of the period as laid out in earlier chapters, and so to appreciate more fully the achievements of these sculptors in their own right and beyond the narrow confines of their subject-matter, within which they are too often detained by the critics. At the same time, one of the real pleasures of a concentrated study of French Animalier bronzes is the increased awareness of the broad variations, the personal characteristics and the technical subtleties of what initially might appear a limited field of expression.

The aim, then, will be towards a double-sided understanding of the Animalier sculptors, through a chronological survey of their individual works considered within the wider context of aesthetic developments in sculpture from the 1830s to World War I.

Although the horse and the greyhound were favourite subjects in sculpture of the classical tradition, the creation of a unified group of sculptors concentrating almost entirely on the realistic description of wild and domestic animals was inconceivable before the birth of Romanticism. In the early years of the century the painters overthrew the restrictions of Neo-Classical discipline long before the sculptors could enjoy similar freedom, but it is significant in this context that the animal had featured strongly in the imaginative, poetic compositions of the first 'Romantic' painters. For although Theodore Géricault [p. 107] died in 1824, before the first 'Animalier', Antoine-Louis Barye (1796–1875), reached creative maturity, undeniable connections exist between painters of Géricault's such as the dashing 'Hussar' of 1814, wheeling on a wild, rearing charger, and Barye's later sculpture. Not only is there every indication that Barye knew and made use of Géricault's freely executed drawings, but the actuality of previous expression of animal vigour in this personal, unshackled way was an essential inspiration to Barye the sculptor.

Barye's official schooling began in 1816 under the forceful if old-fashioned Bosio and soon after also with Baron Gros, a Romantic painter in practice despite his contradictory devotion to 'Davidienne' theory; later the formal stability of Bosio's heroic sculpture and the sense of personal drama in Gros' emotive painting became the dual platform for Barye's work. Two other experiences of his youth were also essential to the older Barye, firstly his detailed technical work for the jeweller Fauconnier, and secondly his dedicated studies of wild animals in the Paris Zoo. All these varied interests were fused together in the driving ambition and creative energy of this remarkable sculptor to produce for the Salon of 1831 a work that laid siege to the Parisian sculptural establishment. The plaster model of 'Tiger Devouring a Gavial' was in every way unprecedented, and even the basically unsympathetic critic Delecluze was forced to admit that the group was 'the strongest and most significant work of sculpture in the whole Salon', and Schoelcher dared to pronounce that 'never before has anyone rendered nature with a more admirable expression, a more profound feeling'. This work immediately placed Barye on the same plane as Delacroix in the search for the Romantic ideal, the re-creation in art form of the full passion of nature; as a painter Delacroix was one of many in the field, but Barye was the only sculptor at the time to follow this course unfalteringly.

The precise nature of Barye's revolutionary work can be seen in comparing figures 132 and 133, the first being a cast made early in the twentieth century by Valsuani from a Géricault maquette of c. 1820. Certain features of this bronze (132), such as the molten patination and the wax-like quality of the metal itself, were the properties of the later editing and not of the original sculpture, but disregarding these extraneous features the style and form remained essentially classical, despite the attractively free definition of the head, ribs and muscles; when comparing it with Géricault's creations in paint it is difficult to suppress the feeling that the effect he actually sought was far closer to the super-realism achieved by Barye in 'Le Cheval Turc' (133).

But in general terms the comparison with Delacroix is more apt, for Barye's small bronze captured in the round the spirit of Romanticism that brought alive the painter's contemporary wash drawings of Arab horsemen, and indeed the revolutionary work of both artists was the first unified expression in their respective media of the rationally comprehended but emotionally depicted movement of animals. The English eighteenth-century painter Stubbs and other artists before had also tackled naturalistic subjects as daring as fighting lions; the sense of rippling life that spread through a Barye bronze or a Delacroix sketch was a total novelty. 'Le Cheval Turc' in fact existed in several versions all of which except a posthumous cast by Barbedienne seem to date from the late thirties, and the title was listed as one of a pair in the first catalogue Barye published in 1847; this period from c. 1830 to 1845 was one of ferocious production for Barye as he strove for technical excellence in the casting of bronzes and for commercial success through the publication of his catalogues. Stylistically it was essentially a period of full-bodied Romanticism, captured permanently in this glorious animal.

Although Barye's animals invariably give the impression of individuality

132 Theodore Géricault's figure of a horse, cast by Valsuani in *c* 1900, many years after Géricault's death in a riding accident in 1824.

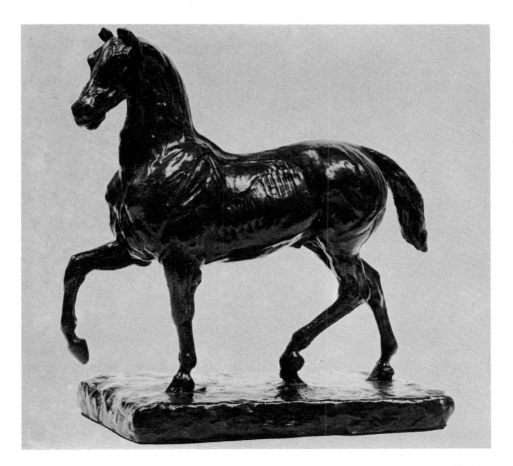

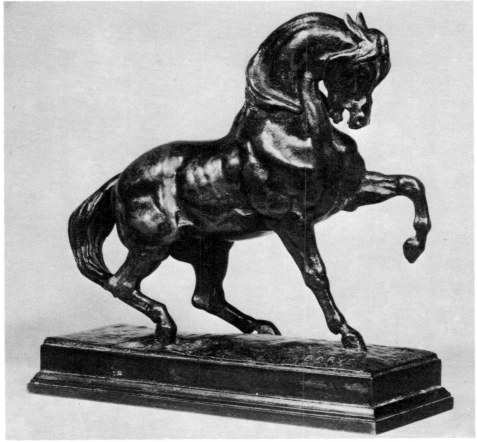

133 'Le Cheval Turc', one of the most popular bronzes by Antoine-Louis Barye.

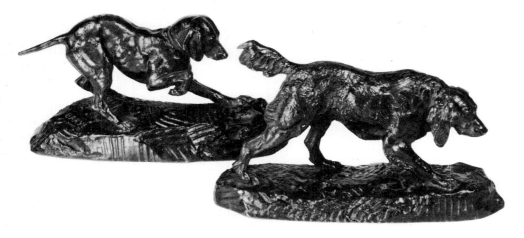

134 These two Barye dogs are early num-
bered casts, modelled about 1830 but probably
cast for sale through his first catalogue in 1847.

beyond the plain character of the species, they were built on a firm founda-
tion of general scientific observation, a fact clearly illustrated in figure
134, 'A Pointer', and 'A Hunting Dog', both of which models were pro-
duced about 1830. These small bronzes have many qualities, including a
superb surface treatment which differentiated so precisely between the
smooth coat of a lithe pointer and the broader curly features of a retriever;
but in this case the most powerful sensation communicated went further
than visual pleasure merely in surface textures, and existed in the sense of
total reality, in the sense of nature calmly and truthfully revealed. And
even in a tiny relief plaque (135), a flight of fancy of the twenties, Barye
was able to describe with sensitivity the animal world in its natural activi-
ties despite the technical difficulties of relief bronze.

Not all Barye's subjects, however, were as benign as those already men-
tioned and he produced many illustrations of the cruelty of nature such as
a royal stag brought down by Scottish hounds (136), for it was in these
compositions that Barye delighted in displaying the full range of his

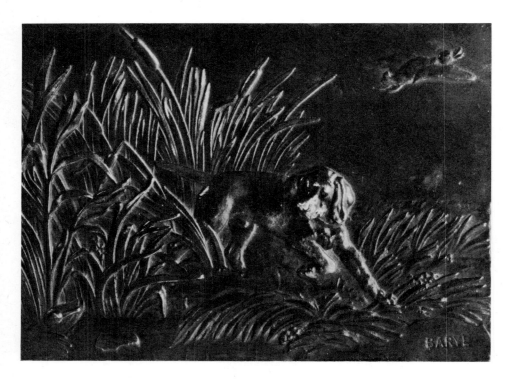

135 A bronze hunting relief by Barye, bear-
ing the founder's stamp of Eck et Durand on
the reverse.

132

136 The most lively of several versions by Barye of this Scottish hunting scene, dated to the mid-1830s.

skills. Barye worked hard at this model in the thirties, for considerable variations have been observed in early casts as the sculptor sought to contain within a viable composition the violent movements of the animals, without losing the physical reality and emotional pathos of the subject. The Victorians showed a particular fondness for what they considered to be the high morality of this type of animal drama by their favourite painters such as Landseer, and by the animal sculptors, and it is an impressive indication of Barye's pure aesthetic qualities that his sculpture should have completely outlasted the tastelessness of the equivalent paintings.

Strangely, the classical control that was the actual foundation for all Barye's work came nearest to the surface later in life with groups such as 'Theseus Slaying the Centaur Biénor' (137), exhibited in 1850. Indeed Barye's subjects varied considerably and his 'Charles VII Victorious on Horseback' (138), dated 1862, had Renaissance associations in form and contemporary literary romanticism in choice of subject; all the same, neither of these bronzes seems incongruous, because each in its way was an extremely personal expression bearing the stamp of true creative power ever present in the work of Barye, the first consistent Romantic sculptor and founder of the influential Animalier school.

Barye has been allotted disproportionate space in this chapter not only because he was first in his field, but also because throughout he remained exemplar to the whole school. In the work of lesser sculptors the debt was especially direct, as in the relief bronze of a stalking lion by J. Bennes (139). It is nevertheless a tribute to the general strength of the school that a completely unknown sculptor could have produced a bronze of this admirable quality.

Although Barye achieved a greater breadth of expression than all who followed, other animal sculpture often differed completely in form and

137 'Theseus Slaying the Centaur Biénor', also by Barye. Although produced for exhibition in 1850, this group revealed his classical training under Bosio.

feeling. Christophe Fratin, born in 1800, first exhibited at the Salon of 1831 in which Barye had gained initial recognition, and though a contemporary witness of Barye's success he remained a complete individualist.

No doubt to Barye's chagrin, Fratin had been a pupil of Géricault's, and hence the choice of subject for this opening Salon, 'Fermer, An English Thoroughbred', influenced by the painters' prints of English shire horses. Even from a photograph of 'Lioness and Cubs with Kill' (140) Fratin's totally different qualities are immediately apparent, as Barye's liquid textures were exchanged for less tactile, pitted surfaces; Barye, in fact, had taken particular care in the patination of bronzes and achieved considerable variations as a result, whereas Fratin concentrated on a thick black or dark brown patination which gave much of his work a sinister strength. Although the divergent artistic personalities of these two sculptors emerge at a glance, it is important to recall their basic similarities in the wider context of sculptural development, for Fratin, like Barye, consciously posed his surging romanticism against reactionary academicism, and both were often excluded from the Salons because of this. Despite banishment from the establishment, both sculptors flourished, and indeed Fratin's citation for a medal in the 1851 Great Exhibition in London distinguished him and not Barye as 'the most celebrated sculptor of animals at the present day'.

The kind of sculpture that appealed to the suspect taste of Victorian England was probably the 'Monkey Lamplighter' (141) which offered a

139 A fine quality bronze relief of a lion by an unrecorded sculptor, J. Bennes, showing a marked debt to Barye.

138 (*below*) Barye's romantic-historical group 'Charles VII Victorious on Horseback', dated 1862.

sentimentalised romanticism treated with sufficient virtuosity to pacify Fratin's more discriminating supporters. The aim again was very different from Barye's because the treatment humanised rather than naturalised the animal world, and also the basic physical form of Fratin's animals was seldom correctly observed. But then Fratin looked at his favourite bears and monkeys with an eye for the bizarre never contemplated by contemporaries, and even unsigned bronzes of this type can be attributed to Fratin without any hesitation. Although Fratin must either have preferred or profited most from these 'popular' subjects, there were other qualities that contributed to his success; for instance his 'Mare and Foal' group, a subject naturally favoured by many Animaliers, communicated in his own rugged style a wonderful feeling of the physical relationship between the mother and foal. In his distinctive way Fratin also rivalled Barye in his studies of the cruelties of nature, for his two groups of 'Horses Attacked by Wolves' gave sensational impressions of violent movement in the wild spiky tossing of the rearing horses' manes and the wiry ferocity of the small but deadly wolves.

The example of these two early specialised sculptors of animals led several contemporaries to experiment periodically in the same genre. One of these was Paul Gayrard (1807–55), who having studied under both François Rude and David d'Angers had benefited from close familiarity with the best in contemporary sculpture, and no doubt it was the general taste for naturalism, albeit restricted as yet, acquired in these ateliers that led Gayrard from his habitual human portraiture to animal subjects. Gayrard's 'Harnessed Horse' of 1847 even broke new ground in the pure observation of natural details unaffected by the messianic romanticism of Barye, and became almost his best-known sculpture, although he by no means lacked admirers of his fashionable portrait busts. It would be fascinating to know Gayrard's personal purpose in these rare excursions into the novel animal genre, for 'The Monkey Steeplechase' (142) was a remarkably imaginative piece for as early as 1846.

Another peripheral associate of the Animalier School who experimented with these new subjects was Theodore Gechter (1796–1844), born in the

140 'Lioness and Cubs with Kill', the terracotta exhibited in 1835 by Christophe Fratin, bearing the uneven black matted surfaces favoured by this artist.

same year as Barye and schooled under the same masters, Bosio and Gros. But there the similarities end, for Gechter was a typical middle-range sculptor of his era. Having no definite style or consuming principle, he produced undemanding decorative works, the finest of which was per—haps 'The Combat of Charles Martel and Abderame', originally exhibited in 1833 and commissioned by the state in monumental bronze at a fee of

141 Fratin was the only Animalier to produce figures in this peculiar animated style, this ex-ample being dated to the 1850s.

142 'The Monkey Steeplechase', an unusual group for its date, 1846, produced by Paul Gay-rard who was principally a portrait sculptor.

136

143 A figure of a greyhound dated 1838, by Theodore Gechter, who was not a specialist Animalier.

three thousand francs. It was therefore typical of Gechter's catholic taste that he also turned his hand to animal sculpture, and indeed in 1838 he produced both 'The English Racehorse' and 'The Greyhound' (143). This group of a greyhound with a dead rabbit was an interesting piece for its date, as Gechter made a conscientious attempt to describe the dog in arrested motion, and only his inability to reproduce the head realistically and his taste for the destructive dregs of classicism prevented its full success.

In commercial terms the most powerful Animalier of all was P. J. Mene (1810–79). Without wishing to belittle Mene's art, for the high quality of his vast oeuvre is unarguable, there is no doubt that his low-brow commercial beginnings reveal themselves in his style in contrast to the inherently advanced ideals of Barye. For Mene, as the son of a metal turner, always seemed to maintain the attitudes of a simple craftsman, and his diligent progress from a modeller for cheap porcelain manufacturers to successful sculptor has something of the fairy story about it.

Unaffected by the aesthetic arguments of the time, Mene continued to exhibit his marvellously real, unpretentious animal sculptures [p. 18] in the Salons regularly from 1838 until his death in 1879, and at no time did the standard drop or the style noticeably change. One of the keys to Mene's success, the uniform quality of his casting, will be discussed later in detail, but it must be pointed out here that the commercial sense which influenced Mene to personal care over founding and marketing was an essential factor in distinguishing him from other members of the School.

Mene produced more sculptures than any other Animalier and his international appeal is indicated by the fact that during his lifetime the English fought for the copyright of a number of models for Copeland's parian

144 A portrait group of the Arab horses, Tachiani and Nedjibe, entitled 'L'Accolade', first exhibited in 1853 by P. J. Mene.

ware and for Coalbrookdale cast iron, after his popularity had been sealed with his displays at the 1851 and 1862 London Exhibitions at the first of which an English critic praised his work 'for the perfection in modelling the figures of animals and for the truth and beauty of his representations'. Indeed, Mene's message was refreshingly simple and direct when the rest of the arts were at a low ebb in terms of aesthetic sensitivity, for, as pinpointed by the English critic, the outstanding feature of Mene's work was the uncomplicated reproduction of semi-domestic animals [p. 36] in pure physical reality.

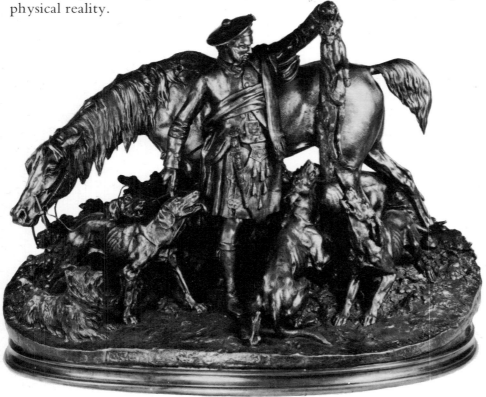

145 'After the Hunt in Scotland', a Landseer-inspired composition by Mene, dated 1861.

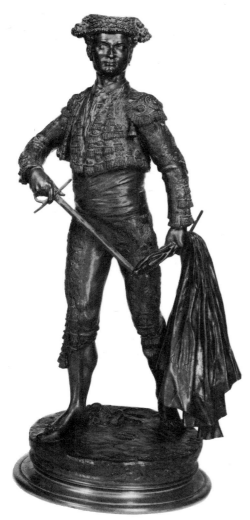

146 An unusually romantic piece for Mene, 'The Toreador', the wax model initially exhibited at the Salon of 1877.

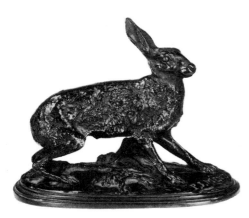

147 Mene at his best in a small-scale, realistic figure of a hare, shown at the 1846 Salon.

Mene's anatomical accuracy was often achieved by actual portraiture, as in the group of Arab horses entitled 'L'Accolade' (144) exhibited in bronze in 1853, and the chief difference from Barye therefore lay not only in the concentration on semi-domestic animals but also in the fact that Mene sought primarily for physical accuracy where Barye considered this valueless without description of the character of the animal and of the atmosphere of a particular situation. Of course Mene was such a fine craftsman that often the character and relationship of his models were also beautifully realised, especially in 'L'Accolade' where the pose of 'Tachiani' and 'Nedjibe' was so sensitive. Even to those unsympathetic to horses the quality of this group impresses, whether it be in admiration of the tantalising technique in reproducing such real details as vein and tendon, or in equal admiration of the quivering arrested motion of the stallion Tachiani.

Naturally in some of the most complex groups Mene fell into the errors of his age, and his monumental 'After the Hunt in Scotland' (145), fully twenty inches high, became a mere technical *tour de force* on the same level as, and indeed directly influenced by, a Landseer masterpiece. Mene produced several groups of this type and size, but the quality of all the individual animals is best appreciated in the casts he published of separate details; thus when lifted out in isolation the central groups of huntsman and single hound smelling the fox revealed magnificent contrasts between the lank, dead fox, the hound trembling with excitement and the human figure manipulating the two.

A field which Mene made almost entirely his own, rivalled only by Moignez and I. Bonheur (151), was the portraiture of champion racehorses and their jockeys, notably 'Vainqueur du Derby' of 1863. The complete 'rightness' of this animal portraiture contrasted with Mene's rare attempts at human romantic subjects, of which 'The Toreador' (146) is the best-known example. In his usual practice Mene exhibited the wax model for this figure first, in 1877, and a year later the bronze; whether Mene felt a latent desire to rival the insipid, literary romanticism of a Picault (42), or whether it was merely a lessening of powers in his old age, the sculpture lacked the sure ring of truth of his earlier work. The lack of any animal in the Toreador was a complete diversion, but even in his 'Moroccan Horseman' of 1878 the spirit had flown despite the adaptation of a much earlier model, 'The Arab Horse Tethered'.

No, Mene's skill lay in the realm of pure animal portraiture, perfectly represented in small-scale works such as 'The Hare' (147). The accuracy in technique, the crispness of the cast, the simplicity of form, all these qualities are immediately apparent, but when these are set against the fashions of the time the true proportion of Mene's achievement can be properly understood. For the Animalier was a 'popular' artist and other 'popular' art of the mid-nineteenth century was so cluttered and clumsy and in such basically bad taste that this hare of Mene's gains added respect for its very simplicity, for its honesty and lack of superimposed human 'significance'.

Many other Animaliers followed Mene's example but none matched his quiet assurance. The closest rival was Jules Moigniez (1835–94) who, conveniently, produced a companion figure of hares (148) directly com-

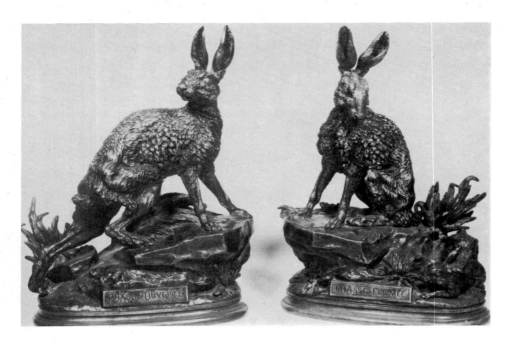

148 Comparable figures by Jules Moigniez, but executed in a more linear style.

parable with the 'Hare' of Mene. The styles were very similar, as Moigniez also succeeded in communicating real animal life. Indeed, if anything, his hares were more lively then Mene's, and it may only be a personal preference for Mene that sustains the suspicion that Moigniez's lack total anatomical accuracy. The important differences between the two artists' work can be seen clearly by actual handling of the bronzes, for it was in technique that the two contrasted most noticeably. Firstly, in the original modelling Moigniez employed a more linear style, and in for instance the description of the hare's fur the surface was drawn in detail whereas Mene relied on broader modelling and texture to achieve reality. Secondly, each favoured different methods of casting, for Moigniez produced a sharp impression often finished in the natural bronze patination, but Mene, although no less precise in his casting, gave greater movement to the surface of his bronzes through the thick black-brown patination originally applied to most of his work and observable even in the photograph, fig 147.

Like his master Paul Comolera (1818–97), Moigniez specialised to a certain extent in sculpture of exotic birds, an area ignored by both Mene and Barye. Some of these figures possess amazing animation, for instance his 'Sparrow Fighting', or the image of a sandpiper with wings spread to balance while dipping to snatch a worm from the mud, and all were described in minutely feathered detail against backgrounds of his characteristic wispy ferns and reeds. Perhaps it was the influence of Moigniez's father, a metal gilder who cast his son's bronzes from 1857 onwards, that inspired him to design a number of exquisite little jewel caskets. The example illustrated as fig 149 was of excellent quality and incorporated various groups of Moigniez's favourite little birds, and indeed humming birds can be seen unexpectedly pecking berries at the scrolled sides. Many of these caskets bearing panels or groups with Moigniez's signature were mass-produced by pirate manufacturers with inferior methods, but the best, probably produced for specific exhibition, were amongst the finest decorative objects of the whole period.

Rosa Bonheur (1822–99), an artist of particular interest to appear briefly on the Animalier scene, produced some assured sculpture of farm animals before relinquishing sculpture to concentrate entirely on painting from 1845 onwards. Known later as 'the Landseer of France', Rosa Bonheur became a tremendously successful painter in both England and France, where the naïve propriety of her farm and country scenes secured her the personal patronage and protection of both Queen Victoria and the Emperor Napoleon III. In sculpture she had concentrated exclusively on farm animals, and her cattle and sheep possessed a comfortable security and an easy naturalness that had been achieved only by Mene; in fact it is argued that in some degree the public acclaim of the painter encouraged Mene to maintain his single-minded study of the semi-domestic animal. Typical of her work, the bull in figure 150 illustrates Rosa Bonheur's ability to woo the Victorian public with the passive, uncomplicated visions that satisfied their 'proper' taste.

The same kind of sculpture was produced by Isidore Bonheur (1827–1901), brother of Rosa, who made a considerable name for himself despite

149 A silvered bronze jewel casket also by Moigniez, possibly produced specifically for an international exhibition in the 1850s.

'The Metamorphosis of Daphne' by the Australian sculptor Bertram Mackennal, who worked for most of his life in London and Paris. (*Sotheby's Belgravia*)

150 'A Bull', a typical sculpture by Rosa Bonheur before she devoted herself entirely to painting in 1845.

151 A highly competent horse and jockey by Rosa's brother, Isidore Bonheur, cast by his uncle by marriage, Hippolyte Peyrol.

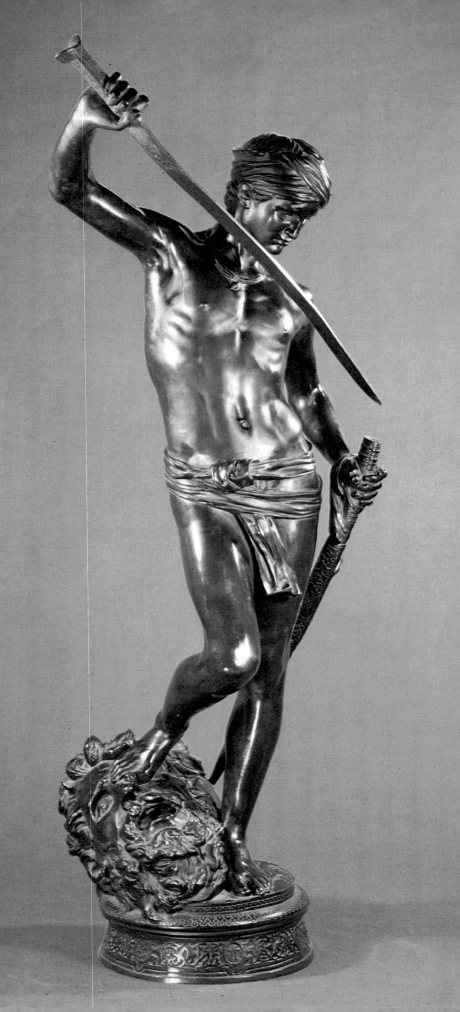

the limitations of his imagination which confined his oeuvre to highly competent discipleship of the masters (151).

Often the more humorous animal bronzes came from the hands of lesser-known sculptors, as in the case of Alphonse Arson (1822–80), all of whose work was confined to the small scale. The difficulty for a less significant sculptor was that the quality of the founding suffered, as for financial reasons it could not be handled personally, and this often removed the general appeal of the artist's work to collectors. Nevertheless Arson did have some notable successes and a rare little group of a frog riding a hare (152), inspired no doubt by a traditional French fable, has considerable charm. Arson, being a genuine student of animal forms like all members of the school, maintained anatomical accuracy despite the fairy-tale treatment of the subject, although in work of this kind there was no pretence at high art. On the contrary, a pleasing dimension of humour was added to what can seem at times a dull field. Also a surprising number of unsigned bronzes of unusual subjects occur, such as an imaginative piece showing a mouse or small rat prising open an oyster shell (153); in a peculiar way this group has a feel about it of the first decade of the twentieth century and therefore lies outside the high period of animal sculpture, but a cast of this quality can never be ignored.

Another admirable characteristic of this school was the ability of comparatively minor members to produce bronzes of quite outstanding qualities. One of these was Paul-Edouard Delabrierre (1829–1912), who spent his whole life as a specialist Animalier, exhibited regularly at the Salons from 1848 to 1882, but never reached high levels of production or importance. Yet Delabrierre was the author of a sensational figure of a camel (154), dated 1849 and thus an early work, making the choice of subject and fully competent handling an even greater achievement. The techniques employed in this bronze were close to Mene's, but the camel was outside the latter's subject range and in any case Mene would have been disinclined to introduce the same amusing characterisation. It was no doubt

152 (*below left*) An amusing composition by Alphonse Arson who specialised in small-scale animal bronzes.

153 (*below right*) A surprising number of well-cast unsigned animal bronzes are to be found, such as this study of a rat prising open an oyster shell.

on the strength of such bronzes that Delabrierre was commissioned in 1857 for the group 'L'Equitation' for the façade of the Louvre.

Of a similar type is the bronze figure of a bloodhound (155) by Jules Gilibert; animal work by this sculptor is extremely rare, and yet he was capable of portraiture of this high calibre. At first sight Gilibert made it obvious that this was no ordinary animal, and indeed the inscription confirmed that the dog was a celebrity of its kind, no less than the great 'Druid', personal bloodhound of Napoleon III. The consistency of a sculptor such as Mene must always be admired, and yet the undoubted genius of a non-specialist like Gilibert in a superb, characterful portrait of this stature has a different if not equal merit.

154 Paul-Edouard Delabrierre executed this craggy camel in 1849.

155 'The Bloodhound Druid' by Jules Gilibert, a characterful portrait of Napoleon III's favourite dog.

At this stage it would be convenient to investigate the technical aspects of animal bronze production as it plays such an important part in the aesthetic appreciation of this highly specialised sculpture. As has been seen, *Les Animaliers* contributed to the development of sculptural style through the presentation of novel themes and moods. They also introduced equally important changes in general taste by their technical revival of the small bronze as a primary means of expression, for all the significant Animaliers employed hand-casting methods to produce small-scale, personal works in significant contrast to the contemporary fashion for sterile marble sculpture, and until very recently the use of bronze in this way, pioneered by the Animaliers, was the accepted technique of modern sculpture.

From the beginning they invariably employed one of two processes, and both were ancient inventions revived regularly in the Renaissance and spasmodically since then. The most laborious and yet the most delicate method, the *cire perdue* or lost-wax process, involved casing the original model in plaster which was then carefully cut away and reassembled; from this piece-mould several casts in wax could be taken and these would then be encased in a heat-resistant mould with escape ducts, the bronze poured in and fired. The marvellous feature of this method was that the sculptor's hand was required at all stages of the production, first in finishing the finer details on the wax taken from the piece-mould and then of course in the chasing and detailing of the final bronze. This meant that however many casts were taken each one had elements of originality and possessed the intimate personality of direct artistic creativity.

However, the expense of the *cire perdue* process forced many sculptors to use sand casting which, although it required extreme skills from the craftsman on complex pieces, allowed for quicker production and placed a less onerous burden on the sculptor. The idea was simple, for the shape of the model was pressed by sections into specially prepared sand boxes and then cast in the requisite number of pieces. In a simple relief such as fig 135, which was cast by Eck et Durand, the model could be taken in one cast, but when it came to making undisturbed impressions in the sand of Gayrard's 'Monkey Steeplechase' (142) the variations were infinite and the craftsman had to choose the least destructive sections and then join and finish the pieces with the greatest care.

Another delight of these processes of hand production is that each sculptor of animals developed his own methods to suit the particular character of his work. First, as always, was Barye, who set up his own foundry and sales system in 1839 and was deeply interested in the technical methods of translating the immediacy of his sculptural visions into commercial bronzes. Prior to this date Barye had enjoyed the partnership of the most distinguished *cire perdue* founder of the time, Honoré Gonon, and then once on his own Barye made a particular study of the patination of bronzes, that is the treatment of the surface after the final casting to enliven the brassy colour of the natural bronze. So Barye not only made considerable alterations to the surface details at the wax model stage, but then after the casting applied numerous different patinations in order to enhance the quality of movement in his animals. His favourite colour, one not used

by any other contemporary sculptor, was a classical green, signs of which can be seen on 'Le Cheval Turc' (133).

From 1848 to 1857 Barye found himself in financial difficulties and was forced to employ Emile Martin as 'editeur' of his bronzes, and although neither these nor those cast immediately after his death in 1875 by Ferdinand Barbedienne were of poor quality, they often lack the full sense of the artist's powerful participation gained from the early numbered bronzes.

Unlike Barye, Fratin never possessed his own foundry but personally commissioned casts from various founders, who included Susses Frères early on and Daubré later in life. However, the best work for Fratin was completed by E. Quesnel, a small Parisian founder active between about 1810 and 1850; here Fratin also paid individually for the casting and was able to control the production, and as a result most of his work had a satisfying uniformity in its rough black surfaces (figures 140 and 141). This kind of regular relationship between sculptor and founder was of considerable importance, and one of the most successful combinations turned out to be that between Isidore Bonheur and his uncle by marriage, Hippolyte Peyrol, and the two of them produced highly commercial bronzes well cast and finished in uncomplicated mid to dark brown patinations (figure 151). Similarly Moigniez benefited immeasurably from the help of his father as founder, and as the expenses were so great with this hand founding, the activities of those fine sculptors like Delabrierre were surely curtailed by unfortunate lack of these benefits.

But, as already mentioned, Pierre Jules Mene was the Animalier who set up the most efficient commercial organisation, operating his own foundry for the whole of his life. Although Mene failed to secure official patronage there was continuous public demand for the two hundred or more bronzes that he modelled. Mene was a simple realist and it was essential to retain the crispness and accuracy of the original model in the commercial bronze, and this could be achieved only by patient supervision [p. 108]. After Mene's death in 1879 the atelier was kept up by his son-in-law, the Animalier Auguste Cain (1821–94), who continued to issue similar catalogues, which increased even further the number of fine casts of Mene subjects (144).

The only other animal sculptor of this generation to be accorded the same kind of wide following as Barye was Emanuel Fremiet (1824–1910). Fremiet, in fact, was to become one of the most popular of all French sculptors in the nineteenth century, and as well as receiving all the French prizes and honours he also became an Associate of the Royal Academy in London; it cannot be claimed, however, that this fame was achieved purely as an animal sculptor, as Fremiet himself refused to accept this limited description.

Nevertheless, all his early and much of his best work was as a pure Animalier, beginning with his opening exhibit, a gazelle, at the Salon of 1843, after an extremely advantageous apprenticeship with his uncle François Rude. Fremiet quickly established himself in the public eye, for in October 1849 the Minister of the Interior commissioned a marble version

156 This group of the dachshunds Ravegeot and Ravegeole by Emanuel Fremiet was commissioned for the Palace of Compiègne after its Salon success of 1851.

of his 'Family of Cats', and his 1851 Salon exhibit of two dachshunds (156) received a court commission for decoration of the Palace of Compiègne. Despite his contrary protestations Fremiet made something of a speciality of intimate animal groups of this nature and they became sought after by collectors during his lifetime, and this sensitive, characterful portraiture of the two hounds Ravegeot and Ravegeole was of course firmly set in the best Animalier tradition.

But Fremiet seldom pursued a single theme for long, and an amazing sculpture was submitted and then rejected at the Salon of 1859. By this time Baudelaire had lent his support to Fremiet and although considering that the rejected 'Gorilla Dragging the Body of a Woman' lacked taste, his general opinion of Fremiet's work of 1859 was that it 'represented human intelligence bearing with it the idea of both wisdom and folly'. This intellectual appreciation must have gratified Fremiet, and at the second attempt, the Salon of 1887, he was fully assuaged by award of the Médaille d'Honneur for his 'Gorilla'.

In the sixties Fremiet produced a number of large equestrian groups, typical of which was the figure of a mounted Gallic soldier (157), shown in plaster at the 1863 Salon, in bronze in 1864 and again at the Exposition Universelle of 1867, and in this Fremiet also revealed the established approach of a realist Animalier with his meticulous attention to the details

157 'The Gallic Horseman', also by Fremiet, exhibited in the Salons of 1863 and 1864, and in the Exposition Universelle of 1867.

of harness and in completely natural composition. This period of activity culminated in the unveiling in 1874 in the Place des Pyramides of his 'Joan of Arc', a monumental gilded bronze that captured the rare spirit of Romanticism in its strong, poetic form.

Although this is not the place to discuss the full variety of Fremiet's work it must be noted that he was capable of outstanding performances in many sculptural roles. For example the 1894 portrait of Meissonier standing at the easel compared for liveliness of surface and of personality with

the best new sculpture of the last decades of the century. Fremiet had also designed a number of decorative interiors, indeed to such a degree of professionalism that he exhibited furniture at the 1867 Paris Universelle, and executed weird Gothic designs for the Hôtel du Dr Dieulafoy, including light fittings inhabited by contorted dragons and snakes. This contrasted violently with the attitude of Georges Gardet (1863–1939), whom D. C. Eaton described in 1913 as 'next to Barye . . . the best sculptor of animal life of the modern French school'. Gardet was certainly very successful, and many groups such as the 'Tiger Attacking a Tortoise' (158) have considerable vigour and absolute control of animal form in the best traditions of Barye. But, in the first place, so much of Gardet's work suffered from his lack of concern for the techniques of founding; and, in the second place, despite an occasional excursion into Symbolism as with the 'Lion Amoureux', Gardet merely prolonged an old-fashioned style without making any original contribution.

The precise advances in style which Gardet ignored can be seen in the three following illustrations. Jules Dalou (1838–1902) has already been discussed at some length in chapters 1 and 2 and there is no need for repetition of the details of his distinguished career. The important point in this instance concerns the texturing of the cast (159) by Hebrard of Dalou's strong horse, for in his display of surface lights and movements Dalou had initiated revolutions in taste in both England and France. The naturalism which Dalou brought to figurative sculpture had of course been the property of Les Animaliers for years previously, and indeed Barye and others had also concerned themselves closely with surface treatment, but always in the interest of realism and not for the independent visual qualities that attracted Dalou (159). Of course Dalou took good care that the horse was correctly proportioned, as his simplistic creed decried all affectations and

158 'Tiger Attacking a Tortoise' by Georges Gardet, the most successful of the younger Animaliers.

exaggerations of form, a characteristic that isolated him from the modern movement which demanded a stylisation of actual form as well as of surface detail.

Degas' horse (160) therefore would have been equally alien to both Barye and Dalou, for although giving a full impression of the animal in movement it took absolute licence with the anatomy of the horse. Edgar Degas (1834–1917) was in fact no intellectual, and the seventy-four bronzes cast posthumously by Hebrard from waxes found in the master's studio concentrated simply on communication of real movement through stylised impression.

The aim had altered little from the principles of the first Animaliers, but the means had changed completely.

159 A Hebrard cast of a horse by Jules Dalou, thought to be his only pure animal bronze.

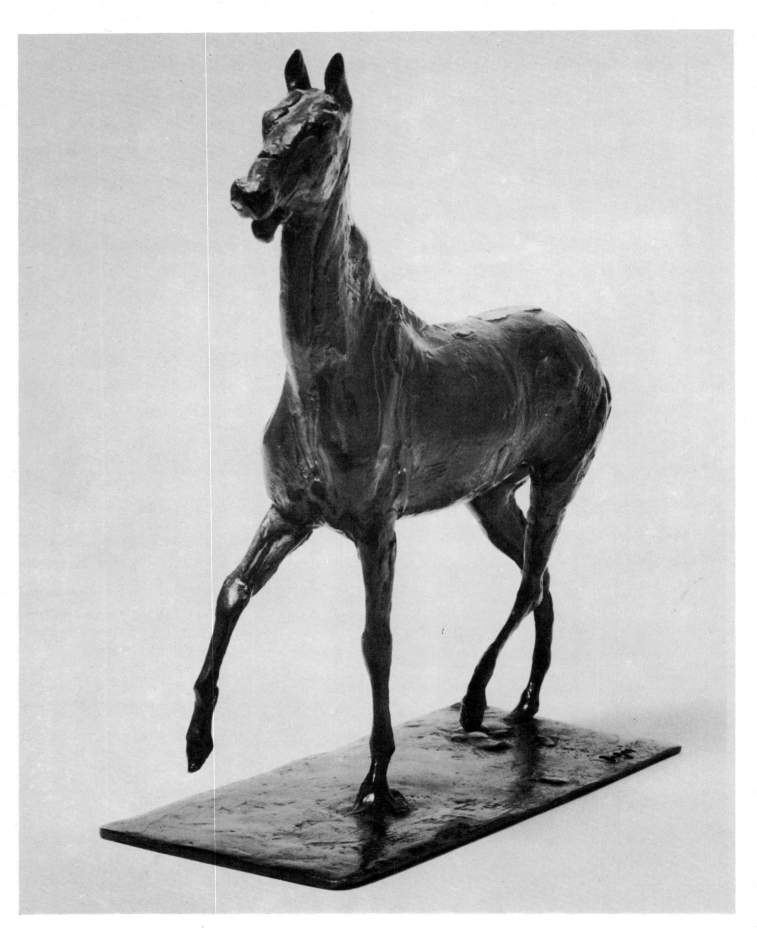

160 This impressionistic model of a racehorse by Edgar Degas was also cast by Hebrard, from wax models found in the studio at the artist's death.

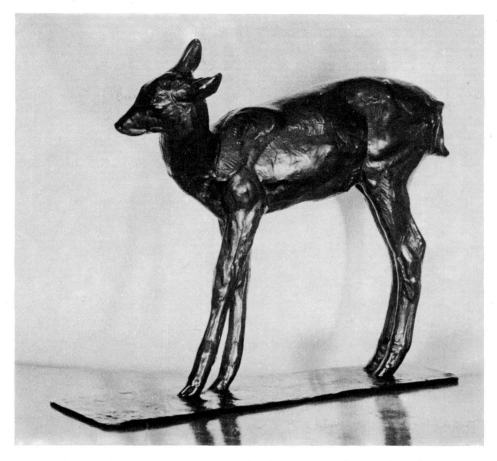

161 'A Kevel Antelope' by Rembrandt Bugatti, whose suicide cut short a promising career as a modern Animalier.

The first sculptor to change also the basic aim of animal sculpture was François Pompon (1855–1933). His first animal exhibit at the Salons was in 1892, but from then on he fought against the prejudices of his time until in 1922 with the 'Polar Bear' he finally gained official recognition for the stylised animals of the modern movement. The only other sculptor of animals who might have accompanied Pompon but for his tragic suicide was Rembrandt Bugatti (1855–1916); it is fitting that the last illustration should be Bugatti's figure of a young antelope (161), for it marks superbly the transition between the characterful realism in animals initially conceived by Barye and the stylised forms of the twentieth century.

By the time the arts rose again to their feet after World War I, Romanticism in animal sculpture had died a natural death; the achievements of the School over a long period, however, had enjoyed a significance far beyond the narrow boundaries of their subject.

Appendix: Market Guide

As both taste and the value of money change with such rapidity, it is impossible to give an accurate guide to prices that has any lasting usefulness, and instead I merely offer some hints on the purchasing of bronzes, concentrating exclusively on the market in London for nineteenth-century romantic sculpture.

At the present time, Christmas 1973, there is a suggestion in the sale room air that English, French and American romantic bronzes might quite suddenly claim the popular attention that has been accorded the Animalier sculptors since the late 1960s. But until this happens there are frequent opportunities for the private enthusiast to form a collection of considerable artistic merit and certain historical importance, the most exciting fields being the New Sculpture in England from 1870 to 1915 and the tyros of romantic sculpture in France from 1830 to 1880. With a few notable exceptions like Alfred Gilbert and Jules Dalou, very few sculptors in these categories command high prices, except for marbles or bronzes that can be positively identified as rare studio works or studies.

This question of identifying as accurately as possible the age and quality of particular bronze casts is a crucial factor in the pricing of bronzes, for the best casts with their original patination are infinitely more desirable than later and less lively casts. The difference in price between an early and late cast is also considerable, and inexperienced collectors can easily be inveigled into paying too high a price for a poor quality cast. The process of identifying the good bronzes is basically visual, for the collector is simply looking for a cast that maintains the closest creative link with the original clay or perhaps marble model from which the bronze was taken. Fine bronzes have that instantly communicated quality of life and freedom in the modelling, even if the style be basically classical, and the keen collector will quickly acquire the visual experience required for an instinctive response to the best works.

However, there are certain mechanical aids to the identification of bronzes. Many of the best bronzes of the period were cast by craftsmen working in either the *cire-perdue* or sand-cast processes, and the majority of bronzes cast by these two methods were hand-finished, in strong contrast to the smooth, untextured surfaces of commercially produced bronzes. The hand-produced casts often have remains of the mould sticking to the inside, and there will often be visible signs of pinning and joining the pieces, again in contrast to the mechanical appearance of the commercial casts.

The presence of founders' stamps can also be informative, as some sculptors used specific founders during their lifetime and the presence of a different mark indicates a later cast. On the other hand, many bronzes of the period occur only in mechanical casts that were made perhaps after the artist's original had secured an award at an Academy or Salon exhibition, so commercial casts cannot be condemned out of hand.

The presence of a signature on a bronze can be no guide to the date of production, but early casts will naturally tend to have a crisper and more calligraphic signature. Another important feature of a bronze is the patination, ie the way the surface of the bronze has been finished. The best method of making a quick assessment of the quality of patination is to rub an area of the bronze with the palm of one's hand, when a nice cast will reveal those rippling surface textures that make the bronze statuette such an attractive item for display.

In the sections below, sale room prices, with dates, are given of some of the actual bronzes reproduced in the illustrations of this book. These prices cannot in any sense be taken as precise indications of value, but may be of factual interest.

French Sculpture from David d'Angers to Rodin. The works of Rodin, Degas and other sculptors dealt with at the end of this chapter are of course purchased at great prices by the collectors of Impressionist paintings, but mid-nineteenth-century sculpture is far less sought after. The majority of the bronzes in this field will have been reproduced in commercial casts, so it would still be possible to collect examples of most of the historically important sculpture of the period.

The medallions of David d'Angers must constitute one of the most exciting unpopularised collecting prospects in the entire art world, for he produced superbly romantic portraits of over five hundred leading personalities of his era, added to which the average cost of each medallion can scarcely be more than £30 and the star of the collection could have been bought in 1973 for as little as £60 [p. 107].

Figure 12	£360	Mar 1973	Figure 32	£660	Nov 1972
16	£240	June 1972	34	£115	June 1972
17	£320	Dec 1972	35	£8	Oct 1971
18	£180	Mar 1972	40	£30	July 1972
20	£440	Mar 1973	41	£55	Jan 1973
23	£660	May 1972	42	£42	Jan 1973
29	£150	Nov 1971			

The New Sculpture in England. The attraction of the bronzes discussed in the latter part of this chapter is that the majority were cast by craft methods and hand-finished by the sculptor himself. The years 1870 to 1915 were an extremely active period of production in England and new collectors will be rewarded by investigating the less well known but nevertheless highly competent secondary figures.

Figure 52	£2,400	Oct 1971	Figure 76	£65	Mar 1972
53	£40	Oct 1971	78	£150	Mar 1972
59	£110	May 1972	87	£42	Oct 1971
60	£270	Nov 1972	90	£400	June 1972
63	£320	Nov 1972	93	£280	June 1971
69	£110	Mar 1972	95	£40	June 1972

American Romantic Bronzes. These seldom appear on the London market and we can give no accurate indication of prices.

French Animalier Bronzes. In this field particularly, the price variations can be gigantic, depending on the age and quality of the cast. Sadly, there are a depressingly large number of absolutely modern casts on the market; some of these are so roughly produced that identification is made simple by obvious physical divergences from the original, as well as the insulting lack of quality in the modelling. But two or three foundries are turning out reproductions of the highest quality and a practised eye will be needed to identify these. The new ones are often slightly heavier than period casts and the patination can never quite match the original.

In terms of sculptural value for money, collectors might be advised to avoid horse subjects which have a wide appeal to the wealthy racing fraternity and are therefore relatively expensive. Unusual subjects again reward investigation, but it is always important to concentrate on whatever pleases the individual taste, and many will claim, with some justification, that the horse was the prime subject of the Animalier sculptor.

Figure	133	£1,200	Nov 1972	Figure	150	£180	Mar 1972
	135	£18	June 1972		152	£115	June 1972
	136	£340	Nov 1972		153	£35	June 1972
	137	£650	Mar 1973		154	£155	Mar 1972
	144	£1,270	Nov 1972		155	£200	June 1972
	146	£210	June 1972		156	£220	Mar 1972
	147	£80	Mar 1972		157	£200	Nov 1972

Specialist dealers and auctioneers in London

Sotheby's Belgravia, 19 Motcomb Street, SW1 (telephone 01.235–4311)
Sladmore Gallery, 32 Bruton Place, W1 (01.499–0365)
Julian, 406 Kings Road, SW10 (01.352–4400)
Fine Art Society, 148 New Bond Street, W1 (01.629–5116)

Acknowledgements for Illustrations

The illustrations are reproduced by courtesy of the following:

Art Institute of Chicago 119
Ashmolean Museum, Oxford 91
Christie's, London 56, 140
City Art Gallery, Birmingham 70
City Art Gallery, Leeds 92
City Gallery, Manchester 79
Corcoran Gallery of Art, Washington, DC 117, 118
Fine Art Society, London 54, 65, 71
D. C. French Museum, Chesterwood, Mass. 108
Harris Museum, Preston, Lancashire 61, 66, 85, 86, 89, 96
Heim Gallery, London 2, 11, 19, 27
D. Katz 30, 37
Alain Lesieutre 159, 161
Metropolitan Museum of Art, New York 103, 107, 109, 113, 120, 124
Musée des Beaux-Arts, Marseille 14
Musée Bourdelle, Paris 45
Musée de Chartres 13
Musée de Dijon 7, 10
Musée du Louvre, Paris 6, 8, 26, 28
Musée Rodin, Paris 43

National Gallery of Ireland, Dublin 112
New York Historical Society 105, 106
Pennsylvania Academy of the Fine Arts, Philadelphia 123
Richard Pollitzer 3, 5, 9, 36, 39, 46, 47, 48
Private collections, London 31, 38, 58, 62, 64, 67, 68, 98, 99, 100, 101, 135, 139, 141
Public Library, Shepherds Bush, London 83
Sladmore Gallery, London 131, 142, 148
Sotheby & Co, London 15, 44, 51, 132, 160
Sotheby's Belgravia, London 1, 4, 12, 16, 17, 18, 20, 21, 23, 29, 32, 33, 34, 35, 40, 41, 42, 49, 50, 52, 53, 59, 60, 63, 69, 75, 76, 77, 78, 82, 84, 87, 90, 93, 95, 97, 116, 133, 134, 136, 137, 143, 144, 145, 146, 147, 149, 150, 151, 152, 153, 154, 155, 156, 157, 158
Sotheby Parke Bernet Inc, New York 22, 24, 25, 104, 110, 111, 114, 115, 121, 122, 125, 126, 127, 128, 129, 130, 138
Tate Gallery, London 73, 80, 94
Mrs Lloyd Thomas 57
Victoria and Albert Museum, London 73
Walker Art Gallery, Liverpool 55, 74, 81, 88
Yale University Art Gallery 102

Select Bibliography

The contemporary sources for nineteenth-century sculpture are legion, and only the most significant have been listed.

GENERAL

PARKES, K. *Sculpture of Today* (London 1921)
RHEIMS, M. *La Sculpture au XIX Siècle* (Paris 1972)
SHEPHERD GALLERY. Exhibition Catalogue 'Western European Bronzes of the Nineteenth Century' (New York 1973)

FRENCH SCULPTURE (including Animal Sculpture)

BÉNÉDITE, L. *Les Sculpteurs Français Contemporains* (Paris 1901)
BENOIST, L. *La Sculpture Romantique* (Paris 1928)
EATON, D. C. *A Handbook of Modern French Sculpture* (New York 1913)
JOUIN, H. *La Sculpture aux Salons* (Paris 1870)
HORSWELL, J. *Les Animaliers* (Woodbridge 1971)
LAMI, S. *Dictionnaire des Sculpteurs de l'École Français du XIX Siècle*, 4 vols (Paris 1919)
MACKAY, JAMES. *The Animaliers* (London 1973)
PRADEL, P. *La Sculpture du XIX Siècle* (Louvre 1958)
La Sculpture Contemporaine (Paris 1900)
SPEED ART MUSEUM. *Nineteenth Century French Sculpture* (Louisville, Ky, December 1971)

ENGLISH SCULPTURE

FINE ART SOCIETY. *British Sculpture, 1850 to 1914* (London 1968)
GOSSE, E. 'The New Sculpture', *Art Journal* (London 1894)
GUNNIS, R. *Dictionary of British Sculptors 1660 to 1850* (London 1968)
SPIELMANN, M. H. *British Sculpture and Sculptors of Today* (London 1901)
UNDERWOOD, E. *Short History of English Sculpture* (London 1933)

AMERICAN SCULPTURE

CRAVEN, W. *Sculpture in America* (New York 1968)
GARDNER, A. T. *Catalogue of American Sculpture in the Metropolitan Museum* (New York 1965)
GERDTS, W. *Sculpture by Nineteenth Century American Sculptors in the Collection of the Newark Museum* (Newark 1962)
TAFT, L. *The History of American Sculpture* (New York 1903)

WORKS ON SINGLE SCULPTORS

French sculptors

Barrias: biography by G. Lafenestre (1908)
Bartholdi: *Art et Decoration* (1899)

Barye: biographies by Ballu (1890) and C. Saunier (1925); exhibition catalogues at Louvre (1956) and Sladmore Gallery, London (1972)
Bonheur, R.: biography by L. Roger-Miles (1900)
Carpeaux: biographies by L. Riotor (1906) and L. Clement-Carpeaux (1934); Petit-Palais (1955-6)
Carrier-Belleuse: biography by A. Segard (1928)
Christophe: *Art Journal* (London, 1894)
Clesinger: Barbedienne catalogue (1867)
Dalou: biographies by M. Dreyfus (1903) and H. Cailloux (1935); Mallets, London (1964)
Dampt: *Art et Decoration* (Paris 1897, 1907)
Daumier: Fogg Art Museum (1969)
d'Angers, David: biography by H. Jouin (1878); Hôtel de la Monnaie, Paris (1966)
Fremiet: biographies by J. de Biez (1896) and P. Fauré-Fremiet (1934)
Mene: Catalogue (*c.* 1875)
Rude: Musée des Beaux-Arts, Dijon (1955)

English sculptors

Bates: *The Artist* (London 1897)
Bayes: *The Studio* (London 1908)
Colton: *Magazine of Art* (London 1902–3)
Reid-Dick W.: biography by H. Granville Fell (1945)
Drury: *Magazine of Art* (1900)
Foley: biography by W. C. Monkhouse (1875)
Ford: *Magazine of Art* (1902)
Frampton: *Studio* (1896)
Gilbert: biography by I. McAllister (1929); *The Connoisseur* (London 1968)
Goscombe, John W.: Cardiff National Museum (1948)
Leighton: biography by E. Rhys (1898)
Lucchesi: *Magazine of Art* (1899)
Marochetti: biography by M. Calderini (1928)
Reynolds-Stevens: *Magazine of Art* (1897)
Ricketts: autobiography (1933)
Stevens: biographies by H. Stannus (1891) and K. R. Towndrow (1939); *The Wellington Monument*, Victoria and Albert Museum, London (1970)
Thomas: Leicester Galleries, London (1922)
Thornycroft, Hamo: *Magazine of Art* (1881, 1898)

Index

The principal page references for each sculptor are in italic. Page numbers at the end of entries in square brackets refer to colour plates; those in parentheses indicate black-and-white plates.